D1265733

A
CENTURY
OF
MODERN
PAINTING

Joseph-Emile Muller
Ramon Tio Bellido

A
CENTURY
OF
MODERN
PAINTING

UNIVERSE BOOKS
New York

Published in the United States of America in
1985 by Universe Books
381 Park Avenue South, New York,
N.Y. 10016
© 1986 Fernand Hazan Paris

86 87 88 89 / 10 9 8 7 6 5 4 3 2 1

Printed in Germany

Library of Congress Catalog Card Number
85-16466

ISBN 0-87663-487-0

contents

Joseph-Emile Muller

Impressionism 14

The Spread of Impressionism 60

Symbolism, Art Nouveau and the Nabis 63

Fauvism 74

Cubism 89

Futurism 115

Expressionism 117

Metaphysical Painting 142

Dada and Surrealism 146

Naive Painting 169

The First Abstract Painters 174

Ramon Tio Bellido

Since 1945 187

List of Illustrations 234

Edouard Manet

MANET
Rest
1869

"M. Manet... has never had any intention of overthrowing old forms of painting or of inventing new ones. He has simply tried to be himself." If Manet (1832-1883) felt obliged to write this in the catalogue of his exhibition of 1867, presumably it was in order to conceal his real aims from a hostile public, not to spell them out. His *Déjeuner sur l'herbe* had been inspired by Raphael and Giorgione, he had drawn directly on Titian's *Venus of Urbino* for his *Olympia*, so he could hardly fail to be aware of the nature of his own innovations.

In Giorgione's *Pastoral Concert*, which shows two naked women in the company of two fully-clothed men, the nudes are idealized, their faces anonymous and half-hidden in shadow. The light playing on the figures is a poetic, melancholy twilight, the overall effect is of a scene from a legend. The Manet is quite different in spirit. At that time you could have met the two men in the *Déjeuner sur l'herbe*, wearing exactly those clothes, on the boulevards of Paris. Far from being idealized, the body of the naked woman is as individualized as her face. The light is cold and ordinary. The picture as a whole has a quality of realism that is in direct contrast to the extraordinary situation in which the figures are shown.

The same is true of *Olympia*. A critic wrote: "We can hardly accuse M. Manet of idealizing foolish virgins, since his virgins are defiled." What can possibly be the significance of this sickly and anaemic, even cadaverous nude, shown in the company of a negress and a black cat who, in Théophile Gautier's words, "leaves its muddy paw-prints on the bed"? The only conceivable explanation is that in these two paintings the subject matter itself is no more than a pretext; the essential point is not the relationship between the characters but the relationship between the colours and the forms. Where Manet wanted to add a patch of light, he painted a nude. Where he wanted a contrasting dark tone, he painted a man in a black jacket, a negress or a cat. In other words the act of painting, which up till then had been simply a means to an

9

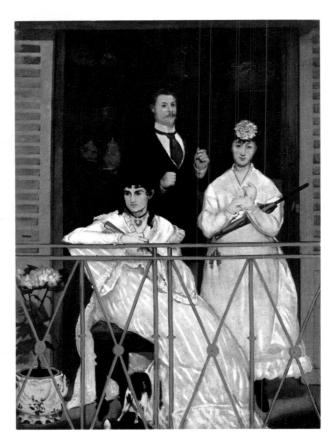

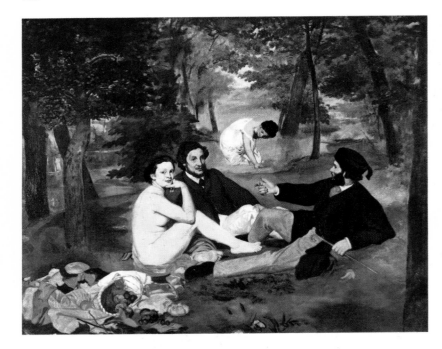

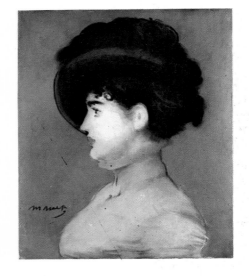

MANET
Portrait of Irma Brunner
1882

end, now became an end in itself. This was an innovation so radical that it could only be interpreted as provocation, a deliberate challenge to the public.

The style of *Olympia* was equally disconcerting. The flattened volumes and wiry outlines, the shadows which, again in Théophile Gautier's words, "are indicated by streaks of boot polish of varying width," the vast areas of light colliding without transition with areas of dark, the lack of depth that makes the figures stand out sharply, like close-ups on a screen—all these marked a break with painting as practised in Europe since the fifteenth century and pointed the way for a new kind of painting.

Yet, although Manet departed from tradition in *Olympia*, the *Fifer*, and the *Portrait of Théodore Duret* (all greatly influenced by the Japanese prints that had recently become popular in Paris), in other works he was content to make use of the traditional language, merely adding his personal inflections to it.

By 1874, influenced by his sister-in-law Berthe Morisot, he was beginning to draw closer to the Impressionists. His palette changed, he began to use brighter and more luminous colours, but rarely painted pure landscapes. In his studies of the play of light and the atmospheric effects over the Seine, or the

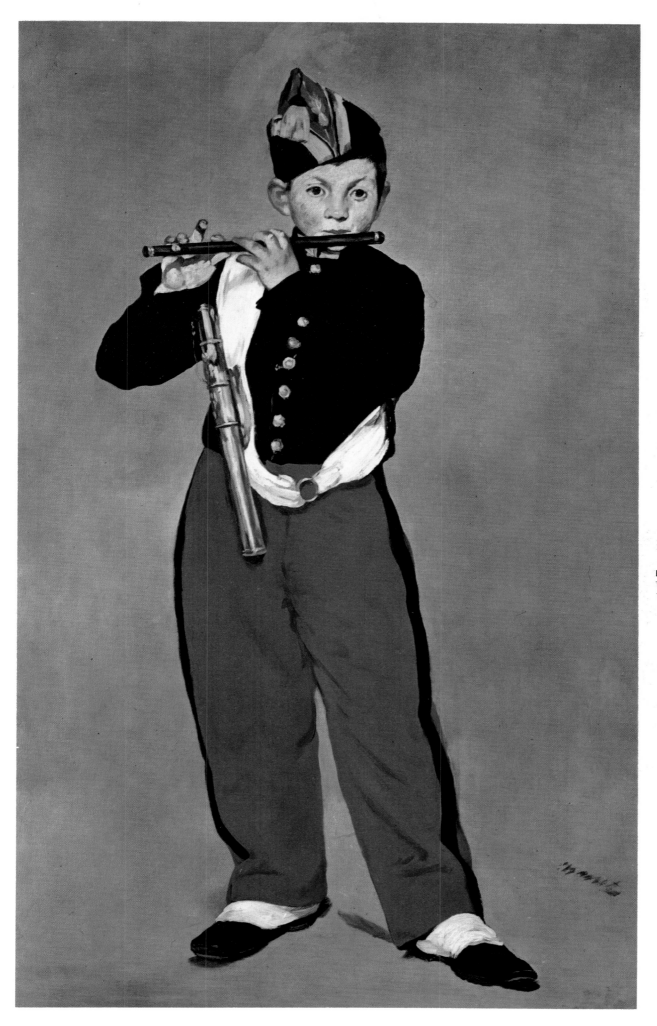

MANET
The Fifer
1866

11

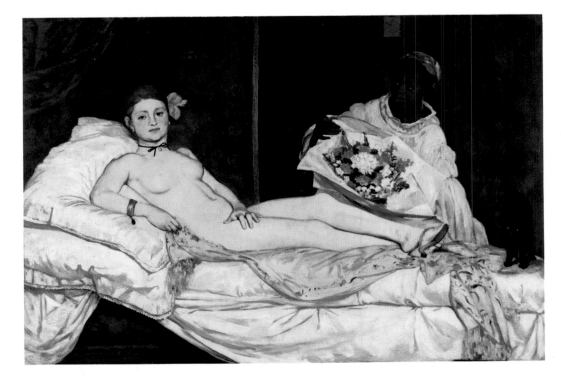

MANET
Olympia
1863

MANET
Nana
1877

MANET
Mademoiselle Victorine
in the Costume
of an Espada
1862

Grand Canal in Venice, he always included tangible elements, continuing to value the density and stability supplied by the human form.

Manet too was an avid student of the social scene, no doubt a further reason why he retained figures in his paintings, whether the elegant crowd of *Music in the Tuileries* and *Masked Ball at the Opera* or the street workers of the *Rue de Berne*. He observed his subjects with detachment, with an almost photographical exactness, yet there is a passion in the painting that takes it beyond cold objectivity. The touch is alert, vigorous, very free and evocative, reminiscent of Frans Hals or Velásquez, both painters whom Manet particularly admired.

His choice of colour does not seem contrived yet it is distinctive. Its rather acid freshness can at times verge on the glacial, but it has a rich and heady flavour. When Manet adopted the Impressionist palette he did not abandon the greys and blacks he had employed to such sumptuous effect before 1874. And by combining what he took from the Impressionists with what he had learned from visits to art galleries, he produced works such as *The Bar at the Folies-Bergère*, where the new manner is harmoniously allied to the old. Fluidity and sparkling spontaneity combine with the solid and the stable in an image that is both marvellously fresh and strongly composed.

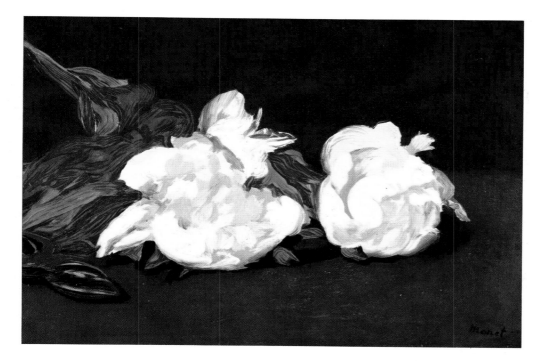

MANET
Two Peony Blooms
with Pruning-scissors
1864

MANET
Le Bar aux Folies Bergère
1882

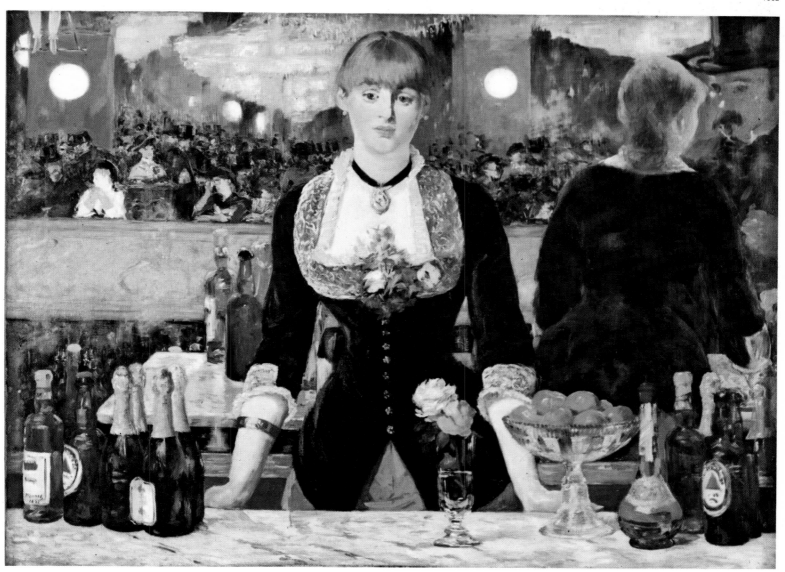

Impressionism

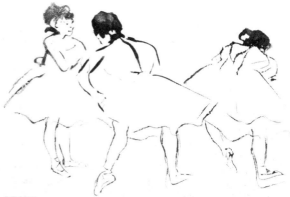

DEGAS
Three Dancers
ca 1876

Impressionism was given its name by a journalist of *Charivari* in 1874, but the picture that suggested the name, Monet's famous treatment of the harbour at Le Havre entitled by the artist *Impression, Rising Sun*, was actually painted in 1872. The origins of the movement go back to the mid-1860s, when Sisley, Bazille and Monet, all friends, were moving in a similar direction in their work and shared similar tastes and points of view.

These three painters rallied to Manet's support after the *Olympia* scandal, but it was more because they admired his stand against the official art of the day than because they were attracted to or influenced by his personal style. Monet's *Women in a Garden,* painted in 1866-1867, shows this quite clearly. It is a *plein air* painting, in itself an innovation. The shadows on the faces and pale clothes are not achieved by dark colours but by using cold tones of green and blue, which set up a play of colour quite independent of form. At this stage there is no more than a hint of the dislocation of form and atmospheric haze characteristic of the later work, and the firm outlines of the figures, viewed from close to, are very much in the old tradition of studio painting. The new manner is more clearly seen in the landscapes painted by Monet and Renoir in 1869 at the famous bathing-place of *La Grenouillère* ; here the figures are viewed from a distance and all the emphasis is thrown onto the light and atmosphere that are central to the Impressionist concept of painting.

Impressionism aroused shock and outrage at its inception, and ultimately it revolutionized painting, yet it emerged as a distinct style only by a gradual process of evolution. In their handling, their love of pure and complementary

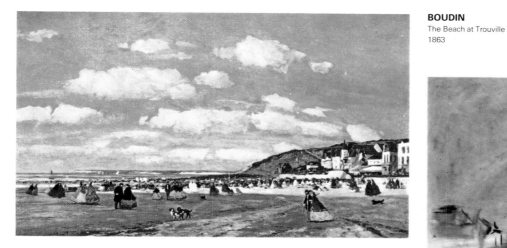

BOUDIN
The Beach at Trouville
1863

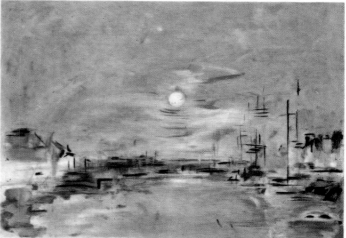

BOUDIN
Le Bassin du Commerce
Le Havre

MONET
Impression Rising Sun
1872

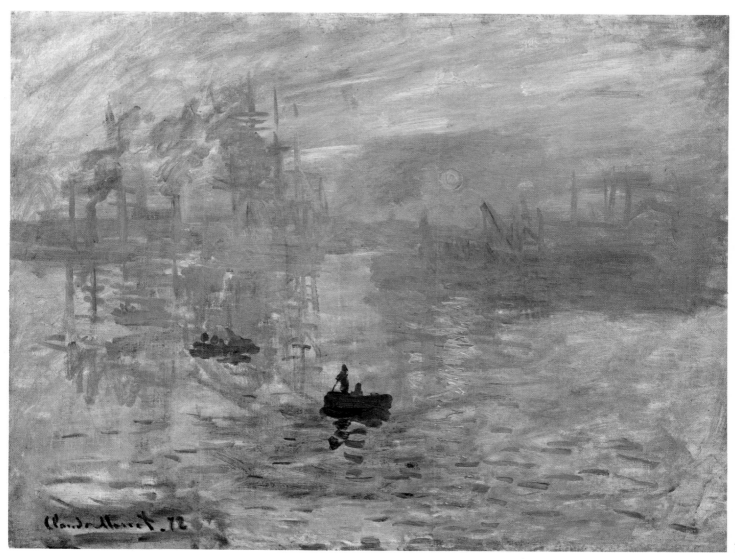

JONGKIND
The Beach at Sainte-Adresse
1863

JONGKIND
Sun setting on the Meuse
ca 1866

colours, its exponents reveal affinities with Delacroix, the king of the Romantics. In their subject matter and their early treatment of it, they are very much in the tradition of Théodore Rousseau, Dupré, Daubigny, Corot and Courbet, all of whom could in varying degrees be described as realists. And there were two painters in particular who had a direct and decisive influence: Eugène Boudin (1824-1898) and Johan Barthold Jongkind (1819-1891).

Manet met Boudin at Le Havre in 1858. Watching him paint on the Normandy coast was, he said "like a curtain being torn aside. I saw then what painting could be." More than any of his predecessors in France, Boudin was sensitive to the way visible reality was altered by light and atmospheric conditions. He said "anything that can be painted directly and *in situ* will have a force, power and vivacity that is unobtainable in the studio." On each

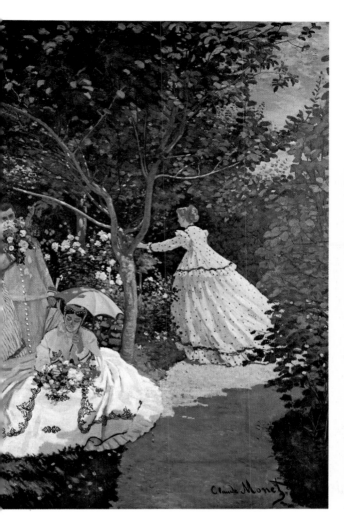

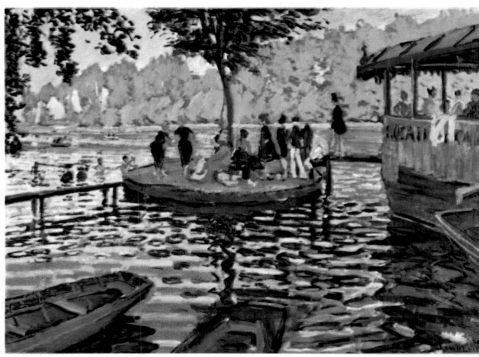

motif he noted how the temperature and humidity of the air blurred the form, the vibrations set up by rays of filtered sunlight, the changing colours of the clouds and waves, the wind effects over land and sea and in the sky. His delicate palette includes a wide range of greys and shows to particular effect in his watercolours, which tend to be lighter and more spontaneous than the oils.

Jongkind, who was Dutch but lived mainly in France, also worked in both media. But while his oils betray a fondness for romantic effects of lighting, in his watercolours he captures the light of the external world with accuracy and skill. His touch is freer than Boudin's and his colours possibly even more fluid. It was his verve and truthfulness, as well as his elliptical and evocative manner, that appealed to Monet, and the influence of Jongkind, as well as

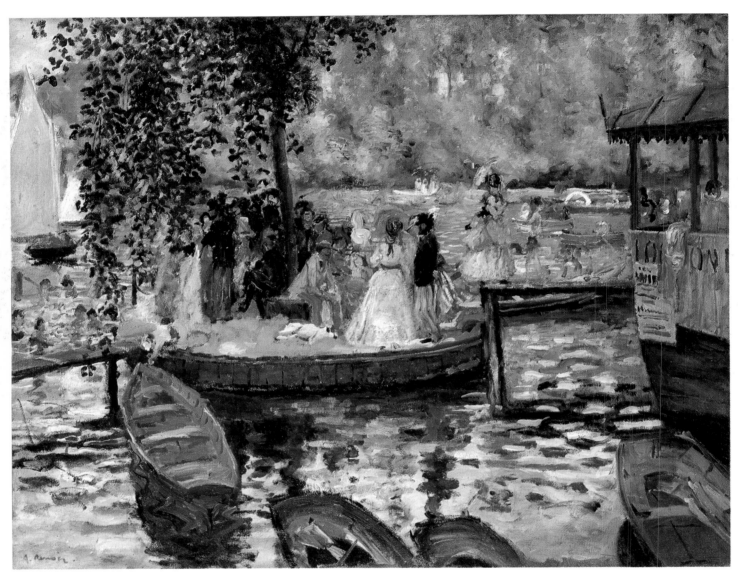

RENOIR
La Grenouillère
1869

Courbet, is particularly apparent in the works Monet painted around 1865 in the Forest of Fontainebleau and at Honfleur.

In 1870-1871, Monet and Pissarro went to London to escape the Franco-Prussian War. There they saw and admired the works of English painters such as Constable and Turner. It was Constable (1776-1837) who, in 1824, had urged Delacroix to rework the background of his *Massacres at Scio.* He was an extraordinary landscape painter with an almost religious feeling for nature, and his canvases are intense recreations of the fertility and abundance of natural life. To express what he felt and saw he employed a near-tachiste technique, which left the outlines of things undefined. That is true at least of his more spontaneous and personal works. The handling is quite different in those of his paintings designed to appeal to conventional

CONSTABLE
Weymouth Bay
1816

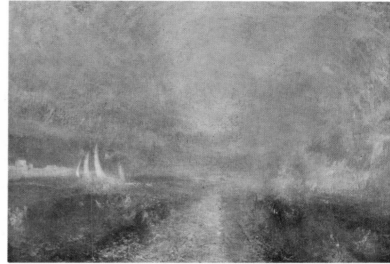

TURNER
Yacht near the Coast
ca 1842

taste. Hence he would often paint two versions of the same subject, one corresponding to his ideals, the other much more detailed but less personal and vivid. Of course it was the earlier versions that Monet and Pissarro preferred. In these the objects seem almost to move, they are so alive. Heavy storm clouds gather in the skies, seeming to shift and grow lighter or darker before your eyes. Nothing is still in this world. Each brush stroke is a quiver of life.

Some sketches and watercolours by Turner (1775-1851) are in the same vein as Constable's landscapes, but his most original works are those in which he projects his own visions onto the natural world. He was a dreamer and a romantic, even when painting a subject like *Rain, steam, speed* (1843) which was based on a train he had seen steaming over a bridge in heavy rain. In general, whether with observed subjects of this kind or in, say, a Venetian scene, he was less interested in the objects themselves than in the way they were diffused in mist and light. In his mature works substance becomes fluid, vaporous and elusive. You might say that Turner painted dreams, in which the real world is no more than a rapidly receding memory. In this his approach set him apart from the Impressionists, who criticized both him and Constable for failing to understand the nature of shadow which, Pissarro said, "in Turner's work is a gap, a contrived effect." They could however appreciate the liberties Turner took with form, for in many ways he anticipated (though in a range of

19

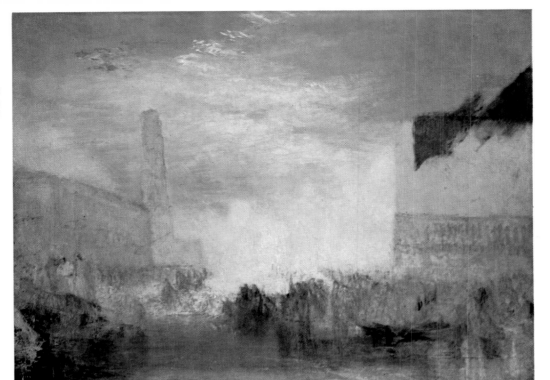

TURNER
The Piazzetta
1839-1840

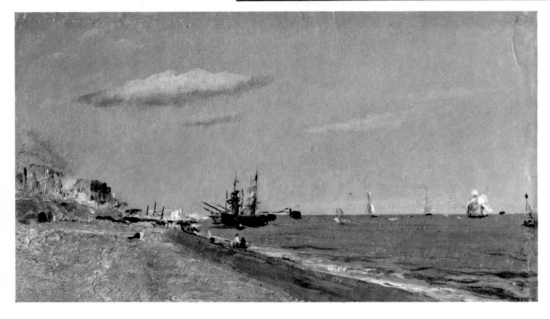

CONSTABLE
Brighton Beach
1824

colours they would never use) the dislocation of form which was to become Monet's hall-mark thirty years later.

The first exhibition of 1874 which gathered the representatives of the new manner of painting together in Paris, at the studio of Nadar the photographer, is an event of such importance in the history of art that one tends to assume the organizers realized its significance at the time. Of course this was not so. The artists who took part in the exhibition called themselves simply a "Limited Co-operative Company of Painters, Sculptors, Engravers, etc." They had no manifesto, no sense of themselves as a school of painting. Many different traditions and kinds of painting were represented. Out of thirty exhibitors only

eight—Monet, Pissarro, Renoir, Sisley, Berthe Morisot, Guillaumin, Degas, Cézanne—were to become famous as Impressionists.

Even these eight had very different temperaments and, in some respects, different concerns as well. What they did have in common was the rejection of all that was dear to academic painting, the historical, mythological and sentimental subjects, the over-polished finish and dull, sooty colours. They shared a determination to make painting modern, taking their subjects from the everyday reality of the time, and trying to express their feelings with sincerity even if this meant breaking with the rules of time-honoured tradition. They all agreed, more or less, in wanting to put on canvas, not what the painter knew, but what he saw at the precise moment of painting. And most of them shared a love of the hazy landscapes of the Ile-de-France, of skies filled with shifting cloud patterns, and the shimmering reflections on the flowing waters of the Seine and the Oise.

Their study of the effects of light also led them to make technical innovations, limiting their palette to the colours of the spectrum, and taking into account the laws of complementary colours. Knowing that complementary colours heighten each other if applied side by side but destroy each other if mixed, they applied their colours pure, in little dabs and accents — and if the marks sometimes cross or merge this is because their principles were applied instinctively and not systematically. Their painting achieved a lightness unknown since Leonardo da Vinci, giving the outside world a freshness and youthfulness, and above all a variety of light effects never before seen in European art.

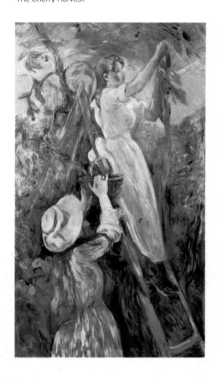

MORISOT
The Cherry Harvest

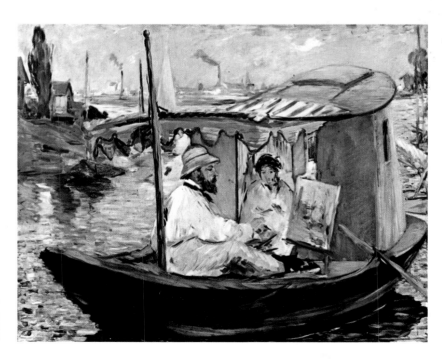

MANET
Claude Monet
Painting in his Boat
1874

Claude Monet

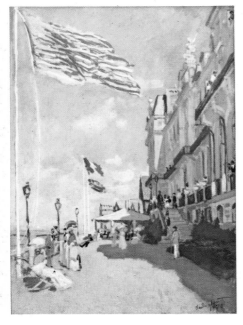

MONET
Hôtel des Roches Noires, Trouville
1870

There is no finer representative of Impressionism than Monet (1840-1926). No one else gave expression to its theories with such audacity and uncompromising logic. Monet himself said: "We paint as a bird sings. Paintings are not made with doctrines." But this often-quoted remark should not be taken too literally. Conscious experiment is clearly a strong driving force in his work, complementing his painter's instinct. We see this particularly in his series of paintings, the first of which, the *Gare Saint-Lazare* in Paris, dates from 1876.

1876 was the Argenteuil period, the "naive" period of Impressionism. Monet had just completed some of the most successful examples of the new manner of painting, scenes of the Seine and the surrounding countryside. Why then should he choose at this point a theme so apparently lacking in picturesque qualities? No doubt part of the answer is that it was the very lack of the picturesque that attracted him. Great artists have often sought to discover beauty and poetry where they are least apparent. But also the Gare Saint-Lazare gave him the opportunity to study an even more insubstantial element than water: the smoke from the engines. The smoky haze, the capricious wreaths of vapour, the iridescent play of the light, transforming engines, metal surfaces and neighbouring houses—all this could hardly have failed to fascinate him.

The *Gare Saint-Lazare* series and the studies of the *Break-up of the Ice*, painted in Vétheuil in 1880, have been described as Monet's "free" series.

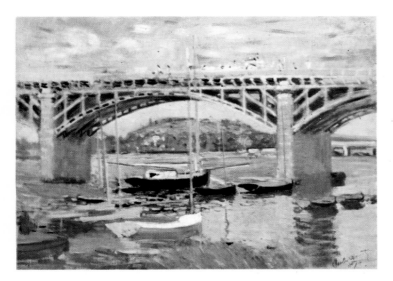

MONET
The Bridge at Argenteuil
1874

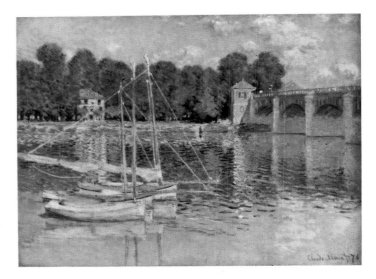

MONET
The Bridge at Argenteuil
1874

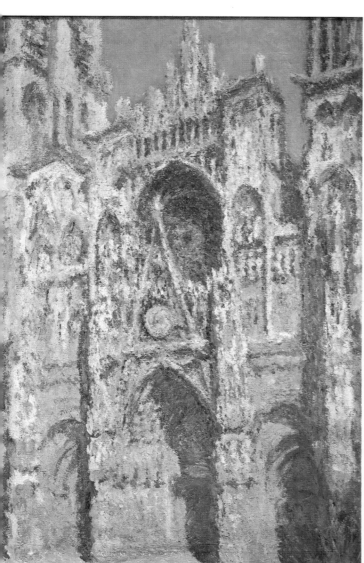

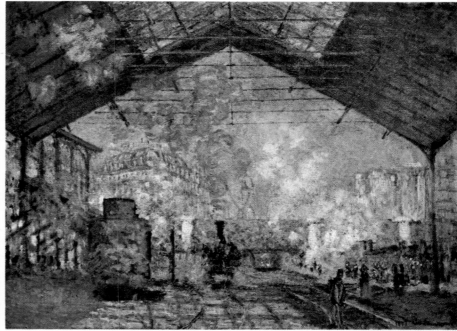

MONET
Rouen Cathedral
The Portal and the Saint-Romain Tower
Morning Study
Harmony in Blue and Gold
1894

MONET
La Gare Saint-Lazare
1877

The so-called "systematic" series came ten years later, the most important of these being the studies of *Rouen Cathedral* (1892-1894). There are twenty variations, all views of the same façade and mostly from the same angle. The series is the clearest possible illustration that Monet's concern was not with the motif as a thing in itself but in the way its appearance changed at different hours of the day, in fine weather or in cloud, in clear air or in mist. Never before had anyone discovered such variety within a single view of an object. Or, more accurately, never had anyone captured with such sensitivity the multiple and enchanted reality of light and atmospheric conditions. For Monet was so obsessed with these natural phenomena that he simply ignored the substance, density and solidity of the tangible world. The façade of the cathedral is like a veil of subtle colour, its structure no more than a fleeting suggestion.

The abandonment of form is even more marked in Monet's studies of the

23

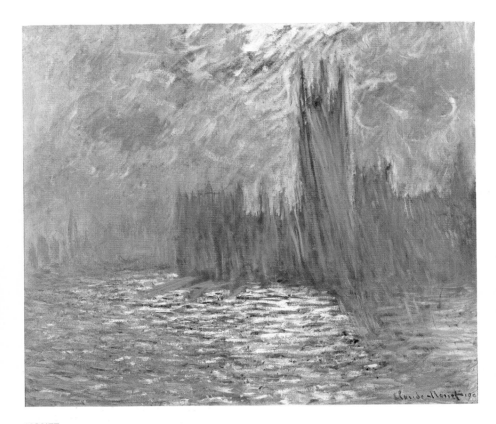

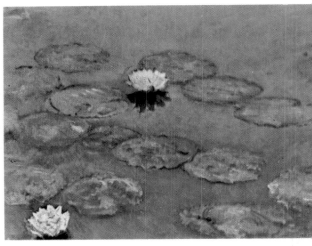

MONET
Water-lilies at Giverny

MONET
London. The Houses of Parliament
1904

MONET
Water-lilies at Giverny

Houses of Parliament painted in London soon after the turn of the century. Wreathed in a blue or purple fog shot with the yellows, oranges and pinks of an ethereal sun, the building is like some ghostly apparition that could be blown away by a puff of wind. The obvious parallel is Turner, although Monet had nothing of his romanticism. Monet may have been a visionary as well as an observer but he never allowed his own dreams to engulf the world he painted.

When he began to paint his series of *Water-lilies* in 1899, nature was once again his point of departure. His subject was the water-garden he had designed for himself in his garden at Giverny. At first the objects are still easily indentifiable: water-lilies, jonquils, wisteria, weeping willows. But later on the plants in the pond and on its banks become blurred shapes, and the paintings consist of blobs and trails, flourishes and tangles of colour satisfying in its own right.

By the end of his life, Monet had moved far away from realism, or even the Impressionism of the Argenteuil period. His colour harmonies had become simplified, invented rather than observed. His handling had an impulsive energy that went beyond mere representation of a visible reality. His *Flower Garden* or *Pond with Wisteria* invite comparison with some modern abstract painting. And this, of course, is why there has been a renewed interest in Monet's work, after a long period when it was neglected in favour of a more structured style of painting.

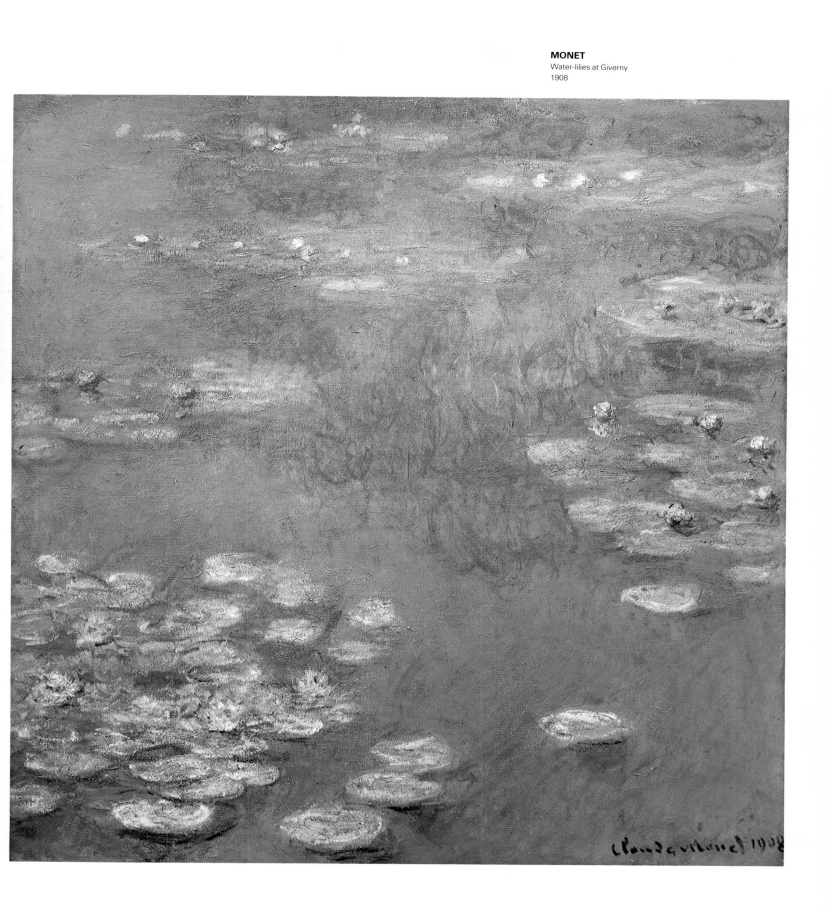

Alfred Sisley

In his early work Sisley (1839-1899) was close to Corot, and even when Monet drew him into the Impressionist circle that early influence remained strong. He had his master's fine sensitivity and gentle eye, but his colours are more differentiated because they are founded in observation rather than fancy.

Sisley lived and worked in the Ile-de-France, for much of the time in the Fontainebleau area. The subjects he chose were a river bank or a canal, a road leading up to a village, or receding into the distance, a village itself, either shrouded by soft light in snowy weather, or flooded with muddy water. Whatever the subject, he viewed it with calm. His flood is in no sense a disaster. His clouds rise above the horizon with no hint of impending storm or buffeting wind; for the most part they float gently past, and one might well suppose they are only there to filter the light, keep the air sweet and relieve the world of any sharpness of colour.

Sisley's work up to about 1877 shows a mastery of nuance and subtle transitions. Later, fired by Monet's example, the artist tried to extend his palette to include a livelier range of colours. This did not really match his temperament and the results lack conviction. Less restrained, his art lost its exquisite delicacy and its distinction, as well as much of its truth to life.

SISLEY
Snow at Louveciennes
1878

SISLEY
The Flood at Port-Marly
1876

PISSARRO
Le Canal du Loing
1902

26

Camille Pissarro

Like Sisley, Pissarro (1830-1903) was initially influenced by Corot and later guided by Monet towards Impressionism and the development of a personal style. The two artists were also alike in temperament, although one finds in Pissarro's work a note of anxiety not echoed by Sisley.

Up to 1884 Pissarro drew most of his themes from the countryside around Pontoise. Sometimes he set up his easel on the banks of the Oise, or at the corner of a road; or he stopped by a farm gate, where he could see a peasant coming home from the field or a woman pushing a wheelbarrow; or he installed himself in a field where harvesting was in progress, or in front of a cluster of houses half-hidden by trees. He loved to include trees, not only because of the way the green contrasted with the red roofs of the houses, but because he liked the lines made by their trunks and branches across the canvas. Impressionist though he was, Pissarro still believed in retaining elements of structure and solidity.

In 1886 Pissarro allowed himself to be enrolled in the ranks of the Neo-Impressionists. It was not long before he realized that he had made a mistake and his painting was becoming over-systematic and arid. He quickly broke free.

In his last years he painted many townscapes of Paris, Rouen and Dieppe. His view from a window, down over the avenues, boulevards, bridges and quays of the Seine, is a sort of panorama that draws the onlooker into its deep perspectives, a vision of breadth and grandeur appropriate to what one associates with the name of Paris. The handling is freer and broader than in the 1870-80 period, the colours are often warmer and the drawing at times no more than suggestive of a particular objet. Yet objects do still exist. Unlike Monet, Pissaro kept faith with the realistic origins of Impressionism.

Auguste Renoir

Monet, Pissarro and Sisley are essentially landscape painters. Renoir (1841–1919) is principally a painter of figures. He too worshipped light and used its effects in each of his pictures, but rather than attempt to capture its fleeting transformations of skies, water, grass and trees, he liked to see it caress the face or the naked body of a young woman. He may have wanted the light to pene-

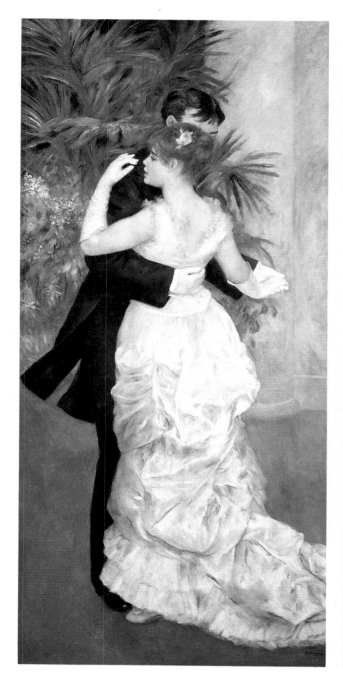

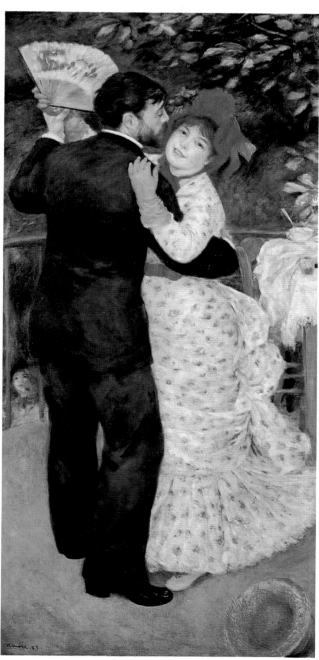

RENOIR
La Danse à la ville
La Danse à la campagne
1883

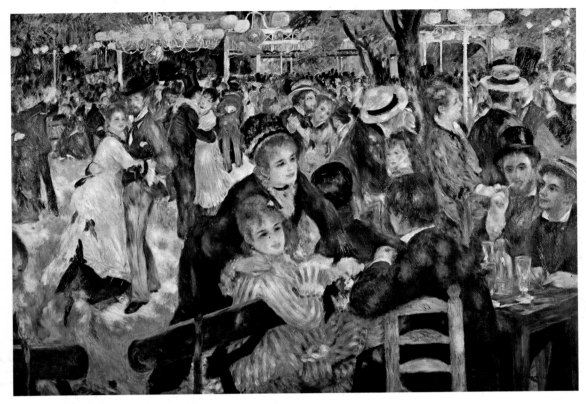

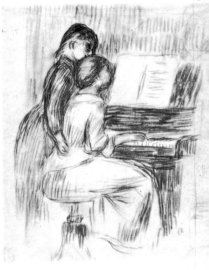

RENOIR
Girls at the piano
1882

RENOIR
Le Moulin de la Galette
1876

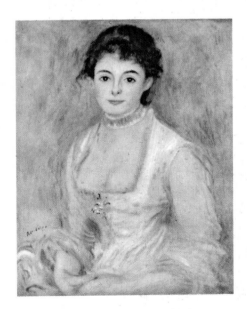

RENOIR
Portrait of Madame Henriot

trate the bodies he painted, but he did not want them to be dissolved in it — the volume and density of the human body was still important to him.

In this respect his position is analogous to Manet's, whom he also resembles in combining innovation with an attachment to tradition. Like Manet, he admired Titian, Velasquez and Delacroix, but also Rubens and Boucher because he loved their sensuality, although it was of a very different order from his own. Rubens and Boucher hardly ever painted a nude without suggesting somehow that it was forbidden fruit. To Renoir, on the other hand, nakedness seemed a natural state. If Eros is present in his work it is a pagan god — not the Eros of whom Nietzsche wrote: "Christianity gave him poison to drink, which did not kill him but made him become degenerate and turn to vice." Nothing could be further from vice than Renoir's nudes, there is absolutely nothing lewd or flirtatious about them. In fact these delicately pearly bodies seem not to have experienced even the fevers of passion. They have a calm, animal innocence, something suggestive of the full and peaceful existence of flowers and fruit.

We find no trace of torment in Renoir, no intellectual anxiety or psychological complication. Even the portraits show us radiant faces which express nothing but the artless pleasure of living in a world of soft, intense light. More often than not, the portraits are of young women. Renoir's woman is an Eve living in

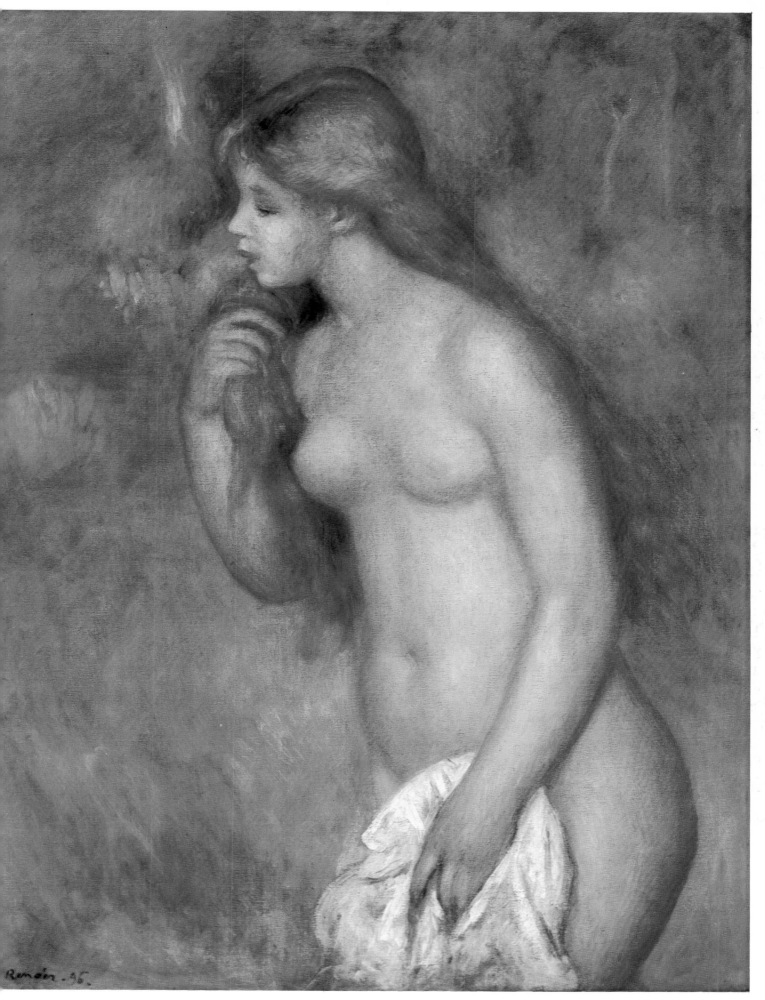

RENOIR
Woman
Bathing
1896

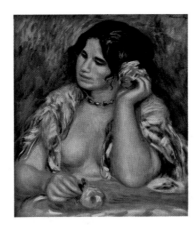

RENOIR
Gabrielle à la rose
1911

RENOIR
Gabrielle à la rose
ca 1905

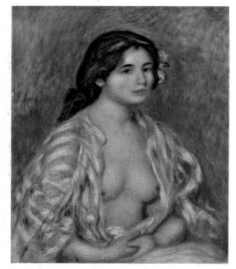

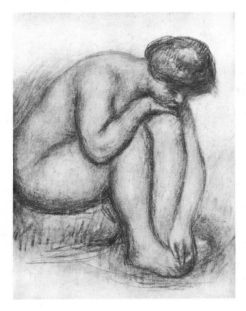

RENOIR
The Crouched Bather
1912

a paradise where there is no tree of knowledge and no serpent. Something of this paradise clings to her even when she puts on the dress of a young Parisienne and goes dancing beneath the trees of the Moulin de la Galette, or goes to a concert, or tries on a hat at the milliner's. At the same time she is the creature of the age when she was painted. Indeed, for anyone interested in what people wore or how they spent their leisure in Parisian society under Napoleon III or in the early years of the Third Republic, Renoir has quite as much to offer as Manet.

Although he had painted many works that rank now among the masterpieces of Impressionism, towards 1883 Renoir felt he had reached an impasse. After travelling extensively in Italy, where he much admired Raphael and the frescoes of Pompeii, he came to the conclusion that he "neither knew how to paint or to draw." He decided to concentrate on his line-drawing, to the detriment of his work over the next few years: his painting became arid, his colours "acid", his light cloying and his composition too contrived. However he came through the crisis, rejuvenated and matured. His drawing lost its harshness but gave his form a new definition. His light came alive again, no longer playing on the skin's surface, but deeply impregnating the bodies of the nudes that Renoir, who from 1897 lived mainly in the south of France, loved to paint in a hot sun that ripened them like peaches.

Now, when Renoir painted scenes of women at leisure, he did not have the distractions of urban life in mind, he thought rather of the more Dionysian pleasures the human being can find when he escapes from conventional society and lives at one with nature. The bodies are opulent, too opulent one might say, except that it is clear the artist is not interested in mere prettiness but in the celebration of a spirit of life that is generous, primitive and primordial. In these late works lyricism abounds. The same intoxicating light is everywhere, the blood coursing in the veins of the women's flesh seems to come from the same source as the sap which flows in the trees and plants. And yet the bodies do not merge into the landscape. They enrich it with their supple forms and precise rhythms, never losing their robust solidity.

Edgar Degas

Although Degas (1834-1917) belonged to the Impressionist group and showed at nearly all their exhibitions, he had very little in common with either Monet or Renoir. He rarely painted landscapes and had little interest in *plein-air* theories. His "fleeting impressions" are of horses or people. If he studied the effects of light it was usually indoors, and artificial light at that. He preferred drawing to painting, whereas the Impressionists drew very little.

Degas's emphasis on line goes back to his early years as the pupil of a disciple of Ingres. As a young man he visited Italy several times, paying more attention to the masters of the Quattrocento (Pollaiuolo, Botticelli and Mantegna) than to Raphael and Michelangelo. His passionate desire to understand the artists whom he admired did not, however, prevent him from having original ideas of his own. In 1859 he wrote in his notebook: "No one has ever done buildings or houses from below, or underneath, or close to, as one sees them when passing in the street." And he also had the idea of executing whole series of pictures on the same themes, such as musicians, dancers or lighted cafés. Later he was to put these ideas into practice, but as a young man he painted for the most part cold scenes of myth and legend, as well as some portraits that are not without distinction.

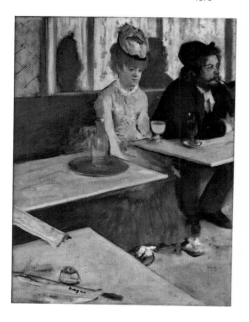

DEGAS
At the Café
also known as l'Absinthe
1876

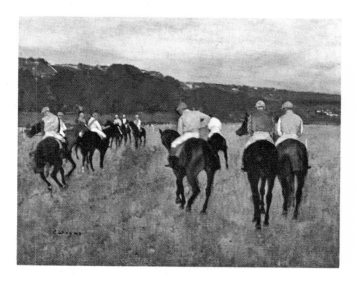

DEGAS
Race Horses at Longchamp
1873-75

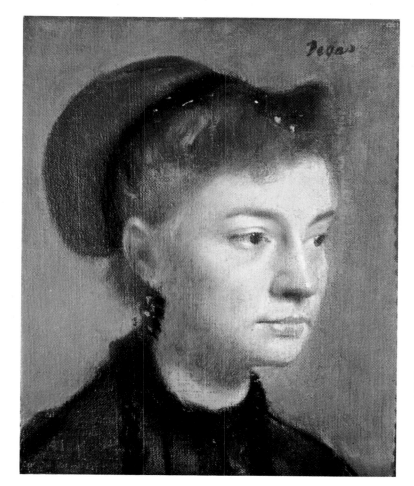

DEGAS
Portrait of a Young Woman
1867

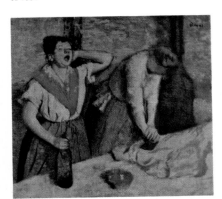

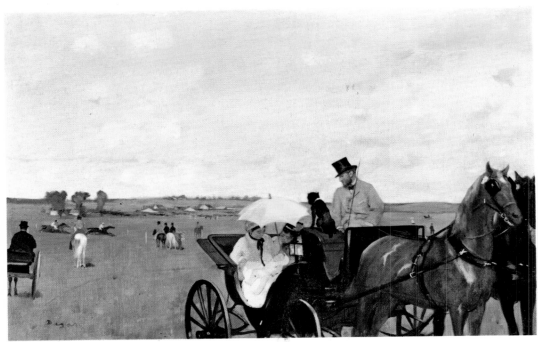

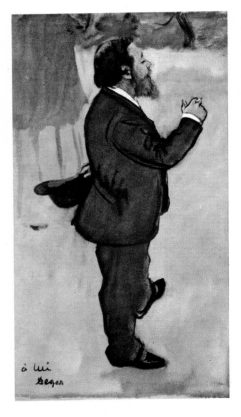

DEGAS
Carlo Pellegrini
1876-77

Horse-racing was the first theme that he took from contemporary life. His first picture on this subject dates from 1862, but it is not until *The Carriage at the Races* of 1873 that we have a clear illustration of the unconventional layout that is such a significant feature of his work. Clearly his arresting sense of composition derives in part from the influence of Japanese prints, but he was also familiar with the work of photographers and it can be no accident that this painting has the casual immediacy of a snapshot.

The pictures of racehorses painted in the following years are similar in character. At the same time form becomes increasingly simplified. Because Degas wanted to include as many different postures and movements as possible, he chose to concentrate, not on the race itself, but on the restless horses and jockeys in the moments before the start.

Degas studied the movements of the human body by observing the dancers at the Opéra. It is significant that he chose to show them mostly in the green-room or in practice sessions rather than performing on the stage — it was not their grace that interested him so much as the extraordinary postures they adopted. Even with a fairly conventional motif, he would try to make it striking

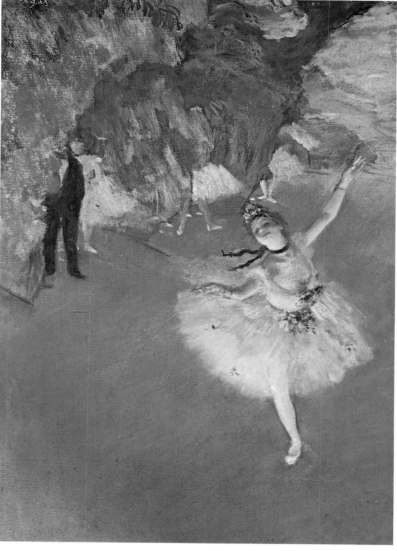

DEGAS
The Star or
Dancer on Stage

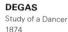

DEGAS
Study of a Dancer
1874

DEGAS
Dancer adjusting her Shoe

by looking at it from an unusual angle. For similar reasons he was also interested in studying the effects produced by artificial light, whether in a cabaret, the theatre or the Opéra. Not only did he try to capture the eerie whiteness and the green shadows which gas-light throws onto a face or an arm, he also exploited these effects of light to distort conventional space, so that it appeared to contract in shadow and open out and acquire depth in the light. As the pictures tend to dispense with fixed points of reference, the eye is swept right into the scene, barely able to gauge distances. There is a poetic dislocation of the senses that is accentuated by the boldness of the contrasts.

Always in search of new material, Degas found his way into milliners' shops and rooms where women yawned over their ironing. He invaded the privacy of women, drawing them as they crouched in the tub, washed themselves, emerged from their bath and got dressed. Yet, though his art may be indiscreet, it is not sensual in character. Degas exhibits curiosity rather than desire.

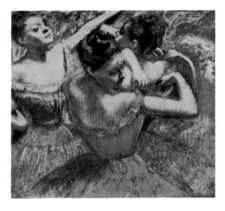

DEGAS
Dancers 1899

DEGAS
The Tub 1886

He does not glorify nakedness like Renoir, or show it as a natural state, on the contrary, he always makes us feel that it is temporary and that the clothes that have been removed will soon be put back on.

"No art is less spontaneous than mine," he said. And it is true that Degas does not record chance impressions, he chooses his subjects deliberately, analyses them with care and expresses them in a considered and purposeful style. From 1880 onwards he used pastel more than any other medium, becoming, literally "a colourist in line". The later work is characterized by its emphasis on colour, its lively cross-hatching, broader handling, fresh and brilliant tones and subtle harmonies.

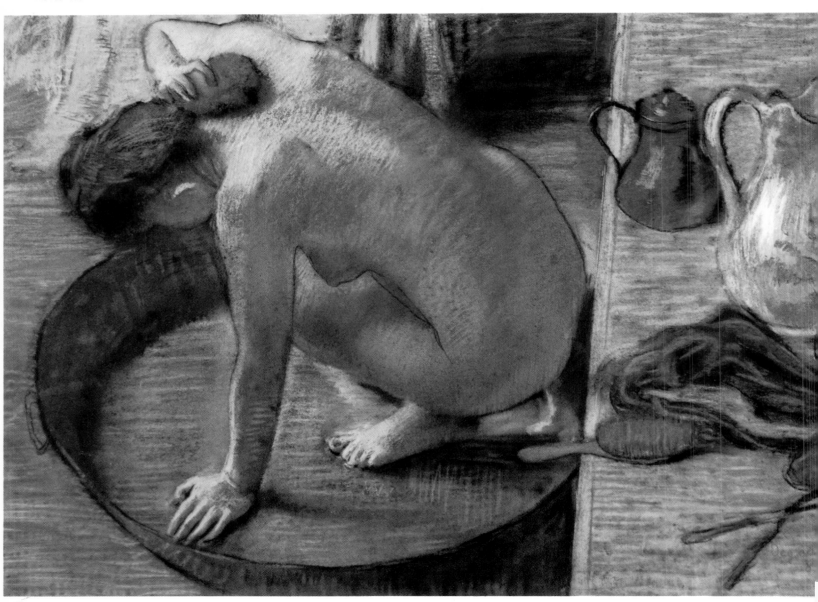

Paul Cézanne

Though Cézanne (1839-1906) had known of the Impressionists-to-be since 1861, it was not until ten years after that, when he was living in Auvers-sur-Oise and working in close collaboration with Pissarro, that his painting began to reflect their influence. The passionate manner of his early works gave way to peaceful landscape in serene colours. But it was the permanence of things that appealed to him, even then, not their transitory nature; he refused to let the form of objects be blurred by atmospheric haze. Structure was always important to him, and he favoured houses, rocks, tree-trunks, anything massive and solid that could be expressed in geometric line.

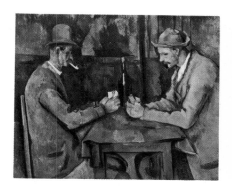

CÉZANNE
The Card Players
1890-95

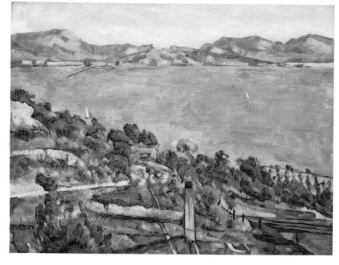

CÉZANNE
L'Estaque
1883-87

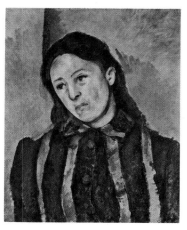

CÉZANNE
Portrait of Madame Cézanne
1883-87

CÉZANNE
Young Man in a Red Waistcoat
1890-95

37

Cézanne did not really come into his own until he left Paris in 1878 and settled more or less permanently in the South, where natural forms tend to retain their clarity and definition in the dry and transparent air. He worked mostly in and around his birthplace, Aix-en-Provence, and at Gardanne and L'Estaque. While his originality is apparent in every picture he painted, it is particularly striking in his landscapes of the Bay of Marseilles. The Mediterranean and the sky have their place in the composition, but they are not dominant, they are firmly situated in a framework of stable elements. There is little movement

CÉZANNE
Still-Life with Onions
ca 1895

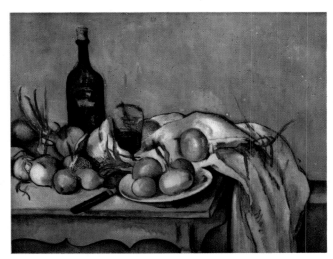

CÉZANNE
The Blue Vase
ca 1885-87

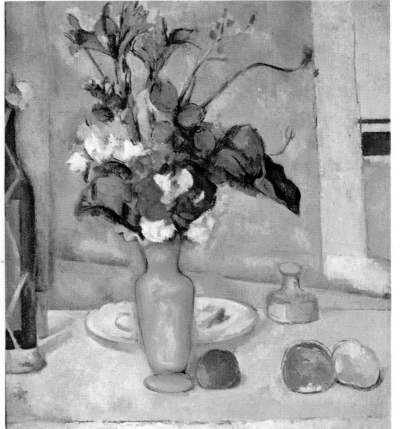

CÉZANNE
Basket of Apples
1890-94

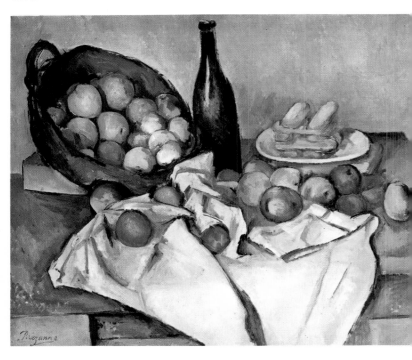

in the sea, and few reflections. Cézanne had none of Monet's love of the glittering play of waves. His water, like his grass and foliage, tends to be a solid mass. His light is not sparkling and alive. His colour does not express the beauty of a fleeting vision. Less iridescent than the Impressionist palette, it also has less of a surface quality, as if the artist had drawn it out of the substance of the objects themselves.

Two contradictory impulses were at war in Cézanne, making painting for him a slow and difficult process of which he complained throughout his career. On the one hand, he had a sensitive response to nature, which he wanted to transcribe without losing any of its freshness and intensity; on the other hand, he felt intuition was not enough, and wanted to clarify his response, use his intelligence to set it down on canvas in an ordered manner. In the end it was the second impulse that won. Cézanne ceased to consider the impermanent qualities of objects, and pushed their forms towards the regularity and immutable perfection of geometric shapes. Colour became essentially a pictorial value.

When he painted nudes he was not interested in their flesh or in anything about them that was sensually arousing; he used their bodies as living architecture. When he painted fruit, it is as though he had never tasted it. He ignores its pulp and flavour but gives each piece such richness of colour, each shape such purity and fullness, that it is transformed into a plastic element of startling strength. In other words, as he deprives objects of some of their natural qualities, he at the same time endows them with a new life derived from art. Inanimate objects lend themselves particularly well to this emphasis on plasticity, hence the large number of still-lifes in Cézanne's work. Indeed one might say that he treats everything except his landscapes as a still-life. His portraits, for example, tell us nothing about the inner life of their subjects, but they have a solidity of form and calm gravity of colour that makes them impressive.

Towards the end of his life Cézanne achieved the same freedom in oils as in his dazzling water-colours. By the 1904-1906 version of *La Montagne Sainte-Victoire*, one of his favourite and most evocative themes, objects are barely defined except in terms of colour, mass or plane. Structure is not forgotten, it is merely less apparent, no longer expressed by line but by accurate distribution of vibrant patches of colour.

''I have blazed the trail; others will follow,'' Cézanne said. He was right. He pointed the way for all the new developments in painting of the first half of the twentieth century. His work was studied with equal fervour by the Nabis, the Fauves and the Cubists.

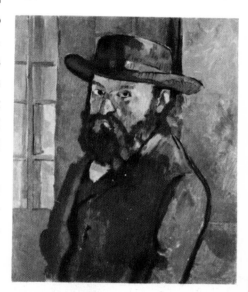

CÉZANNE
Self-portrait
1880

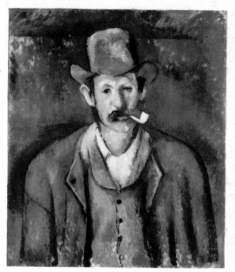

CÉZANNE
Man with a Pipe
1890-92

CÉZANNE La Montagne Sainte-Victoire View from Lauves 1904-06

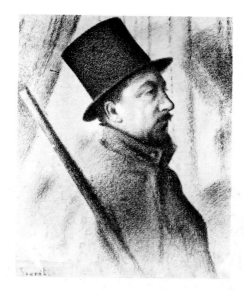

SEURAT
Portrait of Paul Signac
1889

It is rare to find painters like the Neo-Impressionists, with such a clear idea of what they wanted, or such a strong urge to put down their ideas and methods in writing. Paul Signac, a member of the group, published a long treatise in 1899 entitled *From Eugène Delacroix to the Neo-Impressionists* and in 1890, four years after the movement first showed its works to the public, Georges Seurat, the leader of the new school, committed his own aesthetic theories to print.

In essence, what Signac said was that there were to be no more vague perceptions, approximately recorded in "random brush-strokes." The Neo-Impressionists analysed closely what they saw and recorded it by differentiating systematically between the local colour of objects, the colour of the light, and the reaction between the two. They had studied Chevreul's *Law of Simultaneous Contrasts*, they knew the work of the physicists Helmholtz, Maxwell and N.O. Rood, and tried to take scientific facts into account. For the blending of pigments, the Neo-Impressionists substituted optical mixtures, juxtaposing pure colours on the canvas in such a way that they would combine only in the eye of the beholder, and so conserve their full brilliance and luminosity. The size of the touch was, in theory, meant to be "proportional to the size of the picture," and took the form of a small blob or point of colour — hence the term "pointillism." Signac, however, protested, "Neo-Impressionism does not make a *point,* but a *division*" of colour, and this "...division guarantees all the benefits of luminosity, colour and harmony...".

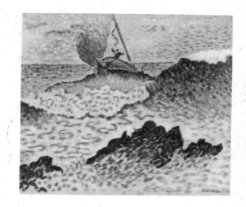

CROSS
The Wave
ca 1907

It must be said that Neo-Impressionist painting shows the effects of all this logic. Many of the pictures are arid and over-systematic. In the long run the movement was important, not for its "precise and scientific method," but for the role it played in liberating colour, and the serious attention it gave to grouping and composition, both by line and colour. It must have seemed very

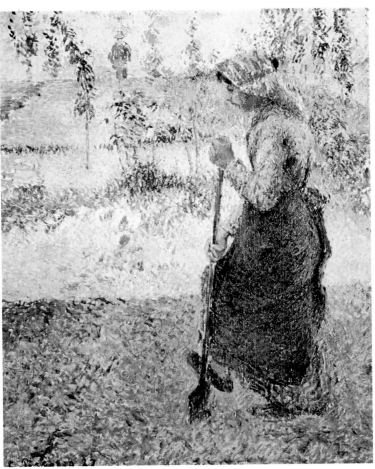

SIGNAC
Saint-Tropez

PISSARRO
Peasant with Spade

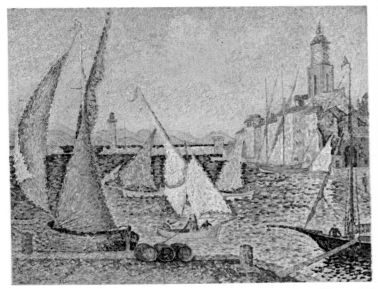

SIGNAC
Le Canal Saint-Martin
Paris
1933

different at the time it was beginning to emerge as a school, which coincided with the break-up of the Impressionist group proper (their last exhibition was in 1886). Then, it was easy to dream of the advantages art could derive from its association with science. And besides, in 1886-1890, Neo-Impressionism was far from appearing a dead end. The group that formed around Seurat and Signac included Camille Pissarro and his son Lucien, H.E. Cross, Angrand and Maximilien Luce, among others, and for a time its methods were adopted by Toulouse-Lautrec, Van Gogh and Gauguin, even though they rejected its principles.

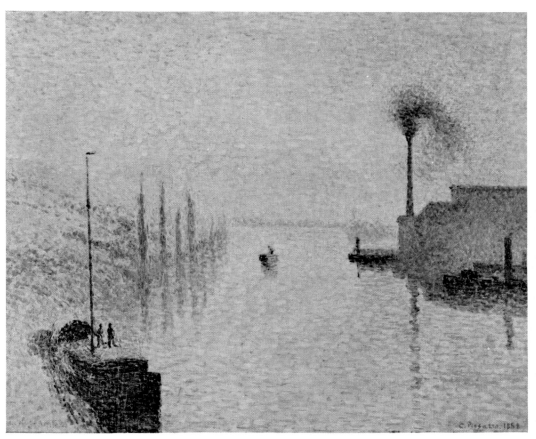

PISSARRO
L'Ile Lacroix. Rouen
Fog Effect
1888

CROSS
The Port of Toulon

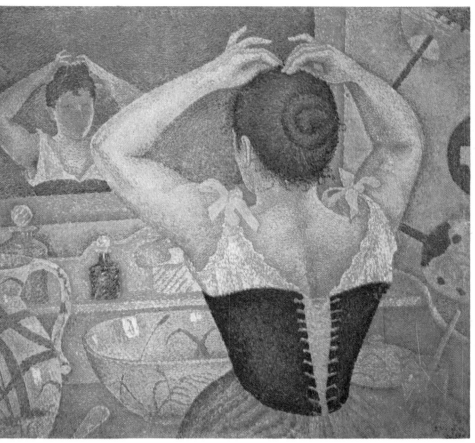

SIGNAC
Woman doing her Hair
1892

43

Georges Seurat

"Writers and critics see poetry in what I do. But no, I apply my principles, that is all." Seurat was no doubt sincere when he said this, but happily he was mistaken about the poetic qualities of his art. Of all the Neo-Impressionists, he is in fact the only one whose sensibility was never stifled by the rigidity of the system — an indication of a powerful sensitivity and of a temperament that responded well to a strict set of rules. Seurat was one of those artists who dislike unrestrained displays of feeling and tend to hide their emotion behind cool and careful composition and a meticulous technique.

From his early youth he recognized the tradition in which he belonged. The artists he chose to copy were Ingres, Poussin, Holbein and Raphael. He also turned to Delacroix, not in admiration of his romantic outpourings, but in order to learn about his use of colour. For the same reason he read *The Grammar of the Art of Drawing* by Charles Blanc, in which he discovered a sentence that impressed him deeply: "Colour, when once reduced to certain definite rules, can be taught like music." Attracted by the notion of scientific truth, he also studied the works of Chevreul, N.O. Rood, David Sutter's *The Phenomena of Vision,* etc.

Up to 1882, Seurat drew more than he painted, and he remained an enthusiastic draughtsman all his life. His vibrant conté crayon drawings are among his most lyrical and appealing works. No less attractive are the small sketches he drew from life in a lively, free style. But these rapid sketches did not satisfy him. He wanted colour to be more "exact" and forms to have definitions and volume — a volume he suggested more by subtlety of contour than by modelling. In addition he liked organizing vast surfaces and filling them with figures in all kinds of attitudes. This was a time-consuming process and he was able to paint only a few large canvases in the course of his short life. It took him two years to paint *A Sunday Afternoon at La Grande Jatte,* the manifesto picture that was shown at the eighth Impressionist Exhibition of 1886 and which marked the entry onto the "official" scene of Neo-Impressionism.

Although this picture is full of incidental detail, it is the style that is memorable. One ignores the fact that the women's clothes are ridiculous and sees only the beauty of the play of lines for which they provide the pretext. Even the parasols are really no more than an excuse for an elegant combination of curves, and the little monkey led on a leash by an over-dressed lady is, in essence, no more than a humorous flourish. Every element is so radically transposed into the domain

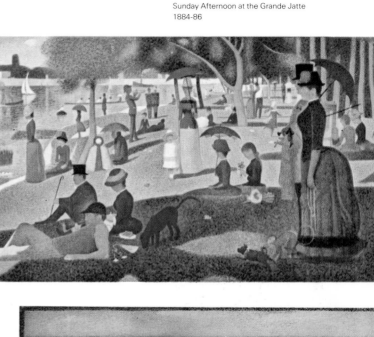

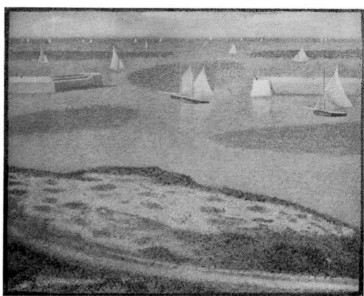

of pure art that life appears to be suspended. Movements are frozen into strange postures. Time ceases to exist, and the figures take on the appearance of statues standing silently in the still light of a museum.

Subsequent compositions are softer and more relaxed, the light has more movement, and the colours are clearer and lighter. Yet it is in his less ambitious works that Seurat displayed his finest qualities, in his landscapes of the Seine at Courbevoie, the sea at Port-en-Bessin, and the harbour at Gravelines. In these, an impalpable delicacy is allied to a masterly sense of composition, and subtle vibrations of colour enhance the sensitive precision of the drawing.

Seurat may not have evinced much interest in movement in his other works,

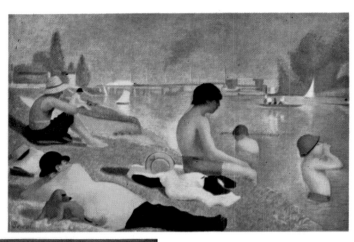

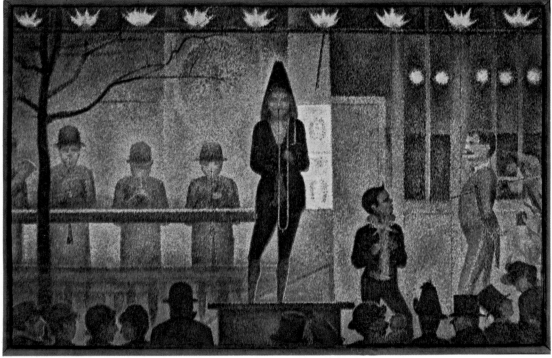

but it is a central feature of his last picture *The Circus*. Even here the painter is firmly in control. However fast the horse is galloping, however fleetingly a position is held by an acrobat, the figure is sharply defined with a line that moves sometimes with snake-like agility, sometimes becomes rigid, breaks away at sharp angles or describes a rapid zig-zag. Seurat's intelligence is always visible. In his work there is always that quality of concise and serene balance that distinguishes the classical painters, an impulse to counteract the confused richness of real life with clean and simple forms and clear order. Hence his appeal to the geometrically-minded artists of the twentieth century, in particular some of the Cubists, who admired him for his intelligence, discipline and restrained sensitivity.

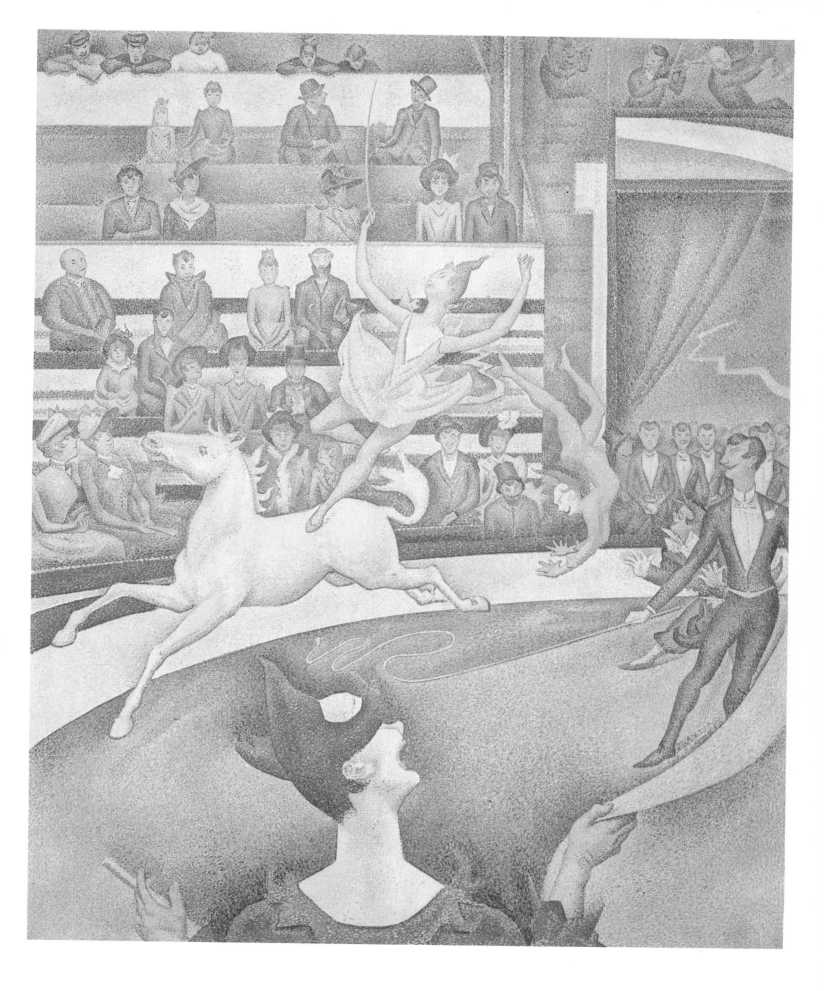

Paul Gauguin

Until he was thirty-four, Gauguin (1848-1903) was an amateur painter who was influenced in his work by his friend Pissarro. Then suddenly in 1883, in order to be able to "paint every day," he threw up his lucrative job with a Paris stockbroker, effectively abandoning his old life of comfortable ease — and later abandoning his wife and five children as well. From then on, poverty, suffering and bitterness were to be his lot, and the conviction that he had only followed his destiny was both a consolation and a torment to him.

In 1886 he went to live at Pont-Aven in Brittany, chiefly because he was looking for somewhere that was not, like Paris "a desert for the poor man." But he also wanted to escape from civilization, sensing that "life in the wilds" would give him back his youth. The following year he wrote "I am going to Panama to live a *primitive* life... I shall find new strenght far from any human being." He moved on from Panama, which disappointed him, to Martinique, where nature proved an inspiration, but ill-health forced him to leave and at the end of the year he returned to France, worn out by illness and with a heavy heart. He went back to Pont-Aven and there a new and personal style of painting began to emerge as he absorbed the influence of Cézanne and of Japanese prints, and benefited from his discussions with the young Emile Bernard, whose work may also have inspired him in some degree.

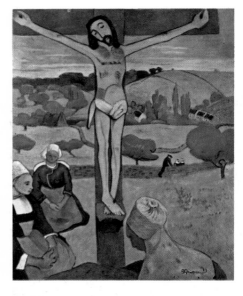

GAUGUIN
The Yellow Christ
1889

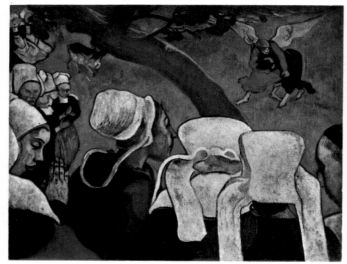

GAUGUIN
The Vision following the sermon
1886

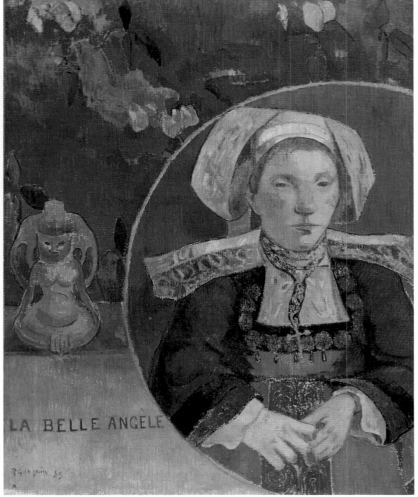

GAUGUIN
La Belle Angèle
1889

48

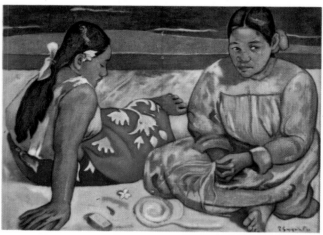

"Do not paint too closely from nature," he told one of his friends at that time. "Art is an abstraction. Draw it out of nature, dream about it, and think more of the resulting creation. The only way to reach God is to follow the Divine Master's example and create." Consequently he ringed his forms with vigorous and harmonious outlines, reduced modelling to a minimum, and restricted himself to the dominant colours of nature, which he applied more or less flat. In addition, he dispensed with shadows when he saw fit, abandoned aerial perspective and made hardly any use of linear perspective, suggesting depth mainly by planes and reference points of colour. Whether his subject was taken from reality (*The Swineherd, The Haymakers*), or from his imagination (*The Vision following the Sermon*), whether it was a portrait or a landscape, in his treatment of his subjects Gauguin was always inspired by a feeling for the world in which he lived. "When my clogs ring on this granite," he said, "I hear the dull, muted and powerful sound that I look for in painting." It was not only from the granite rock underfoot that Gauguin drew his inspiration, but — unusually for his times — from the crude and simple carvings of calvaries and from popular art in general.

49

But in the end Brittany was unable to satisfy him. He thirsted for the primitive life and, poverty-stricken, looked further afield for his "promised land." In 1891 he left for Tahiti. Penniless and ill, he returned to France in 1893, but two years later again set sail. In 1903 he died on the island of La Dominique in the Marquesas, where he had settled in 1901. Although the South Sea Islands of reality were not the same as those of his dreams, and his life there was full of suffering and despair, nevertheless it was in these islands that his art found its fulfilment. His forms became more ample, his drawing more forceful, his colouring richer and more harmonious. The exotic character of the people and the vegetation was, of course, reflected in his work, yet Gauguin's exoticism was always more than a response to the picturesque, it reflected his feeling for life as well as representing an outside reality.

Gauguin's response was not that of a primitive but that of a civilized European who had plunged himself into primitive life, viewing it with nostalgia and fully aware that he could never recapture the innocence needed to become a part of this Paradise Lost. Hence the presence in Gauguin's painting of something melancholy and unsatisfied. It is evident too in the titles he gave some of his works: *Alone; Nevermore; Where do we come from? Who are we? Where are we going?*. Abstract though these titles are, they do not overshadow the pictures themselves. Gauguin never let the interest of an idea assume greater importance than its realization in painting.

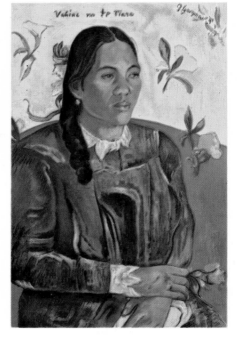

GAUGUIN
Vahine with Gardenia
1891

GAUGUIN
Riders on the Beach
1902

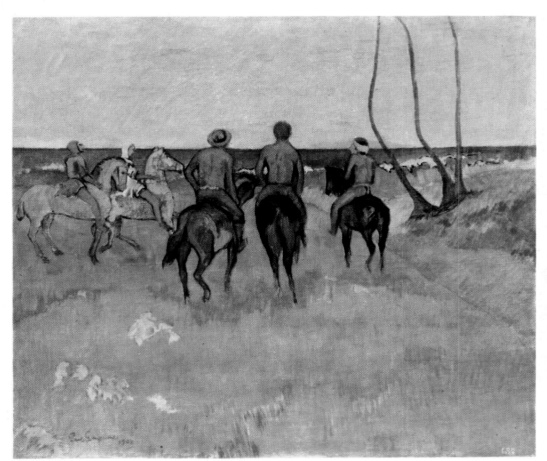

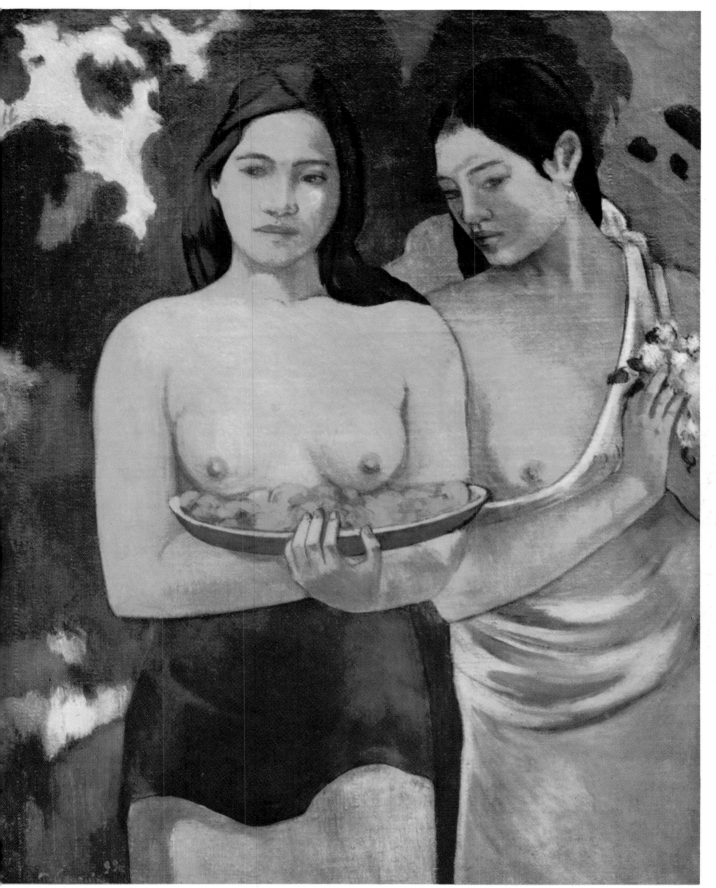

51

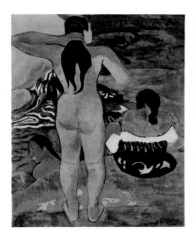

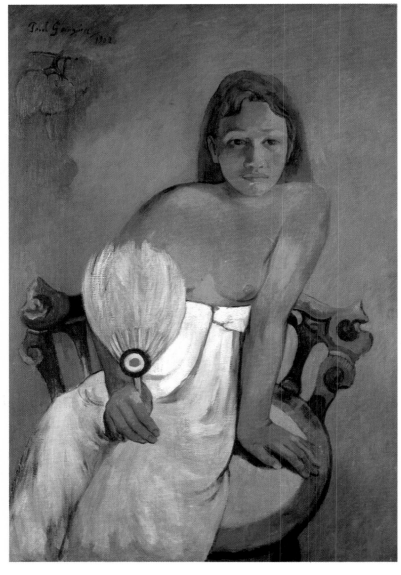

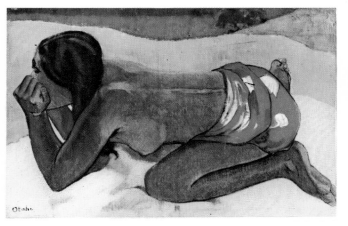

Just as he avoids the trap of over-intellectualizing his painting, he in general avoids the purely decorative, not easy for a painter who favoured stylization, used no chiaroscuro or relief, and applied his colours flat. That he succeeded with his approach was the proof that the traditional path of artists since the Renaissance was not the only one capable of producing pictures satisfying to the emotions. He said himself, "I went right back, way beyond the horses of the Parthenon, to the old wooden rocking-horse of my childhood." He also said that he had tried "to take painting back to its sources" and "I wanted to establish the *right* to try anything." These words influenced twentieth-century painting as much as his work itself. Even artists who did not like his painting remembered what he had said and drew encouragement from it.

Vincent Van Gogh

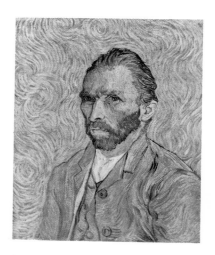

VAN GOGH
Self-portrait
1889

Few careers have been as meteoric as Van Gogh's (1853-1890). He was twenty-six when he dashed off the first drawings he thought worth preserving, thirty-three when his distinctive personal style began to emerge, and thirty-seven when he died. We know the reasons for his relatively late start as a painter. His life up till then had been one failure after another, and it was only in despair that he turned to painting and drawing. The final blow, and the hardest to bear for this son of a Dutch minister, had come when he tried to work as a missionary in the coal-mining district of the Borinage. His inability to preach, as well as his "exaggerated" practice of Christianity, led to his dismissal. It was when everyone considered him a "good-for-nothing" that he turned to art, no doubt partly because he wanted to prove that he was "good at something"; but probably even more because he wanted to find some way of expressing the love he felt for his fellows. For him art was a mission, not a diversion.

In these circumstances, it is no surprise that when he returned to Holland and settled in the country, he chose peasant life as his subject. Nor is it surprising that he admired and copied Millet. But he also admired Zola, and

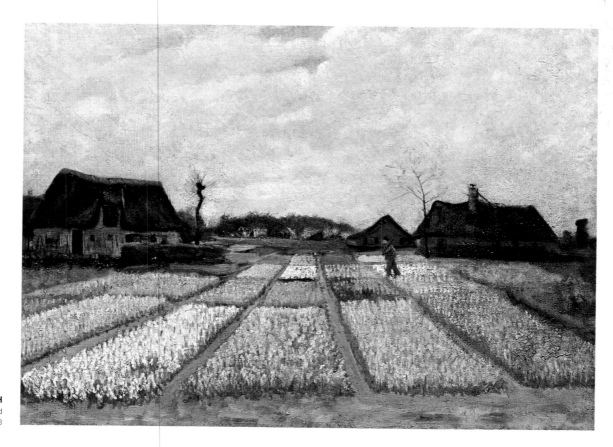

VAN GOGH
Field of Flowers in Holland
1883

53

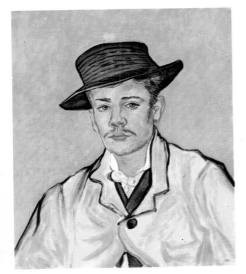

by about 1885 his work had an earthy directness about it, in which the influence of the painter of the *Angelus* and the author of *Germinal* is equally felt. His figures managed to look dignified and rough at the same time. In general, his palette was dark and muddy and his handling bold and stark. But the works in this style, although of interest, would never have made Van Gogh famous outside his own country. It was not until he went to Paris in 1886 that he won the place that is his in the history of modern art, lighting a beacon for the Fauves and Expressionists of the twentieth century.

Touched by the influence of Pissarro, Gauguin and Signac, his painting lost its peasant heaviness and sentimentality. The colours brightened, the touch became lighter and more fragmented, at times even pointillist. Van Gogh painted views of Paris, flowers, still-lifes and portraits that are marked by their calm, their airy harmonies and relaxed drawing. Only his self-portraits show that he was not entirely satisfied with city life and the endless meetings and discussions with fellow artists; after a while it became too much for him, he felt the need for change.

VAN GOGH
Van Gogh's Bedroom in Arles
1889

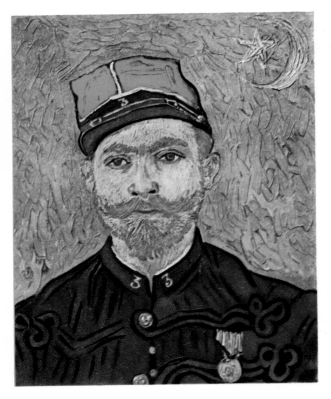

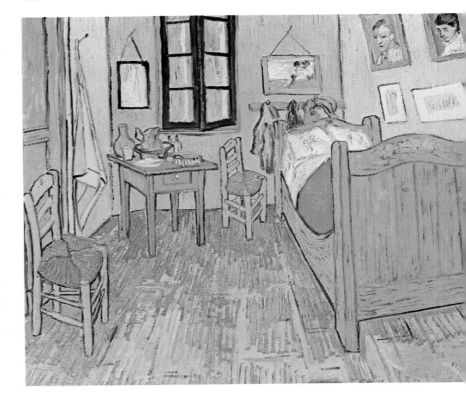

VAN GOGH
Portrait of lieutenant Millet
1888

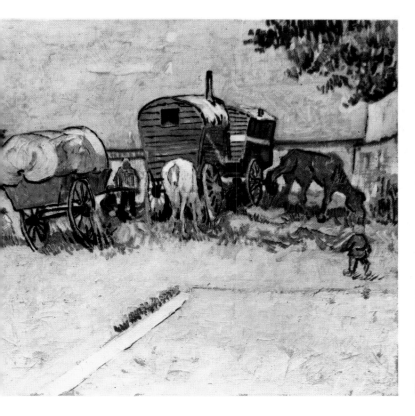

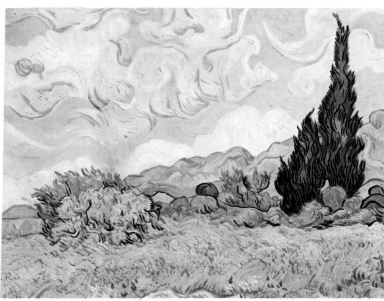

VAN GOGH
Caravans, Gipsy Encampment
1888

VAN GOGH
Cornfield with Cypress Tree
1889

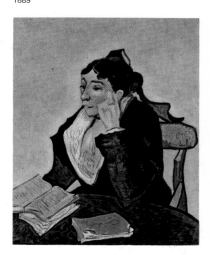

VAN GOGH
L'Arlésienne (Madame Ginoux)
1888

Attracted by the sun, in February 1888 he went to live in Arles. He loved the South and thought it "as beautiful as Japan," which of course he had never seen although he had imagined it from studying Japanese prints. Soon his brush-strokes became broader, his colours more intense, and his drawing firmer. He worked without sparing himself, in sun and wind, and sometimes set up his easel in the fields in the middle of the night. He was not content just to record what he saw, but tried to express the emotion of his whole being, every feeling of his heart, every vision of his mind, exaggerating in his painting what seemed to him essential and discarding what he thought trivial or insignificant. Obsessed by the sun, which he worshipped all the more because he came from the north, he created a much more brilliantly coloured vision of the South than did Cézanne, for example, who was a native of Provence. Pure colour abounds too in his portraits, flower-paintings and interiors. He regarded colour as having a symbolic value. In his *Café de Nuit*, he says, he "tried to express in red and green the terrible passions of human beings." He dreamed of expressing "the emotions of two lovers by mixing two complementary colours, by their blends and their contrasts, by the mysterious vibrations of the two colours juxtaposed." At the same time he was concentrating on drawing, and produced a quantity of powerful and sensitive sketches in pen and reed pen. To all of his many activities, he devoted the same passionate energy and lucidity of purpose.

55

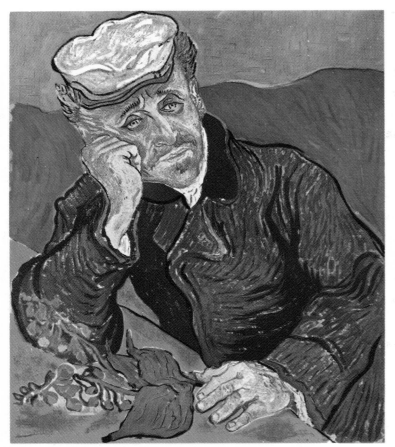

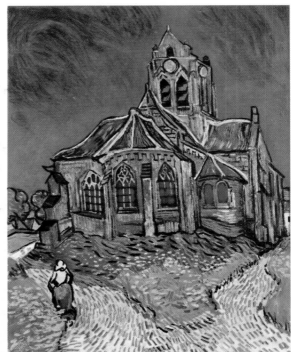

VAN GOGH
The Church
at Auvers-sur-Oise
1890

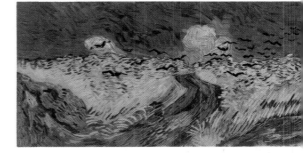

VAN GOGH
Wheat Field
with Crows
1890

VAN GOGH
Docteur Gachet
1890

His lucidity never entirely deserted him, although he suffered from periodic fits of madness, and in the first of these in December 1888, following a quarrel with Gauguin, cut off his own ear. Several months later he was admitted at his own request to the asylum at Saint-Rémy, but even there, between fits, he was perfectly clear-sighted both about his own condition and his work. The jubilant colour of the Arles period had disappeared, the drawing had become a tortuous whirling and writhing of lines, with a tearing sense of anguish and despair, yet these works are not the product of a deranged mind or a faltering hand.

Of the paintings done in Auvers-sur-Oise in the last two months of his life there are just a few that betray an occasional lack of assurance in their handling. This apart, Van Gogh's creative powers seem undiminished. The *Portrait of Dr Gachet* is an undoubted masterpiece. There are a number of intensely dramatic landscapes, vast panoramas of threatening sky, and fields shuddering with anxiety or whipped by a vicious wind. The style is more cursory but still vigorous. In spite of the black despair that overwhelmed him and drove him to suicide, his manner remains controlled, his composition as firm as ever.

Henri de Toulouse-Lautrec

Artistic activity and personal destiny were as closely intertwined in Toulouse-Lautrec (1864–1901) as in Van Gogh and Gauguin. He was descended from the Counts of Toulouse and his father was an eccentric with a passion for hunting and horses. He broke both his legs in childhood and grew up a crippled dwarf who could barely walk unaided. This infirmity determined the flavour of his art as much as it determined the course of his life.

Unable to lead the normal life of men of his class, he very soon withdrew from polite society. He went to Paris in 1882 to pursue his studies and three years later settled in Montmartre, spending much of his time at balls and in cabarets and brothels. In this world of debauch and easy pleasure he felt at ease as he did nowhere else. But he was a keen observer, and experience had made him disillusioned and bitter, so the picture he gives us of this world is often pitilessly cruel. His bitterness comes out too in the way he represented movement, whether of his father's horses or the dancers of Montmartre. The faster and freer the movements, the more his passions were aroused. He took a malicious delight in capturing them at just the moment when they looked their most grotesque. The drawing is sharp and astringent, with an element of caricature, and the colouring is almost aggressively acid in tone. In this he differed from Degas, whom he admired. What they did have in common was a love of the bizarre, an indifference to landscape, a predilection for artificial lighting and the importance they both attached to line.

Generally his models are not the same as those used by Degas. He found them, not at the Opéra, but in the Moulin-Rouge, the music-halls and the circuses. They were not anonymous models but famous personalities of the day, such as La Goulue, Valentin-le-Désossé, or Jane Avril — whose fame, incidentally, was considerably enhanced by the unforgettable Lautrec posters that plastered the walls of Paris.

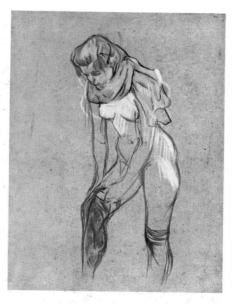

TOULOUSE-LAUTREC
Woman pulling up her Stocking
1894

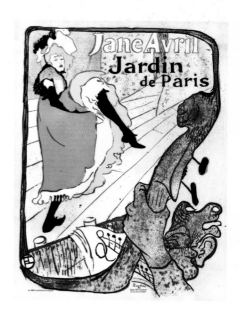

TOULOUSE-LAUTREC
Jane Avril in the Jardin de Paris
1893

TOULOUSE-LAUTREC
A Ride in the Country
1897

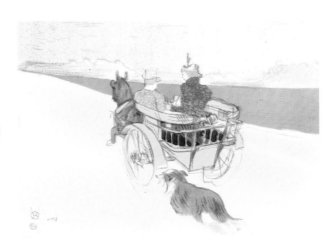

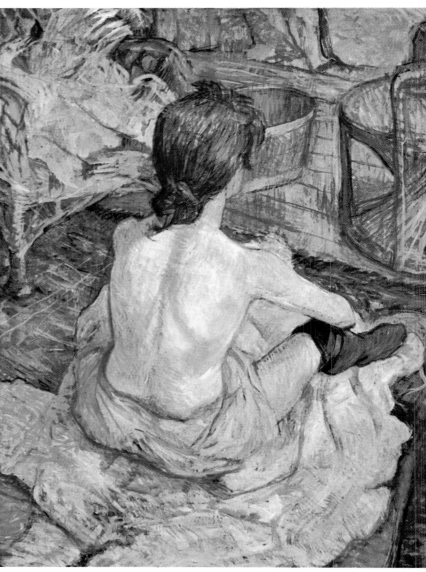

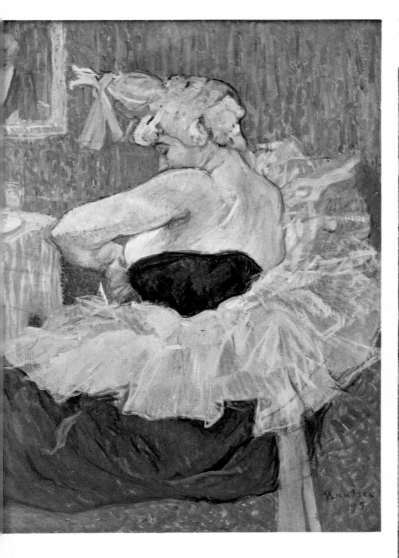

TOULOUSE-LAUTREC
La Toilette
1896

In general Lautrec's posters and lithographs are as fine as his paintings. They include some of his most authoritative work. Form is subordinate to the expressive vitality of the outline. Colours are concentrated and applied in large flat areas, with unusual and striking harmonies. No one assimilated the lessons of Japanese prints better than Lautrec. However his brushwork is far freer and his manner more direct, and there is not a hint of Eastern restraint in the drawing or the colours, both of which are bold to the point of audacity.

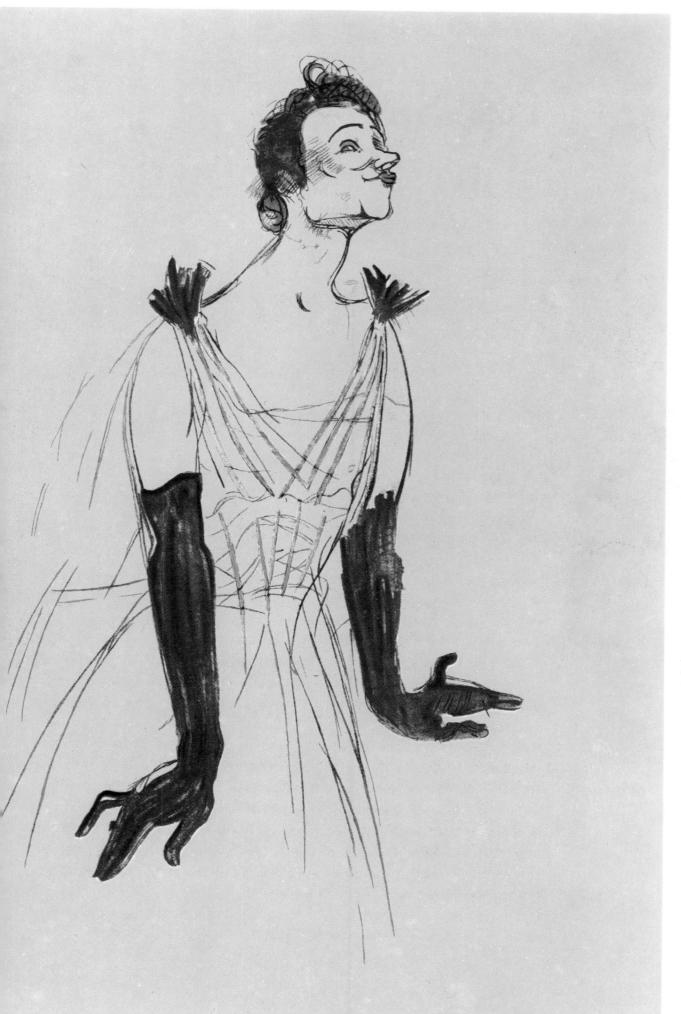

TOULOUSE-LAUTREC
Yvette Guilbert
1893

The Spread
of Impressionism

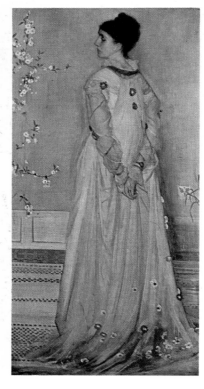

WHISTLER
Portrait of Mrs Leyland
1872-73

That Impressionism was primarily a French phenomenon is not in doubt. Yet there were comparable developments in painting in other countries at the same time, and just as there were precursors of the movement in France, so there were "pre-Impressionists" elsewhere, notably: Adolf von Menzel in Germany; Louis Artan and Hippolyte Boulenger in Belgium; the School of The Hague — the Maris brothers, Anton Mauve, Hendrik Johannes Weissenbruch — in Holland; and the American James Whistler, who lived in Paris and met Manet before he settled in England in 1880. In addition, it is relevant to mention the Italian painters Giovanni Fattori, Telemaco Signorini and Silvestro Lega, who, from the 1850s onwards, belonged to the Florence-based group of the Macchiaioli (Tachists). Members of the group talked of conveying impressions in their painting, and broke with academic tradition by applying colour in light and dark blobs, or *macchie.*

As for the painters outside France who have been described as Impressionists, I shall confine myself to mentioning only a few: in Germany, Max Liebermann, Fritz von Uhde, Max Slevogt and Lovis Corinth; in Belgium, Emile Claus and Guillaume Vogels; in the Netherlands, George Handrik Breitner and Isaac Israëls; in Great Britain, Walter Richard Sickert and Philip Wilson Steer; in Italy, Giovanni Segantini. (Federico Zandomeneghi was also an Italian Impressionist, but he moved to Paris in 1874 and exhibited regularly with the French group.)

It is merely stating facts to say that, as innovators, these painters were not in the same league as Monet and his associates. Even if they were

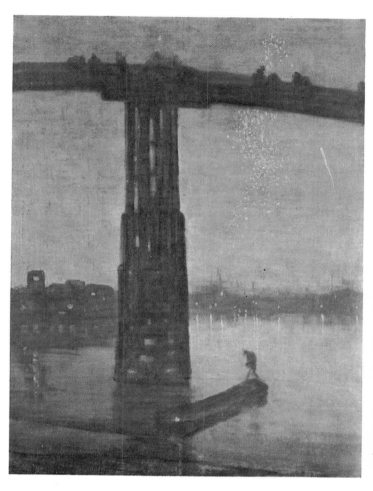

WHISTLER
Battersea Bridge
Night Scene in Blue and Gold
1865

WHISTLER
On the Beach
ca 1875

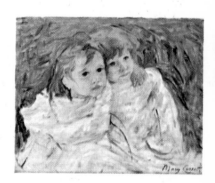

CASSATT
The Little Sisters
1885

interested in light phenomena or the division of colours, and not all were, their analysis did not go very deep. On the whole, it is fair to say that they stopped at the point Monet reached in 1874. Nevertheless their work is important and in some instances gave a new direction to the painting of their own country. There were of course many others who used Impressionism as an excuse for producing slap-dash sketches from life that are merely facile and superficial. Such artists have nothing whatsoever in common with Monet or Pissarro, who were not painters of views for tourists.

Impressionism had a colossal influence on the development of modern art. All the main twentieth-century movements, except Dada and Surrealism, were influenced by it, either directly or indirectly. I have already mentioned, in passing, the numbers of modern artists who were inspired by Cézanne, Gauguin, Van Gogh and Seurat. But the orthodox Impressionists too have given encouragement to many painters, even if they later developed in a quite different direction. Impressionism helped them to challenge official doctrines and so go on to find a personal voice. This is particularly true of the Expressionists, almost all of whom went through an Impressionist phase immediately before their work abruptly changed its character.

SIGNORINI
Piazza di Settignano
1880

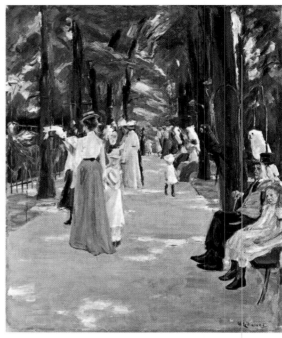

LIEBERMANN
Amsterdam Zoo
The Parrots
1902

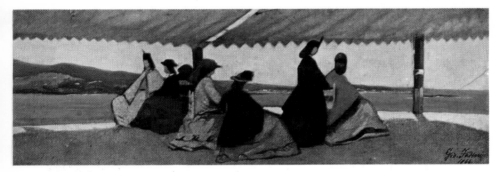

FATTORI
The Rotunda at Palmieri
1866

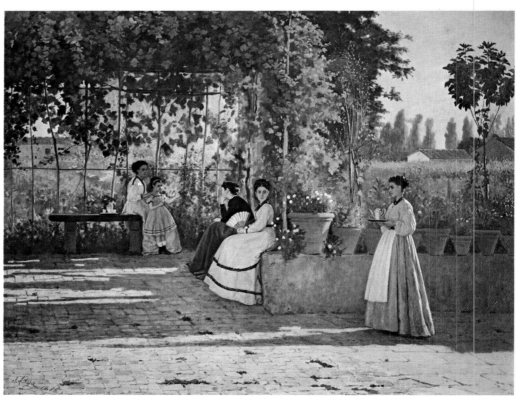

LEGA
La Pergola

Symbolism, Art nouveau and the Nabis

VALLOTTON
Portrait of Moréas

In 1886 the poet Jean Moréas published the manifesto of literary Symbolism; five years later, the critic Albert Aurier defined Symbolism in painting. "Symbolist poetry seeks to clothe the Idea in a form that appeals to the senses," wrote Moréas, and Aurier added later that "a work of art should be idealist..., symbolist..., synthetic..., subjective..., decorative...". Writing in 1882, he gave the following list of practitioners of the new method: Gauguin, Van Gogh, Redon, and among the younger generation, Sérusier, Emile Bernard, Filiger, Maurice Denis, Roussel, Ranson, Bonnard, Vuillard. He might also have included a number of French and European artists who started their careers before Gauguin and the Impressionists proper. One thinks of the English Pre-Raphaelites, the German painter Böcklin, the French painters Puvis de Chavannes and Gustave Moreau. More traditional in spirit than Monet and his group, they had little influence on the broader evolution

CHÉRET
Loïe Fuller
1893

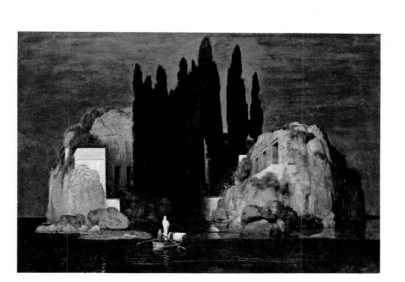

BOËKLIN
Island of the Dead
1880

63

of modern painting, but there were a number of painters who drew inspiration from certain aspects of their work. Chirico and Dali both owe a debt to Böcklin. Gustave Moreau was much admired by the Surrealists, and the exponents of abstract Tachisme praised his watercolours. The work of Puvis de Chavannes, which included murals—unusually for that period—and was characterized by flat, decorative planes of colour, was studied by Gauguin; it is also close in spirit to the painting of Maurice Denis.

Gustave Moreau (1826-1898) had close links with the Romantics, Chassériau in particular, but he also drew on Italian painting of the fifteenth century, choosing themes like *Orpheus and Eurydice, Œdipus and the Sphinx* and *Salome dancing before Herod.* In oils his style was minutely descriptive, particularly in the treatment of clothes, ornaments and jewels, whose gaudy brilliance sometimes led Moreau to excess. "He would have us believe the Gods wear watch-chains," said Degas. But in his watercolours Moreau

MOREAU
Delilah

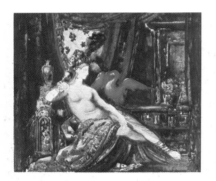

MOREAU
Woman and Panther

64

MOREAU
The Tattooed Salome 1876
detail

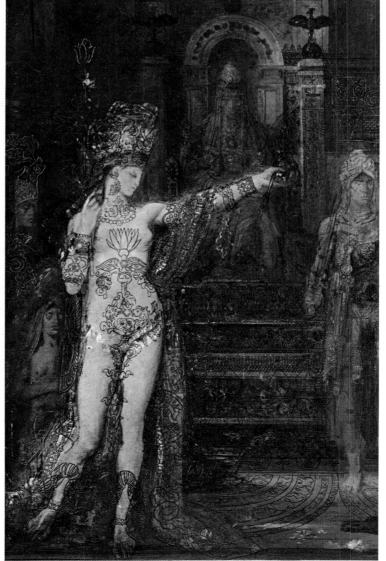

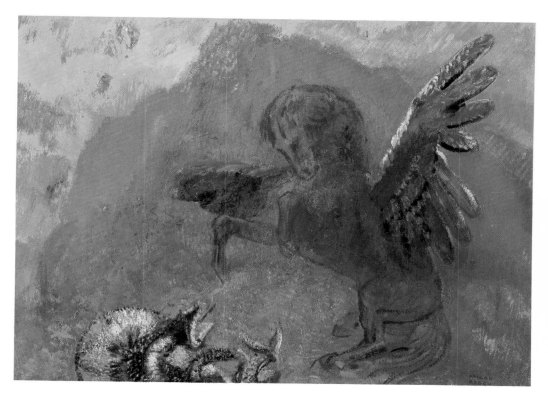

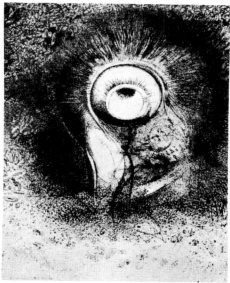

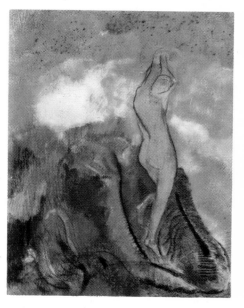

abandoned any attempt at realism and his style was eloquent and wonderfully evocative, perfectly suited to his rather bizarre visions. Their appeal has lasted because they are not only poetic but modern in spirit, full of invention in the colour and brushwork, as well as in the choice of themes.

Odilon Redon (1840-1916) belonged to the same generation of painters as Monet, but he criticized Impressionism for "pitching itself too low" and having cut art off from "that which could illuminate the most humble attempts with the light of spirituality." Obsessed by the dark and mysterious side of life, for a long time he concentrated largely on the range of blacks available to him in charcoal and lithography. When he drew *Smiling Spider*, or *Eve with Poppy*, where the motif is isolated in the pale rectangle of a window, or *Marsh Flower*, which is meant to represent a "sad human head" hanging from a drooping stem, one is inclined to feel that his attempts to be mysterious are a little forced, but the sheer beauty of the blacks and greys is irresistible and proof of a powerful sensitivity.

Redon was a genuine visionary, not only in themes like *Pegasus*, *The Cyclops*, *Apollo's Chariot* and *The Birth of Venus*, but also in, for example, his flower paintings, where he stayed close to observable reality. Although he studies the flowers with the eye of a botanist, he turns them into light, fragile, almost insubstantial things that appear to float miraculously into our world. Even the most brightly coloured are delicate and ethereal. Beyond

realism, they are imbued with that spirituality whose absence Redon deplored in the Impressionists.

Redon was well aware of the dangers to the artist of an over-intellectual approach. He wrote: "Where there is no plastic invention, you are left with an abstract literary idea." It has to be admitted that "plastic invention" was lacking, or indeed non-existent, in several of the Symbolist painters. Pictorially, their work is uninspired, with little to offer beyond a nebulous haze that accentuates the unhealthy pallor of the figures. True there is occasionally a distinctive quality, notably in the work of the Belgian painters William Degouve de Nuncques and Fernand Khnopff, that is faintly akin to later Surrealist paintings, and the work of Magritte in particular. But more often than not the images are sentimental, and one is forced to conclude that for many of the Symbolists the word "poetry" was synonymous with anaemic languor. "Fin-de-siècle" in spirit such paintings may be, but they are of more significance in the history of taste than in the history of art.

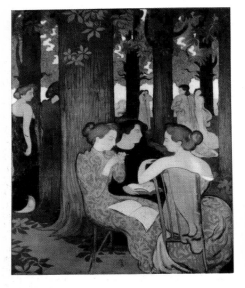

DENIS
The Muses
1893

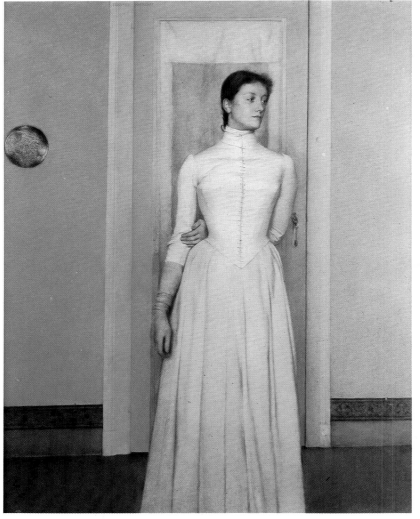

KHNOPFF
Portrait
of the Artist's Sister
1887

PUVIS DE CHAVANNE
Young Gi
at the Seasi
18

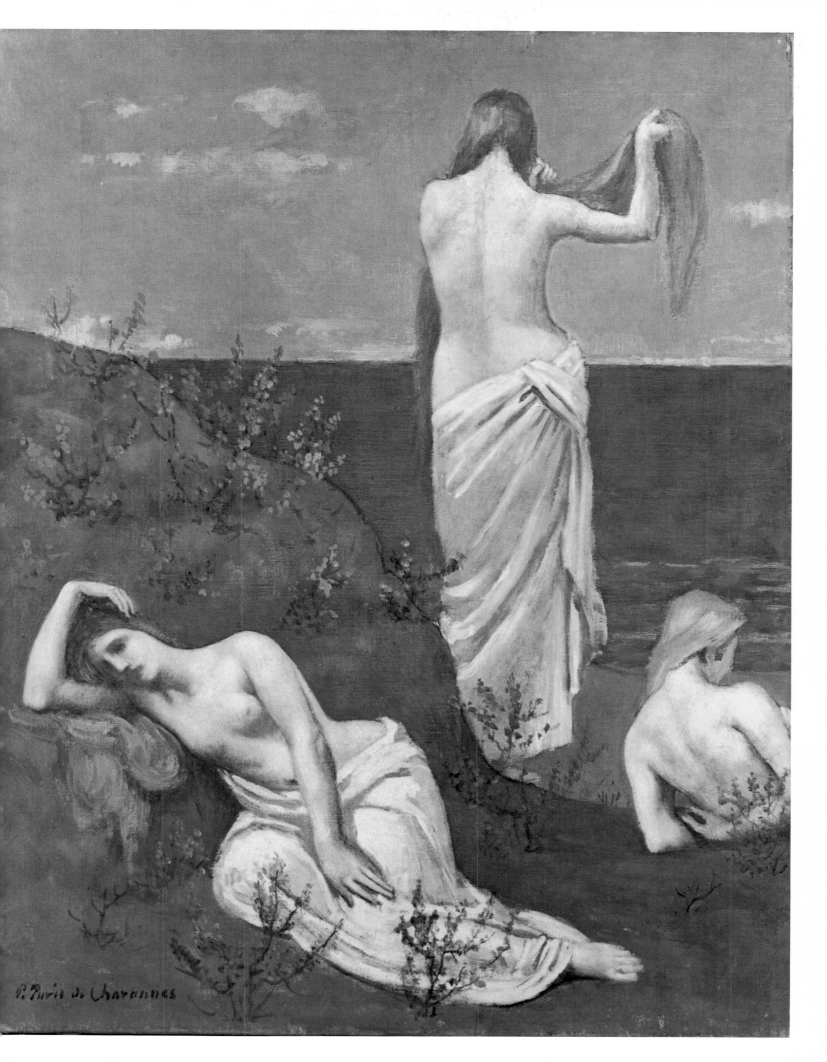

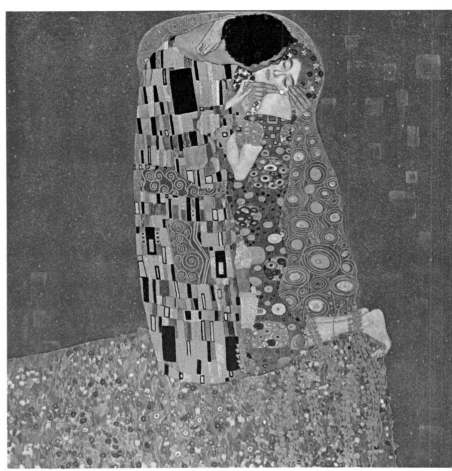

KLIMT
The Kiss
1907-08

KLIMT
The Myth of Danae
1907-08

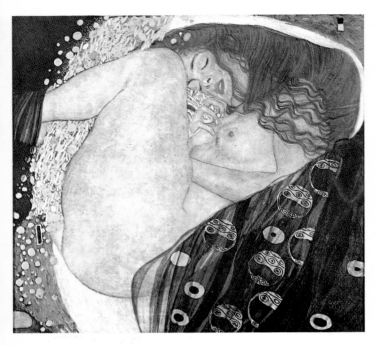

To find painters of the generation after Gauguin who, while linked with Symbolism, were more interested in innovations of form, we must turn, on the one hand to the forerunners of Expressionism, such as James Ensor and Edvard Munch, and on the other hand to the Art Nouveau group and their associates.

Art Nouveau is the French name for the "new art" that spread across Europe in the early years of this century. In England it was sometimes called the Modern Style, in Germany it became *Jugendstil*, after a Munich magazine *Jugend* (Youth). The movement encompassed architecture, sculpture and the applied arts, as well as painting. Following a period of imitation and eclecticism, Art Nouveau saw itself as creating an original and coherent style of its own. If it did not entirely succeed in this objective, it certainly enriched architecture and the decorative arts and inspired remarkable developments in both these areas.

In painting, unfortunately, the Art Nouveau predilection for floral designs

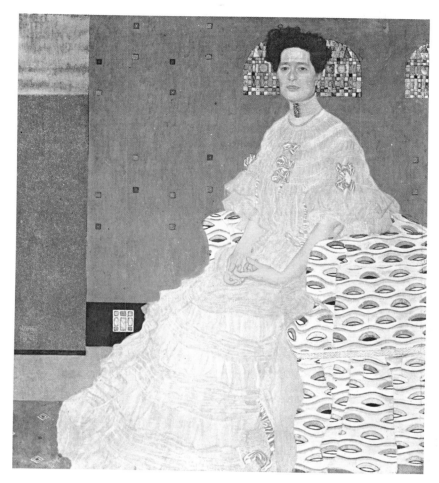

KLIMT
Fritza Riedler
1906

BEARDSLEY
Isolde
ca 1890

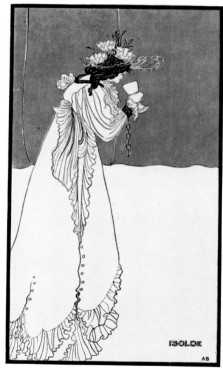

and stylized curves—influenced by the vogue for Japanese prints—frequently resulted in artificiality and affectation. This is true even of painters like the Austrian Gustav Klimt (1862-1918), whose *Kiss* and *Danae* are painted in beautiful planes of glowing colour, and of Aubrey Vincent Beardsley (1872-1898), a draughtsman first and foremost, whose sinuous line curls and straightens with all the elegance characteristic of the Modern Style. In the last analysis, these artists sacrificed so much to decorative effect that the emotional content of their paintings suffered. One responds more readily to other Art Nouveau painters who resisted the cult of the decorative.

Among these is the Expressionist painter Munch, as well as some of the younger artists listed by Aurier. They called themselves the Nabis, from a Hebrew word meaning "prophets," and first came together in Paris in 1888. They were united in their rejection, not only of the officially taught style of painting, but of Impressionism as well. One of the group, Sérusier, was the recipient of Gauguin's famous words of advice: "How do you see this tree?

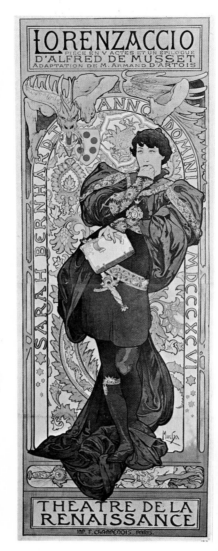

MUCHA
Sarah Bernhardt:
Lorenzaccio

Is it green? Then use green, the most beautiful green you've got — and this shadow, does it look blue? Then make it just as blue as you possibly can.'' Sérusier passed the word to his colleagues, Bonnard, Denis, Ranson, Roussel and Vuillard, and they absorbed the message, along no doubt with the lessons of Redon, Cézanne, Degas and the Japanese print-makers.

Many Nabis works are somewhat mannered in style, but for the most gifted personalities of the group, Bonnard and Vuillard, the reality and warmth of life were never sacrificed to the purely ornamental. These two painters abandoned the Impressionist palette, which was also Gauguin's and began using greys, ochres and generally more muted tones. They liked to paint peaceful domestic interiors, and when they chose the streets and gardens of Paris as their theme they did not turn them into sunlit landscapes. Unlike their Impressionist predecessors, they did not emphasize the sweep of the boulevards with broad perspectives, but sought to give a more intimate character to their scenes and to bathe them in soft, dreamy light. They were not interested in the effects of luminosity but in the street as a setting for a particular way of life, usually that of ordinary people, men going to work and women shopping.

MUNCH
Women
on the River Bank
1898

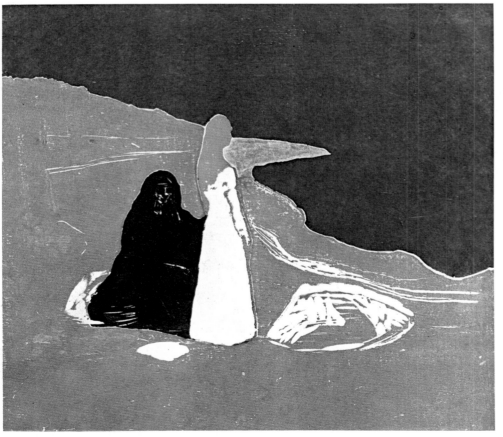

Pierre Bonnard

Prior to 1900 it would have been no easy matter to establish a preference between Bonnard and Vuillard. The Vuillard (1868-1940) of those early years displayed an exquisite sensitivity, his delicate colouring was full of distinction, and his composition was original and discriminating. In some ways he seemed more open than Bonnard, to have more new possibilities inherent in his work — he was experimenting in several different directions in around 1890 — and at times he even seemed the more inspired of the two. By 1930-1940 all this was changed. Vuillard had lost his distinction and originality, while Bonnard had reached new heights of expression. It is not that Bonnard (1867-1947) was late in finding a personal voice, more that his whole development as an artist was a continuous process of enrichment and regeneration.

The most commonplace objects caught his eye and astonished him. But his surprise is never forced or artificial, and although he wants us to share his reactions, and delights in ensuring that we do, he is never over-emphatic. His scenes of everyday life, carefully chosen though they are, have the spontaneity of random selections. Nor does his composition appear contrived, its equilibrium seems to be achieved as though by magic.

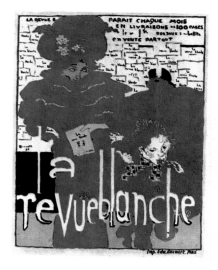

BONNARD
Poster for la Revue Blanche
1894

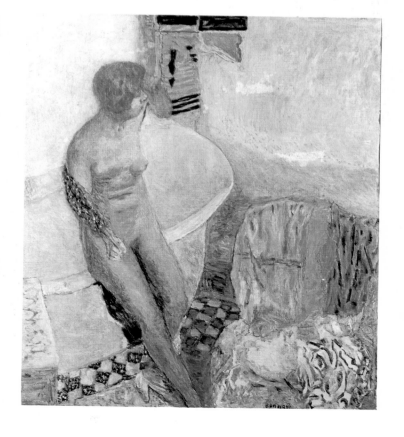

BONNARD
Getting out of the Bath
Ca 1930

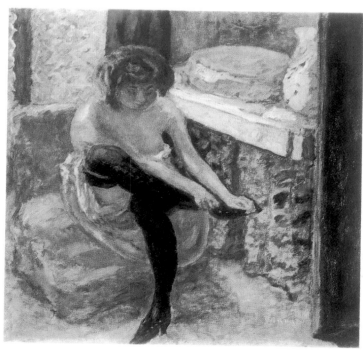

BONNARD
Woman with Black Stockings

BONNARD
Nude in the Bath
1944-46

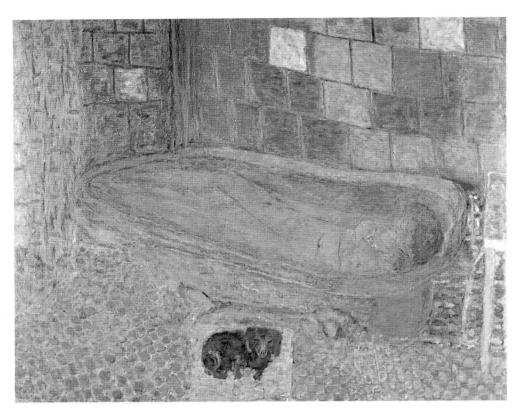

BONNARD
Nude in the Bath
1944-46

BONNARD
View of Le Cannet
1924

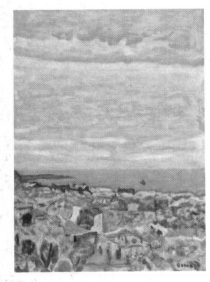

During the Nabis period his palette tended to be subdued, but towards 1910 it became brighter, and by the end of his life, Bonnard, who spent much of his life at Le Cannet, was one of the boldest colourists of the twentieth century. Under his brush the world blossomed in a riotous mass of colour. Intense solid colour was set against subtle iridescent shimmers, the brilliant reds and oranges of the blazing midday sun against the subtle play of the morning light reflected in the dew. And his daring treatment of the notoriously difficult range of lilacs and violets was a triumph in itself.

Some of the later paintings look as though they were inspired by a firework display, but there is nothing harsh or abrupt in all this dazzling intensity. The enchantment is made to last, and we are invited to savour it at leisure. Everything in Bonnard's painting is designed to give pleasure to the eye and delight to the senses. He does not care that the pulp of the fruit is perishable as long as it is tasty and refreshing to the palate. We are in the world of Renoir rather than Cézanne. Like Renoir, Bonnard is a painter who celebrates the joys of being alive, the miracle of a world transformed by a benevolent sun. What distinguishes him from his predecessor is that he expresses himself with even more freedom. He transcribed his impressions with such imagination, and gave colour such independence, that towards the end of his life he appeared not only one of the richest and most lyrical of contemporary painters, but also one of the most inventive.

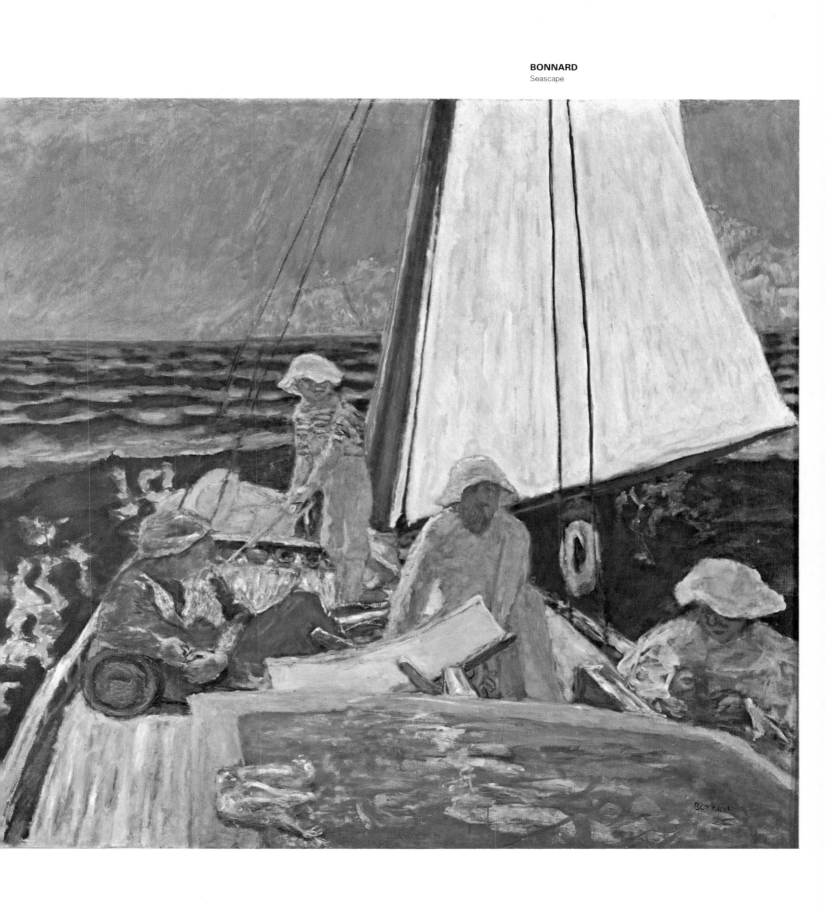

Fauvism

VLAMINCK
Woman's Head
1906

VLAMINCK
Portrait of André Derain
1905

"Painting as it is now," wrote Van Gogh in 1888 to his brother Theo, "promises to become more subtle, more like music and less like sculpture. At last is promises *colour*." These prophetic words were to receive powerful confirmation in the works of a group of artists active in the early years of the twentieth century. Van Gogh was right in every respect but one—colour, as used by this group, was never subtle, right from the start it was strident and violent, like the roar of an animal. Faced with these pictures at the Autumn Salon of 1905, the art critic Louis Vauxcelles spoke of "fauves" (wild beasts), and so gave the new movement its name. Like every other artistic movement, this one embraced a variety of styles—there was an extreme form of Fauvism, and a disciplined form, one heeding only instinct, the other directed by thought and logic. On the one hand there was Vlaminck who, on his own admission, tried to "paint with his heart and guts, without worrying about style." On the other hand there was Matisse who said: "For me everything is in the conception. It is therefore necessary to have a clear vision of the whole right from the start."

Although it was Vlaminck who proclaimed "I am Fauvism," there is no doubt that it was Matisse who was the real leader of the group. His close associates included Marquet, Camoin, Manguin and Jean Puy. Even Vlaminck's friend, Derain, benefited from his advice, and Friesz, Dufy and Braque came to admire his work. Vlaminck claimed that it was Van Gogh alone who was the father of Fauvism. He had seen a retrospective exhibition of his work in 1901 and had immediately been fired with enthusiasm. The fact that he totally misinterpreted Van Gogh's intentions was neither here nor there. To him, Van Gogh was a man who unburdened his soul with utter spontaneity and unrestrained abandon. That was what he wanted to do himself, and he sought support for his views wherever he could. Matisse too studied Van Gogh, even

before 1901, but he also learned from Gauguin and Cézanne. The Neo-Impressionists were another influence, and in 1899 he painted a number of pictures in a pointillist style. He returned to the principles of the division of colour in 1904 while painting with Signac and Cross in Saint-Tropez. He needed only to choose his colours with greater freedom, enlarge his dots and make them into blobs and flat tints, for his painting to become Fauve.

The decisive point was reached in the following year at Collioure, where on this occasion Matisse was in the company of Derain. It is more than probable that the intensity of the southern light itself, as well as the excitement it communicates to northerners, played a part in bringing about this change of manner. Though others, such as Vlaminck, apparently needed no such direct inspiration—he saw glowing embers in a street at Marly, and set on fire the branches of trees silhouetted against the Seine. In much the same way, Derain painted some of his finest landscapes in London, and they are even more highly coloured than those of Collioure. Even in painting the human face, or in portraits, the Fauves—notably Matisse, Vlaminck, Derain and Van Dongen—made use of the same bright and violent colours.

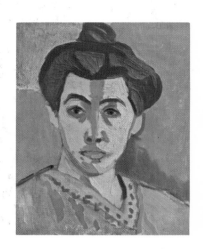

MATISSE
Portrait of Madame Matisse
1905

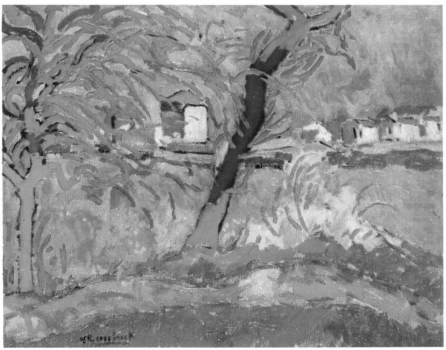

VLAMINCK
The Banks of the Seine
at Carrières-sur-Seine
1906

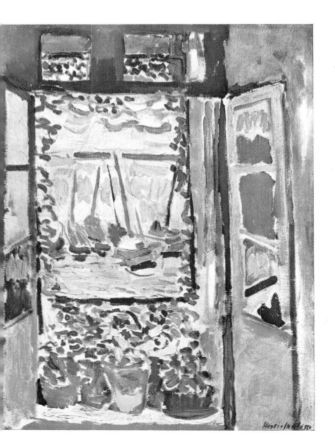

MATISSE
Open Window, Collioure
1905

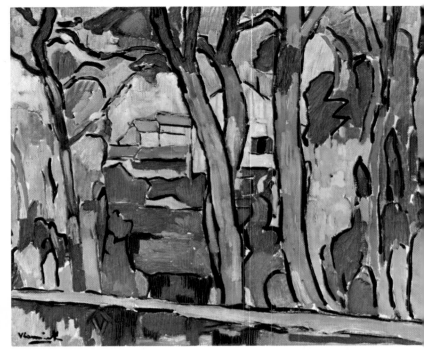

VLAMINCK
Red Trees
1906

DERAIN
Woman in Chemise
1906

DERAIN
Sun reflected on Water
1905

It was not only the heightening of colour that concerned them. Like Van Gogh and Gauguin before them, they also used colour with more freedom, both in relation to the outside world, and in respect of the rules which their predecessors had tended to regard as sacrosanct. To indicate shadows they did not rely solely on cold colours but would also use purple or red. They used complementary colours quite unsystematically, striving for unusual harmonies and undeterred by stridency or discord. In addition they rejected chiaroscuro and relief, and relied entirely on colour and line to construct their forms. In general the line itself was coloured, so that objects tended not to be defined with great precision.

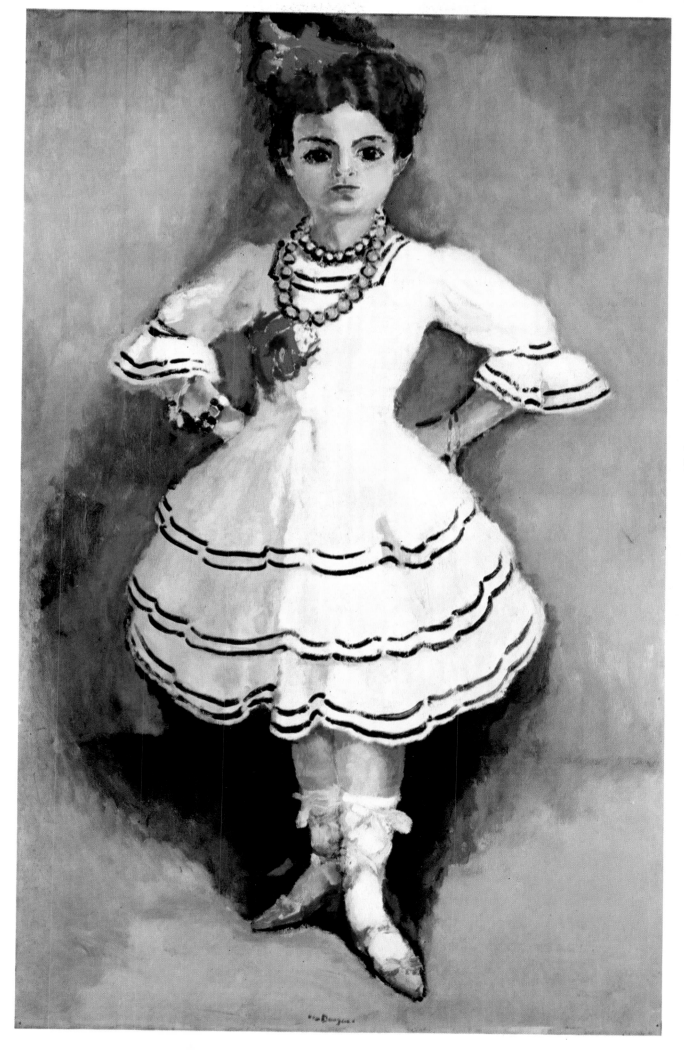

77

"Remember," wrote Maurice Denis in 1890, "a picture, before it becomes a war-horse, a nude, or some kind of anecdote, is essentially a flat surface covered with colours assembled in a particular order." Most of the Fauves seem to have kept this sentence very much in mind. "The need to proportion colours could lead me to modify the form of a figure or to transform my composition," declared Matisse. It does not mean that colours could be combined only for decorative reasons. On the contrary. They were intended to translate sensations and feelings by emphasizing their most intense and subjective qualities. Again it was Matisse who said: "What I strive for above all is expression." And: "Expression for me does not reside in the passion that is about to break out in a face or erupt in a violent movement. It is in the whole arrangement of my picture: the position of the figures, the space around them, the proportions, all these play their part. Composition is the art of arranging in a decorative manner all the various elements the painter has at his disposal to express his feelings." Ideas like these would never have been advanced by Vlaminck, yet he too looked for expression, and sometimes verged on an Expressionist manner.

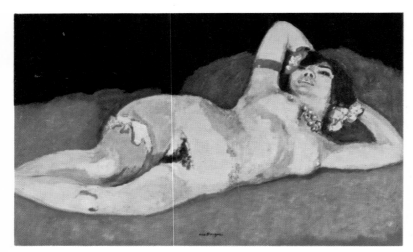

VAN DONGEN
Anita
1905

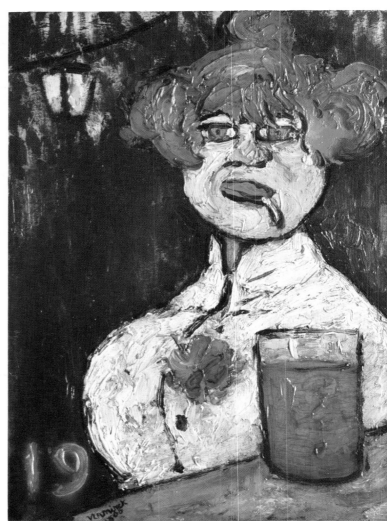

VLAMINCK
Sur le zinc
1900

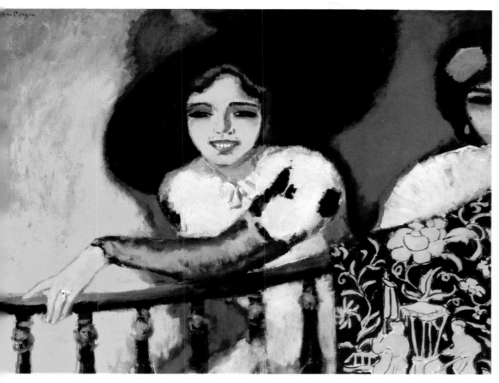

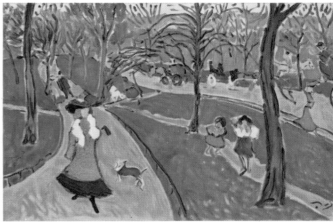

The extraordinary thing is that, only three years after its emergence, the movement died. Among its supporters, Matisse and Van Dongen alone continued to paint in the same manner. The latter remained faithful to Fauvism until 1912, and even after the First World War, when he was known as the most fashionable portrait painter in Paris, he did not altogether abandon the palette of a period when he had been, if not one of the most original painters, then at least one of the most spirited and piquant colourists. For all the others, there was a complete change of direction. The blazing tones, the orgies of colour, these all vanished. It was as though carnival time gave way to Lent. Those who had so gleefully sacrificed everything for the pleasures of the senses turned, almost overnight, into austere ascetics. It was at this point that Cézanne's influence eclipsed that of Gauguin and Van Gogh, and Cubism was born.

Dufy later returned to pure colour. But Vlaminck, Friesz and Derain never again employed the harmonies that characterized their most inspired works. Derain actually rejected everything to do with modern art. After brief flirtations with Cubism and Gothic painting, in about 1920 he went back to realist principles. After that, whether he was painting nudes, landscapes, portraits or still-lifes, he resolutely applied the rules which had been laid down in the Renaissance, and which had been discarded by every movement in modern painting since Impressionism.

As for Vlaminck, who during his Fauve period had "wanted to consume the École des Beaux-Arts in the flames of his cobalts and vermilions," he too began to adopt geometric forms and develop a more disciplined approach. In about 1920 he opted for a realistic Expressionism, and painted in that style until the end of his life. Although his lively handling shows that he still had the same exuberant and impulsive temperament, his colour range darkened, and to depend principally on the contrast of light and dark. These effects were occasionally sentimental or melodramatic, but at their best are intense expressions of deep feeling. He excels in capturing the atmosphere of harsh winter evenings in the villages, the lowering skies over the snowy roof-tops, the desolate muddy white of the roads against looming walls.

MATISSE
Michaëlla
1943

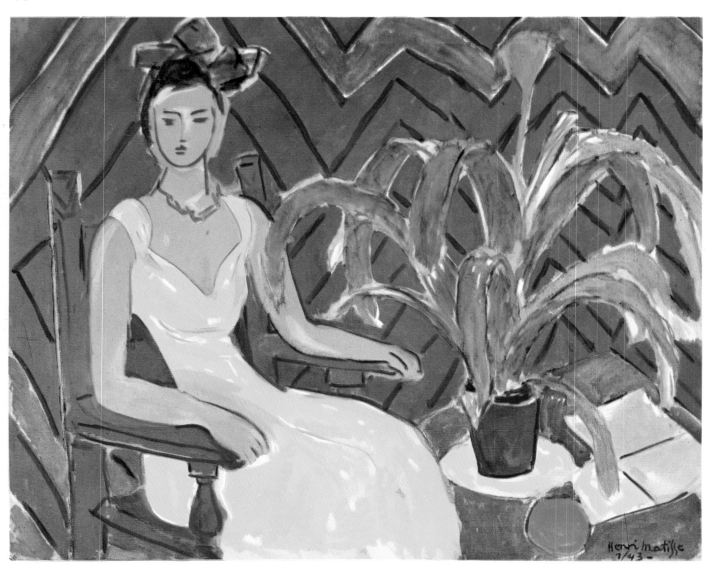

Henri Matisse

Matisse (1869-1954) is the master of colour—no modern painter deserves the title more. His career was devoted to experiment with pure colour and the exploration of its potential. His bright tones are reminiscent of Van Gogh and Gauguin, yet their radiance has a subtlety that is more akin to the Persian miniaturists, whose flower-like and heavy palette he admired. Even in the early canvases of his Fauve period, where the style is often rather carefree, his unusual harmonies have a quality of artifice that shows he did not, like Vlaminck, paint "from the tube onto the canvas," but as the result of profound study.

No one realized better than he did the complexity of the problems faced by Fauvism. It was not merely a matter of splashing brilliant colours onto canvas. What was needed was to transcribe the world in a way that left colour its purity, without impoverishing the picture in the process; to discard modelling, chiaroscuro and classical perspective, and yet to create sensations of volume, light and space. In short, the problem was to perfect a new idiom that would be as expressive as the old. This was the task Matisse set himself. And when the palettes of the painters around him abruptly lost their fiery glow, in 1908, he had no reason to feel he had reached an impasse. He made light flow from the brilliance of his colour harmonies. He suggested volume through contour,

MATISSE
Woman leaning
1938

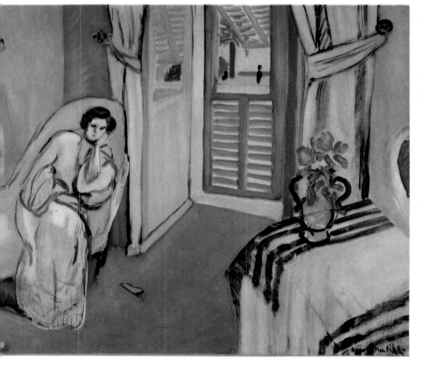

MATISSE
Figure in an Interior in Nice
1921

81

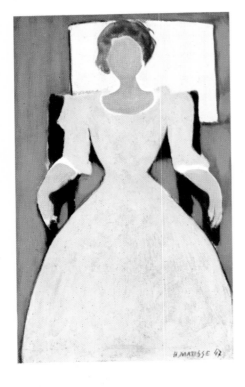

at the same time giving the outline the quality of a flourish. He conveyed an impression of space by his choice of colours, and by placing certain objects so that they acted as landmarks.

Towards 1913, under the influence of Cubism, Matisse made his work less lyrical and more severe. His drawing became more angular and geometrical; the reds and oranges gave way to purples, greys and blacks; his composition was simplified, harder, even austere. If in some respects this was contrary to his natural inclinations, his *Moroccan Praying* and *Piano Lesson* of this period are among his masterpieces. They are intellectually satisfying without being at all cold or academic.

After 1918, a new, relaxed manner took over. Matisse was to spend most of his later life in the South of France, and for a period he gave himself up to celebrating the joys of living and did not try to break new ground in his work. He even began to accomodate certain realist principles. Sometimes he made use of modelling, and when he painted interiors occupied by idle young women or languishing odalisques, he employed linear perspective to suggest depth. He did continue to experiment with his colours, which tended to be less vivid and more harmonious. More than ever before, Matisse's painting approached the ideal he had described in 1908, when he said: "I dream of an art that is balanced, pure and calm, with no disturbing or challenging themes, that will offer the man who works with his brain, be he businessman or writer, a

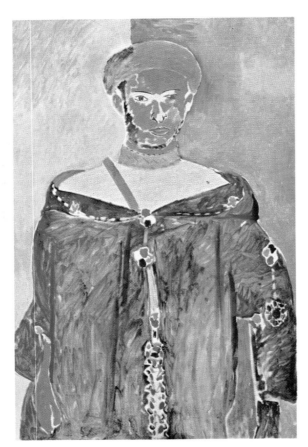

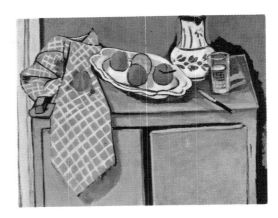

82

MATISSE
Odalisque with Red Trousers
1922

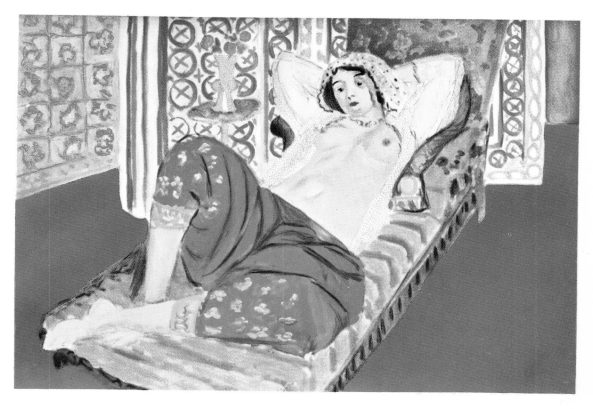

MATISSE
France
1939

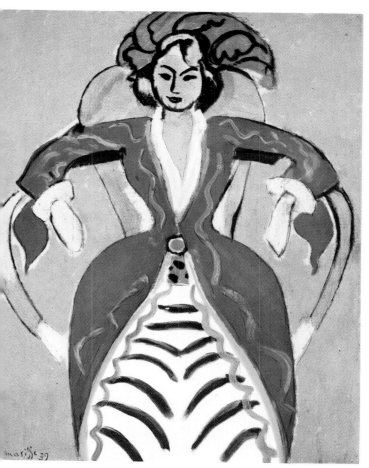

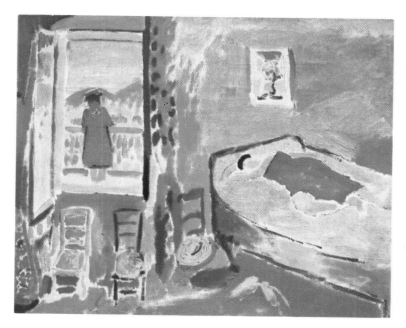

MATISSE
The Siesta. Collioure
1905

tranquillizer to soothe his mind, something analogous to the comfortable arm-chair in which he relaxes his tired body."

Carried to its logical extremes, this approach could have resulted in mere prettiness and affectation. But towards 1930, Matisse stiffened his resolve and recovered much of the audacity of his Fauve period. More authoritative than before, he married vigour with subtlety and achieved sumptuous effects by simplified means. The subjects remained the same—young women in interiors, nudes, still-lifes, flowers. In themselves they did not matter, for their colours and forms all expressed the same thing: a love of life untroubled by anxiety, suffering or tensions, that revelled only in voluptuous ease and rich harmonies. Although the sun is never shown, Matisse's art belongs to the summer. It is bathed in a shining serenity, intoxicating in its clarity.

There are points of similarity with Bonnard. But Bonnard is more "fleshy," Matisse more "abstract." If the former makes us feel the flesh and taste of his fruit, the second conserves only their essence. One offers us good things to eat, the other makes us drunk. Bonnard is intimate and approachable even at his most lyrical, Matisse is serious, a little remote and solemn; if his sensuality is less apparent it is because it is translated into other terms.

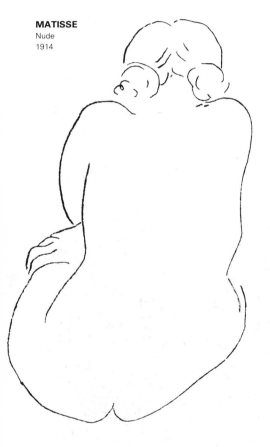

MATISSE
Nude
1914

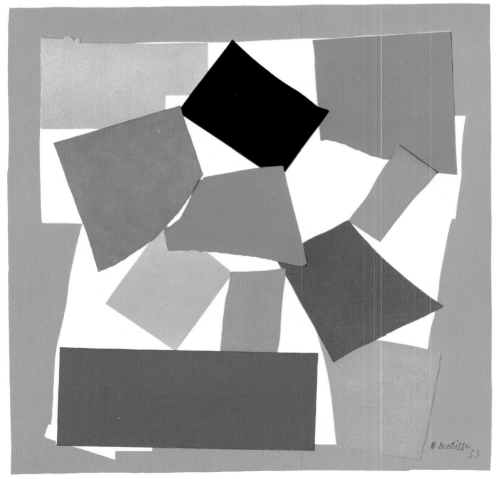

MATISSE
The Snail
1953

84

Raoul Dufy

Dufy (1877-1953) has such a graceful, easy manner that at first sight his work may appear slight or even facile. In fact this easy style is deceptive and was achieved only by hard work. There is no hint of it in Dufy's Fauve period. Nor in the landscapes he painted in 1908 at L'Estaque, with their hard geometrical forms and restricted palette of greens, blues, greys and ochres. It was not until 1920 that Dufy discovered his personal style, but once he had found it he never deviated from it, and went on to produce his most characteristic works.

DUFY
Portrait of Michel Bignou
1934

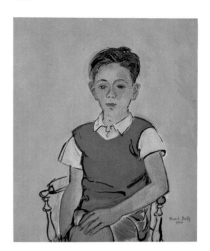

DUFY
Seascape

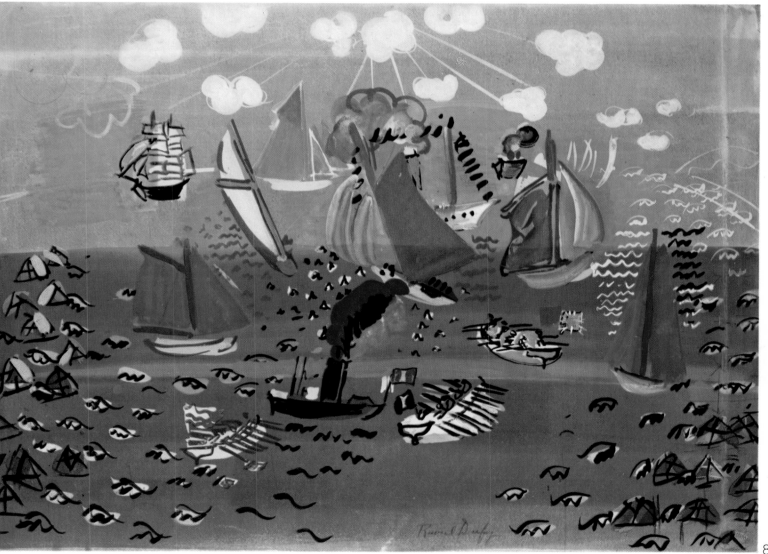

DUFY
Interval
1945

DUFY
The Red Violin
1948

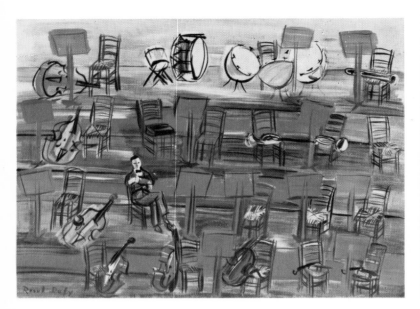

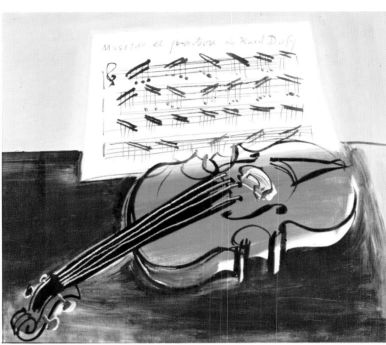

DUFY
Consolè with Yellow Violin

As he recognized himself, he owes a clear debt to Matisse. It was a picture of Matisse's Fauve period *Luxe, calme et volupté* that made him understand, in 1905, "all the new reasons for painting"; in it he saw for the first time "the miracle of the imagination transforming drawing and colours." Of course, Dufy's colours and drawing are his own, not borrowed from Matisse. And, though a painter of happiness, like his mentor, he approached his subject in his own distinctive manner.

Dufy did not dislike painting interiors and flowers but, like the Impressionists, he concentrated on outdoor scenes and landscapes. However he was not satisfied by the purely visual pleasures nature could offer. He would allow the blue of the sky to wash over him, or plunge right into the sea, relishing the cool of the water like someone who has grown hot lying in the sun. His expression of these sensations was sharp and direct, almost impatient, and it was achieved by the way he used colour. He could manipulate colour, heightening it, reinforcing it, spreading it flat, modifying it as necessary until, within one picture, it would echo like a clarion call, or sparkle brightly, or glow with a subtlety that was never insipid. In his oils Dufy could appear strident, but he was not aggressive or vulgar; his art was always distinguished by its gentleness and charm. He always took into account the natural light of the scene he was painting, but was too fond of precise colours to let them be dulled by atmospheric layers. Generally his air is crystal-clear, his world as fresh as if it had just been created or as if the rain had washed away all its dust and dirt.

Dufy's drawing enhances this impression. It is supple, alert and airy, never defining objects too closely or making them thick and heavy. The line is elliptical in the extreme, with witty abbreviations and invented signs, yet it is clear and full of spirit and emphasis. Even an apparently casual scribble is evocative. The way the forms are left open means that people and objects are less isolated and more receptive to their surroundings. It also enabled Dufy to paint the same subject several times without monotony. Whether the series he painted was of the Côte d'Azur at Nice, of paddocks or regattas, cornfields, threshing or orchestras, each individual work has such freedom and such verve that it seems to be unique, a spontaneous reaction to a delightful surprise.

DUFY
Anemones

DUFY
Ascot

DUFY
Regatta
1938

Albert Marquet

Marquet (1875-1947) belonged to the Fauve movement principally because he was a friend of Matisse and not because violent colours corresponded to anything fundamental in his nature. In his early work, it is the sensitivity and accuracy with which pure colours are deployed that is appealing, rather than any audacious effects.

He was mainly a landscape painter and his favourite subjects were town scenes, harbours and beaches, every place were human life animated the peace of nature. He looked down on this activity from a vantage point high above, so that men appeared as tiny insect-like creatures, often faintly ridiculous as they went about their business. He painted in many different towns and countries—Le Havre and Naples, Hamburg and Marseilles, Norway and Egypt—but seemed most at ease in Paris, looking at the embankments and bridges of the Seine. He loved the way objects were enveloped in the light veils of the moisture-laden air, and was particularly fond of effects of rain, snow and mist. In some ways he resembles the Impressionists, except that he was more concerned with synthesis than analysis of sensations, and he differs from them too in his practice of emphasizing the structure of his paintings by long sweeping lines. Marquet was not really an innovator, and his range is limited, but of those painters who remained true to the principles of realism, he was one of the most genuine and sincere.

MARQUET
Le Quai Conti, Paris
1947

88

MARQUET
Le Quai des Grands Augustins, Paris
1905

Cubism

PICASSO
Man's Head
1912

By the end of 1907, Braque was beginning to move away from Fauvism, to stress form at the expense of colour, and to consider volume as well as line. A few months later at L'Estaque he painted a number of landscapes in which every object appeared as a solid body, geometrical in form. The massed foliage looked as hard as the tree trunks and the walls of the houses. "Monsieur Braque... reduces everything... to geometrical diagrams, to cubes," wrote Louis Vauxcelles, so coining the name of this new development in painting: Cubism.

At that time Braque himself was not consciously trying to make objects take on the shape of cubes, any more than was the Spaniard Picasso whose work was moving in a parallel direction. Although there is a certain justification for describing their pre-1910 works as Cubist, it is not until after that date that the term fully applies. By then the two artists had freed themselves of the influence of Cézanne and primitive art, which had been formative elements in their style until then, and Cubism emerged as the most revolutionary force in figurative painting since the fifteenth century. It effectively broke with all the conventions of surface realism and discarded traditional perspective, modelling and verisimilitude of light effects, not because it was indifferent to objects but because it was concerned to analyse them in a more fundamental way and to give a more complete representation of their reality. The Cubists were the first to realize that by choosing a single viewpoint the Renaissance had, admittedly, introduced a certain order into the picture, but at the same time had condemned itself to giving only a partial view of things, that seen by a motionless observer. Modern man, on the other hand, is increasingly accustomed to rapid movement from place to place, and the picture he receives of the world is complex in the extreme. It was this complexity that the Cubists wanted to commit to canvas, by juxtaposing on one surface all the different aspects of an object that the mind knew existed, even though the eye could not view them simultaneously.

But it would be idle to pretend that the Cubists were entirely governed by

89

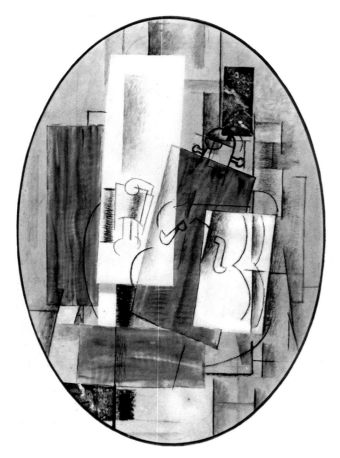

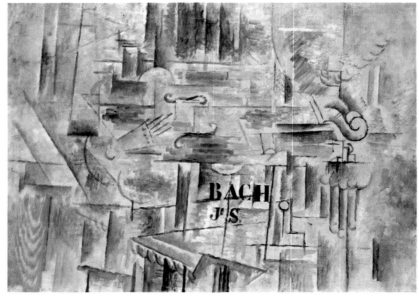

BRAQUE
Homage to J.S. Bach
1912

BRAQUE
Fruit-dish, Pipe and Glass
1919

the desire to give a rigorous new interpretation of reality. It is quite obvious that they also enjoyed experimenting with natural forms, or even ignoring them completely and substituting their own inventions. "The painter," said Braque, "does not try to reconstitute a situation, but to construct a pictorial fact." The subjects he and Picasso chose were unimportant in themselves—often still-lifes that might include a bottle, a glass, a pipe, a newspaper, a guitar or a violin. If on occasion they painted a human figure, it would be stripped of all its dignity and significance. There was no place for psychology in their art, except the psychology of the artists themselves.

In several works of the period 1910-1912, Braque and Picasso fragmented objects to the point where they lost their identity and disappeared altogether. They were, in other words, on the threshold of abstract art. But at this point they stopped, and in fact retreated. Working in concert until the outbreak of war in 1914, they attempted to re-establish objects as things in their own

PICASSO
Bass
1914

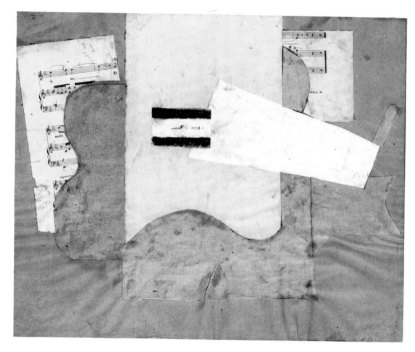

PICASSO
Music Sheet and Guitar
1912-13

PICASSO
Guitar on a Table
1918

right, not by reverting to naturalistic devices, but by breaking them up less and allowing them to be more defined. During the same period they also began to introduce printed letters in the form of words such as BAL, LE TORERO, MA JOLIE, which gave the picture certain associations as well as supplying a decorative motif. They went on to invent *papiers collés*—pieces of newspaper, painted paper, wrapping paper, stuck straight onto a backing-sheet with no more than the addition of a few lines and sometimes a few dabs of colour. Quite banal elements of everyday reality were brought into the transposed reality of art, and in the process they took on a pictorial value and poetic significance of their own. These *papiers collés* helped Braque and Picasso to move from the analytic to the synthetic phase of Cubism. They gave them the idea of creating an illusion of space by the most elementary means—two strips of differently coloured paper, for example. And they also gave them the impetus to bring colour back into their work. Preoccupied largely by questions of form, the Cubists had

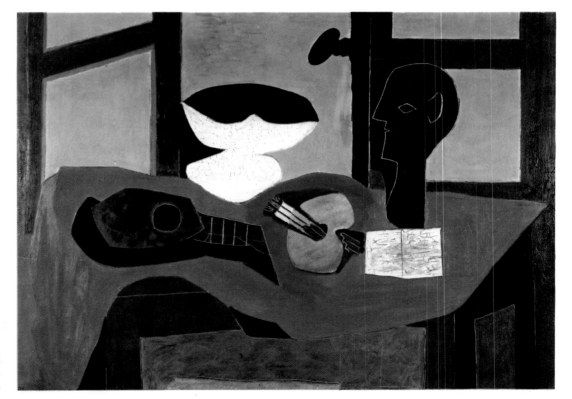

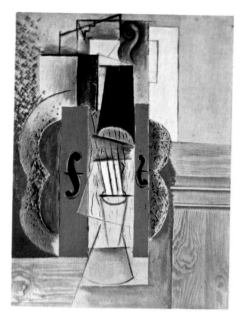

PICASSO
The Violin
1913

to use a palette of some austerity. Light focused arbitrarily over the canvas by the artist had been subtly graded into cadences of grey, ochre and brown. This near monochrome was abandoned in about 1913 in favour of a much more varied and strong range of colours.

Colour had for some time been a central preoccupation of two other artists who were associated with Cubism: Delaunay and Léger. As early as 1910, Delaunay declared that Braque and Picasso "paint with cobwebs." His own colours were clear and warm, while Léger had begun to experiment with pure reds and blues in about 1912. There were other respects in which they differed from their colleagues as well. They too had been influenced by Cézanne and developed geometric forms, but these were never broken up and fragmented. They did not shut themselves up in their studios and paint objects on a table. Delaunay found inspiration in the *Eiffel Tower,* and Léger painted a *Level Crossing* and a *View of Paris from the Window.* Both were acutely conscious of the pace of modern life and the abrupt sensations of the new world being created by technology.

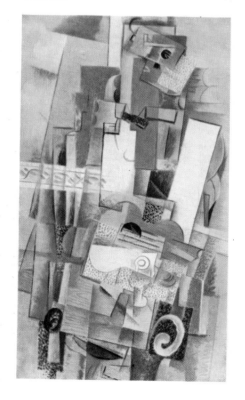

BRAQUE
The Guitarist

Braque, Picasso, Delaunay and Léger may have been the guiding spirits of Cubism and the principal innovators, but there were many other artists associated with the movement. All very different, they may nevertheless be grouped together under general headings. The experiments of Juan Gris, Marcoussis and Pettoruti link them in certain respects with Braque and Picasso. Valmier is similar to Léger, though more delicate. Jacques Villon and especially his brother, Marcel Duchamp, were interested in movement; while Gleizes, Metzinger, La Fresnaye and André Lhote saw Cubism as a discipline, a means of simplifying form and strengthening composition, so giving new impetus to traditional concerns. The influence of Cubism was considerable. It extended not only to other painters, but to poster design, typography, theatre design, sculpture and architecture.

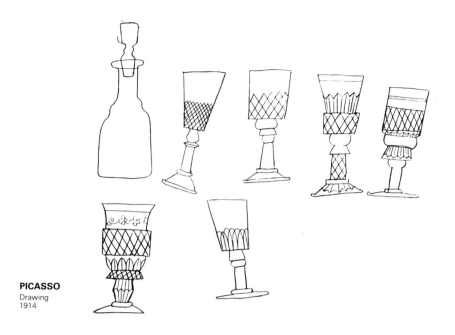

PICASSO
Drawing
1914

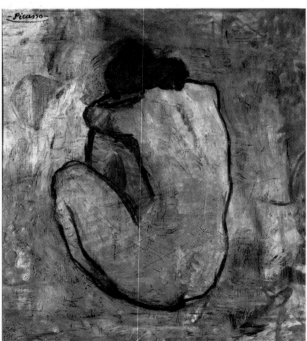

PICASSO
Nude
1902

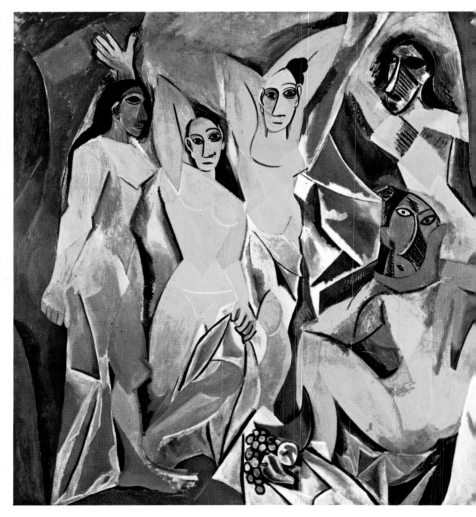

PICASSO
Les Demoiselles d'Avignon
1907

94

Pablo Picasso

To the layman modern art and Picasso (1881-1973) are synonymous. Among people who have not even seen a single reproduction of his work, his name stands for everything experimental, aggressive or excessive in art. Yet Picasso was not the most revolutionary painter of this century. Kandinsky and Mondrian were more sweepingly radical than he ever was. They rejected tradition outright, Picasso merely reacted against it. Nor does Picasso's work actually encompass the greatest variety—not more than Paul Klee's, for instance. Yet it is not hard to see why he has become the popular symbol for everything that is shocking about modern art. No one else attacked the conventions with quite such gusto and abandon, and no other painter ever bewildered the public so, with his rapid and spectacular changes of course.

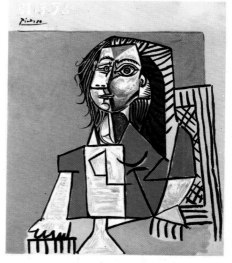

PICASSO
Sphinx
1953

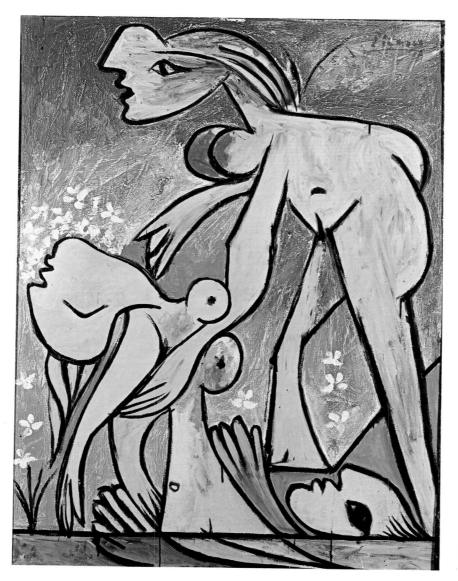

PICASSO
The Rescue
1932

When Picasso first went to Paris in 1900, he painted somewhat prettified scenes of Montmartre in a style reminiscent of Lautrec and Vuillard. The following year, a cold blue began to dominate his palette and his subjects were sad, anaemic young women, sickly children and emaciated beggars. Three years later this Blue Period was succeeded by a Pink Period, of harlequins, acrobats and tumblers—resigned and unsmiling figures but with nothing of the desolation of the earlier models. Picasso, who had left Spain for good, moved into the famous Bateau Lavoir in the rue Ravignan in Montmartre. Shortly afterwards he began to develop his Cubist style and continued in this vein for some years. When, in 1917, he began to paint portraits that were clearly influenced by Ingres, it looked like a complete repudiation of his Cubist manner. Not at all. In the following years he alternated between the two modes of expression. Sometimes he represented human figures in the neo-classical

PICASSO
Two Women running on the Beach
1922

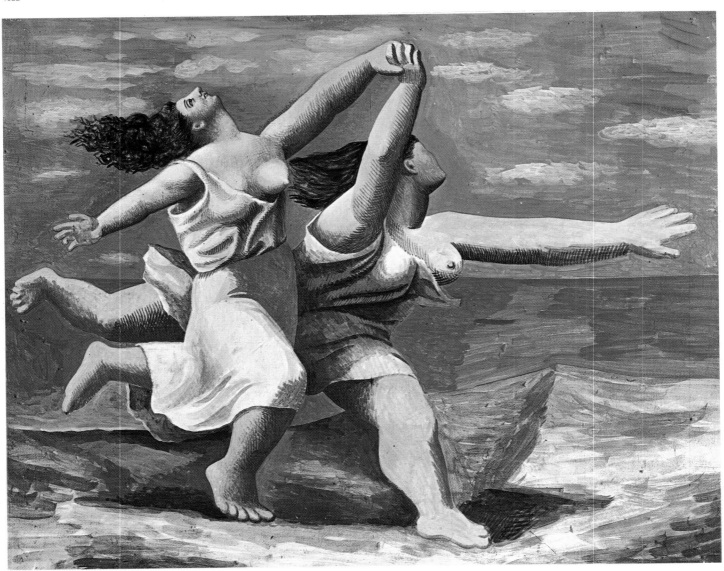

96

style, showing just a touch of irreverence by choosing to make them enormously fat. At other times he constructed his figures entirely of invented forms. Later, when he abandoned neo-classicism in favour of a more and more personal style, he continued to adopt the most contradictory attitudes, in turn calm or tormented, tender or brutal, friendly or pitiless. Somehow he was always himself. In a lesser artist such versatility would have seemed like a lack of conviction, in him it merely proved the range and richness of his genius. It does also indicate something of Picasso's need to express himself always with complete freedom. He always did exactly what he wanted at the moment he wanted. In a society that tends to order life more and more by strict rules and to encourage conformity, an attitude like his was bound to appear monstrous and deliberately provocative.

What Picasso most wanted to achieve was strength of expression, an incisive

PICASSO
Women on the Beach

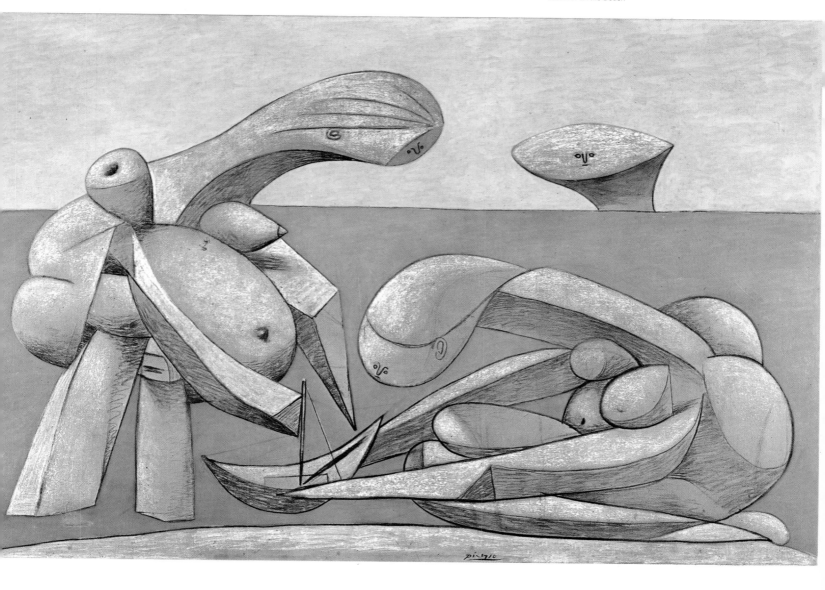

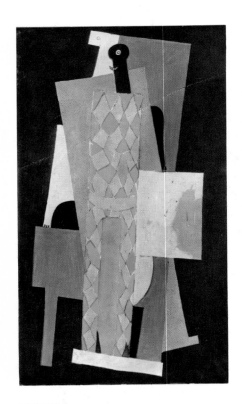

PICASSO
Harlequin
1915

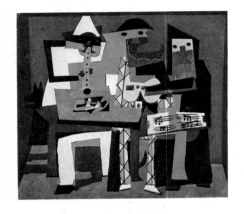

PICASSO
The Three Musicians
1921

and telling statement. He never aimed to please. It would never have occurred to him to make art, in the world of Matisse "a tranquillizer to soothe the mind." On the contrary, he wanted to excite us, make us uneasy, shake us to the depths of our being. His colours clash more often than they form harmonies. The handling in many works shows contempt for conventional beauty, a casual roughness and aggression. His line can have a feline suppleness, but it can be stern, hard, steely and angular. In a sense he was an expressionist, who built on his Cubist experience to create an idiom far more revolutionary than Expressionism proper. Once again it was his love of freedom that led him to push his invention of forms as far as he could go without lapsing into merely gratuitous excess. Though it must be said that there are such lapses—there is a part of his art that is a sort of jest, amusing but cruel. But we should consider that aspect of his work in the context of all the many paintings of every period that are both deeply felt and passionately expressed.

By 1937 his work had changed markedly. The cause was political, the Spanish Civil War. Up till then Picasso had been preoccupied with his own artistic and personal problems, now it was the fate of a nation that weighed on him, and after the bombing of the little town of Guernica by Fascist planes, he painted as his cry of protest one of the most poignant pictures ever to be inspired by the horrors of brute destruction. He made his position equally clear during the Second World War, when he painted a series of seated women with monstrously distorted faces, who communicate with almost unbearable intensity the torment and anguish suffered by so many people in those terrible years. Picasso's art does not exist in a vacuum, it is a committed art, intimately bound up with the artist's own life, expressing its passions and quarrels, its pleasures, disillusionment and bitterness.

It also expresses a lust for power and dominance. Everything Picasso touches, he has to transform and make his own, so that he alone gives it its existence —even if he has to twist, pillage and destroy it in the process. But if he does destroy it, he does not sit and contemplate the ruins, he uses them to build a new structure, in which things are transformed, given new and expressive life, become even more obsessive than they were before. Of course such an attitude is immensely arrogant, but it is no more arrogant than the attitude of men in our time, who destroy the natural order as they make the world conform to the image of their own desires and needs. In a sense Picasso reflects typically twentieth-century behaviour. And if he is brutally honest in showing its attractions, he also makes us share its anxieties, by raising the agonizing questions that man must face by virtue of the very extent of his power and achievement.

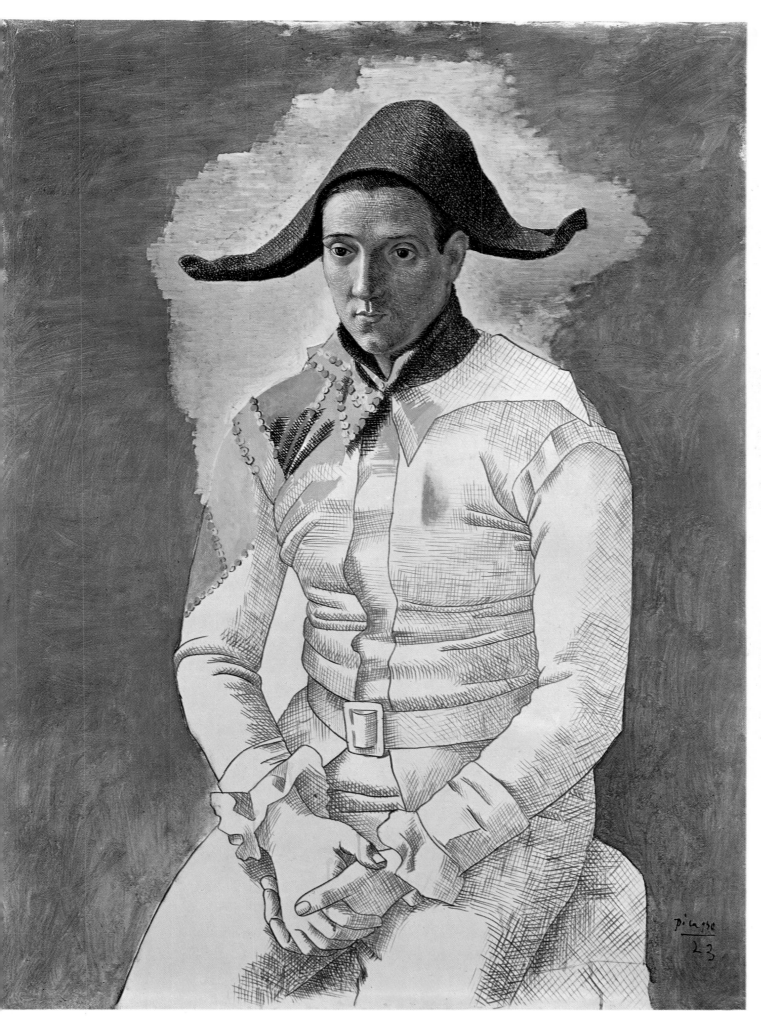

PICASSO
The Painter
Salvado
dressed as a
Harlequin
1923

PICASSO
Guernica
1937

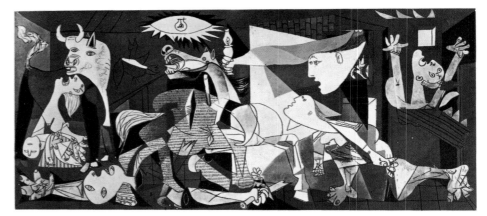

PICASSO
Reclining Woman
called 'The Sleeping Atlantid'
1946

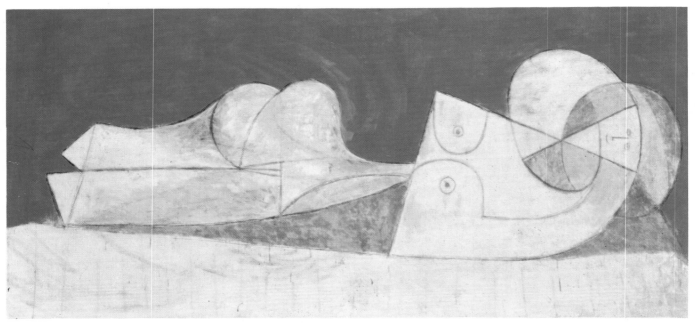

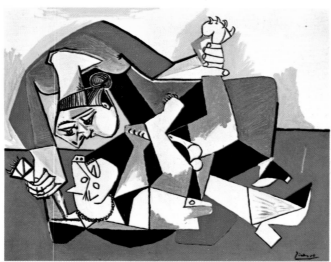

PICASSO
Woman with Dog
1953

PICASSO
Centaur
1948

Georges Braque

Although Braque (1882-1963) had much in common with Picasso during the Cubist period, the two artists are fundamentally very different. Picasso advanced in fits and starts and was always impatient to move on, Braque's progress was thoughtful, logical and measured. Picasso treated objects and people alike in the most cavalier manner imaginable, Braque approached them with humility and a certain gentleness. Of course he "deformed" them, quite

BRAQUE
Female Bust
1937

BRAQUE
Three Lemons

BRAQUE
Cabins, small Boats and Pebbles
1929

101

systematically, yet one almost feels it was in reply to the secret wishes of the objects themselves.

As far back as his Fauve period Braque was not regarded as one of the more moderate spirits. But he was bold without being impulsive. There was no squandering of colour, no vehemence of style. Always a desire to keep emotion within bounds. And already this penchant for the curving line, that takes possession of an object, without haste, in successive strokes. It may have been his association with Picasso that later prompted him to draw with a swifter rhythm and to use sharp, abrupt angles. But even then his line rarely had the bite and arrogance of his friend's, and would tend to be softened by

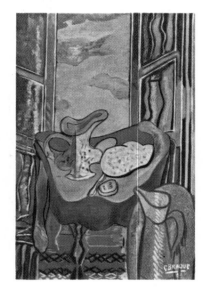

BRAQUE
Washstand by a Window
1943

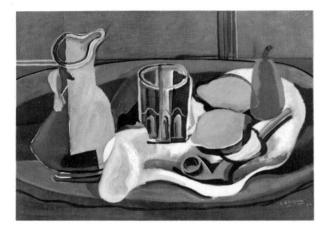

BRAQUE
Still-life
1929

the restraint of his colouring. At all events, it was through Cubism that he found his personal voice, being temperamentally suited to a type of painting that was reflective and reserved, and in which "rules discipline emotion."

After 1918 his style changed. His objects became less geometrical and more individualized. They also took on a certain thickness and began to suggest more of the qualities that belonged to them in reality. The fruit bowl held the fruit better, the fruit itself was more fleshy and easier to identify. The table was more obviously made of wood and designed to hold a jug, a pipe, two apples and a newspaper. But in no sense was this a return to realism. Braque kept the inverted perspective of his Cubist period, representing objects flat against the surface plane of the picture, very close to the eye of the beholder. He also continued to modify their shape and sometimes their colour, in other words, to adapt them completely to suit the requirements of his composition and the atmosphere of their setting. The mood is reminiscent of Chardin and Corot, a world where life is peaceful and contemplative, cloaked in subdued light. Browns, beiges, greys, olive green and blacks predominate, and if there is a touch of red, orange or pale blue, it is muffled by the generally muted tones around it. The texture of the paint reinforces the effect of the colours. Sometimes thin and smooth, at others thick and clotted, it too invites the eye to linger and consider.

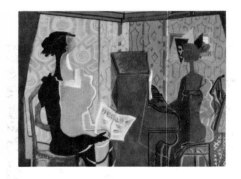

BRAQUE
The Duet
1937

BRAQUE
Tea-pot with Lemon

Braque's style is intimate, even in most of the seascapes he began to paint around Dieppe in Normandy in 1929. A grey or dark blue sky prevents the eye from straying into the distance, and if the sky or a slightly menacing quality of the light hints at an approaching storm, there is no real sense of threat. Braque was not inclined to pathos or drama, or to violence.

There is one exception. In about 1930 he painted the *Baigneuses*, where, in the manner of Picasso, he treated the human body as a malleable thing, that could be stretched, compressed or reassembled at will. But this was an isolated experiment, and the figures that he began to paint in 1937 have all the qualities associated with his usual style. Freer than the robust *Canéphores* of 1923-1926, younger and more elegant too, they are firmly integrated within the decorative scheme of the picture, and have no psychological interest in them-selves. Each face is bright and rounded as it looks straight at us, but to one side of it is a fine black profile, with a fixed interrogative gaze, full lips and strong chin. Suddenly, these are the sisters of those graceful goddesses on antique Greek vases, not dolls or modern women, but incarnations of the eternal feminine.

For a time it looked as though Braque had found his style and would do no more than modify it. But in 1949 he embarked on a long series on the theme *L'Atelier*, the versions of which are highly complex and abstract in character. Objects are again flattened, but by now the drawing has more breadth, colour is freer and often warm and lively, and space is suggested in a more subtle manner. Against the stillness of the objects is set the figure of a large bird in flight. It is entirely characteristic of Braque that, when he wanted to introduce movement into his work, he should choose its most gentle and peaceful mani-festation, one poetic association of nostalgia and dreams.

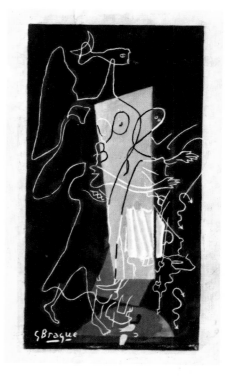

BRAQUE
Engraved Plaster
1948

BRAQUE
Notebook

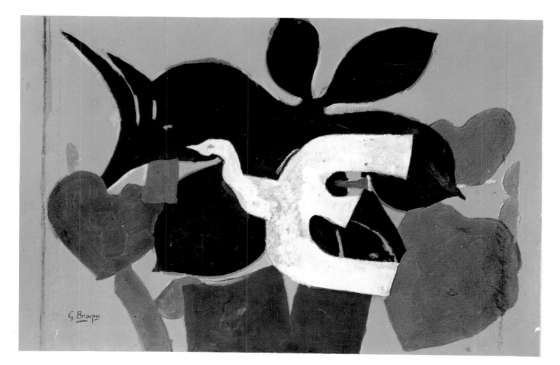

BRAQUE
The Bird
1962

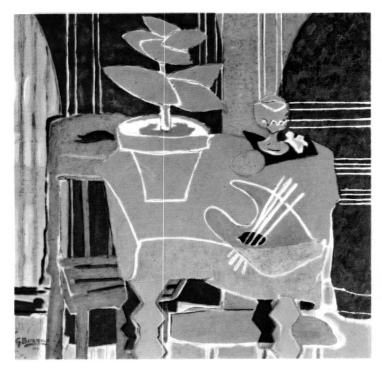

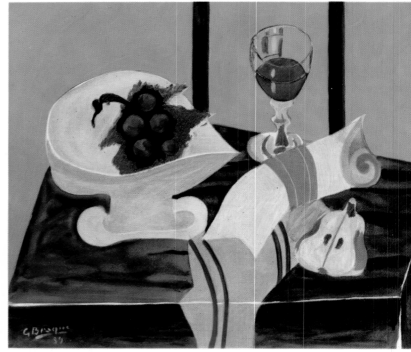

BRAQUE
Still-life
1939

BRAQUE
The Red Gueridon
1943

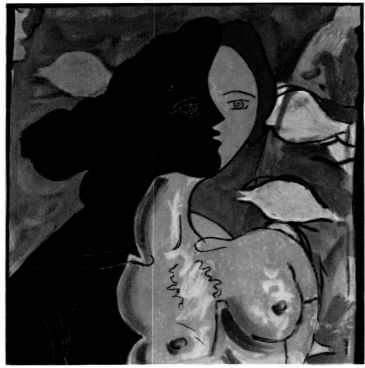

BRAQUE
Woman's Head
1942

Juan Gris

Like Picasso, Juan Gris (1887-1927) was a Spaniard. He went to Paris in 1906 and he too lived in the Bateau Lavoir, where he observed at close quarters the experiments and discoveries of his compatriot. It was not until 1911 that he became part of the Cubist movement and even then his attempts might appear cautious when compared with the works of Braque and Picasso at that time. In fact Gris, while interested in the effects of light, was not so much cautious

GRIS
Vase of Flowers

GRIS
Still-life with oil-Lamp
1912

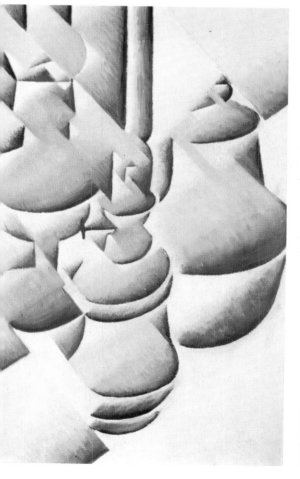

GRIS
Still-life
with Siphon
1916

GRIS
The Album
1926

GRIS
Bag of Coffee
1920

GRIS
Still-life with Dice
1922

as unwilling to push his analysis to the point where objects would cease to be recognizable and tangible things.

Between 1915 and 1920, he produced a series of still-lifes that are full of authority and ease of manner, and which are probably his most accomplished works. The forms are so strictly geometrical that they are practically diagrams. They are not, however, mere stylizations. The colours are strong and clear, though subdued in tone, and certain of the harmonies are exquisitely subtle and precise, particularly where blacks are beautifully blended with greys and blues. The sensitivity of the colouring counterbalances the severity of the line, giving a more spontaneous quality to a style in which nothing is left to chance. If Picasso proclaimed his freedom and demanded the right to satisfy his every whim, Juan Gris loved nothing better than rules to follow and a system to work within.

Towards the end of his life, his manner became more relaxed. The line was less rigid and more descriptive, generally corresponding to the outlines of objects, where before it had tended to have an autonomous life of its own. There are times when it even betrays a certain tiredness, as though the disease which had been undermining Gris' health since 1920 actually made it impossible for him to maintain the resolution and tension that had distinguished his drawing only a few years before.

Fernand Léger

Stripped of all prettiness, sentimentality or romanticism, the painting of Léger (1881-1955) has close affinities with the industrialized life of the twentieth century. It is a uniquely powerful expression of enthusiasm for a civilization that is widely regarded as inhuman, but which Léger viewed with unstinted admiration. Even the experience of the First World War, in which he served as an engineer, did not prevent him being "dazzled by the open breech of a 75 gun in the sunlight, the magic of light on the white metal." He was prompt to declare: "This breech has taught me more about art than all the museums in the world." And he was equally prompt to acknowledge the changes this new civilization had forced on man. In about 1913 he painted robots with disjointed limbs, and in 1920, figures whose bodies consist of metal tubes, with pistons for arms and bolts for fingers.

LÉGER
Contrast of Forms
1913

LÉGER
Disks and the City
1919-20

LÉGER
Still-life with Beer Mug
1921

107

LÉGER
Composition I
1930

This rather diminished view of human nature was succeeded by a phase in which the human figures were exalted : massive, majestic and indolent women, like goddesses. Not the goddesses of metaphysics, but of the painting itself, the incarnation of the artist's desire to express his own serene consciousness of power in hard, tangible form. Later, in his *Divers* and *Cyclists*, this consciousness finds expression in a style that is more supple, less hieratic. But still the figures seem to belong to a race that is more vigorous and healthy than our own. Léger may have been acutely responsive to the dynamic forces of our age, but he had no conception of its unhappiness and stress. Other modern artists share their mental anguish and confess their confusion. He shows us only his elation and proclaims his certainty and optimism.

LÉGER
The Mechanic
1920

LÉGER
Bather
1931

108

LÉGER
Leisure
Homage to Louis David
1948-49

LÉGER
Butterflies and Flowers

LÉGER
The Great Parade
1954

LÉGER
Two women with Flowers
1954

Free of anguish it may be, but his work is not free of conflict. In a sense, each picture represents a victory over opposing forces. Léger achieved unity and equilibrium only by reconciling sharp contrasts of colour, form and objects. The colours are pure and vivid, and at times violent. The forms are robust, some geometrical, some more irregular. Some of the objects are drawn from nature, others are man-made. And in about 1942, he introduced a further contrast by separating colour and outline, allowing the first to become abstract, the second to remain figurative.

Vigorous and solid, Léger's art is essentially monumental. It was therefore well suited to the commission Léger was given to execute the stained-glass windows for the new church at Audincourt. They are one of his most impressive works, a great masterpiece not only of modern art but of the art of all time.

Robert Delaunay

Delaunay (1885-1941) is important in two respects: for the pioneer role he played, and for the emotional power of his work. That the two are not incompatible, he amply demonstrated in his canvases up to about 1930. *Simultaneous Windows* or the first *Circular Forms*, painted before 1914, are among the most beautiful and original works the Cubist period produced. Already Delaunay was preoccupied by the problems that concerned him to the end of his life. Could colour alone be used to construct a picture, to suggest form without the help of line, or space by flat planes of colour? Could it as well convey movement and express the dynamism of the modern world? Delaunay was convinced that it could, and at first his art brilliantly illustrated his theories. Later the demonstration of the theories tended to take precedence and the lyrical qualities of his painting suffered. It is fair to say that, in the

DELAUNAY
The Cardiff Team
1912-13

DELAUNAY
Runners
1926

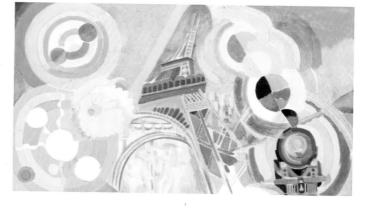

DELAUNAY
Rhythm
1936

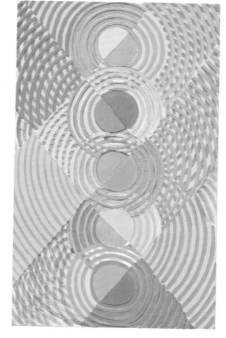

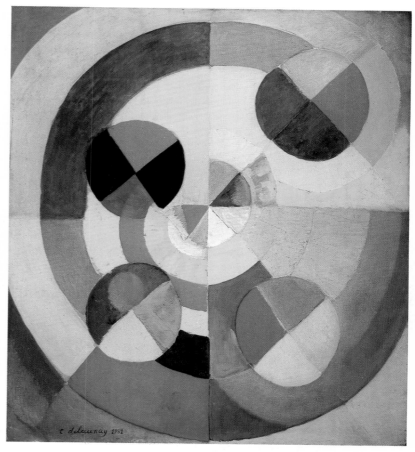

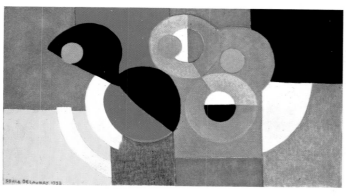

SONIA DELAUNAY
Composition
1952

DELAUNAY
Rhythme. Joie de vivre

Coloured Rhythms and *Unending Rhythms* he painted after 1930, the forms are more simplified and vital than in the earlier works. And the decorative qualities of these compositions are equally apparent—dating as they do from a time when Delaunay was trying to relate painting to architecture. Yet real feeling is lacking. They are just a little too systematic. The early paintings may have been less assured but they do contain genuine passion.

111

Jacques Villon

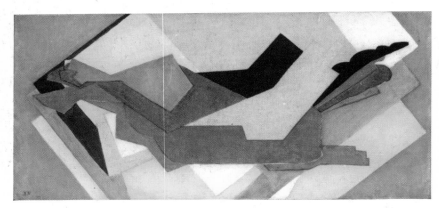

VILLON
Seated Woman

"I was the Impressionist Cubist," said Villon (1875-1963), "and I think that is what I still am. Maybe less Cubist, or less Impressionist, or more something-or-other-else that I am still looking for." A Cubist since 1911, he was interested both in colour, which he used with great delicacy and subtlety, and in form. He showed the human figure in movement and in repose, painting one marvellously evocative study of a troop of *Soldiers Marching,* which is composed entirely of oblique lines and angular planes.

His work was interrupted by the war, and afterwards he took up engraving, on which he concentrated almost exclusively until 1930. The few canvases he did paint are fine examples. Normally Villon took his subjects from nature, but twice, around 1920, and again after 1930, he concentrated for a period of a few years on non-figurative painting, which contained only geometrical figures of strict form. The remarkable thing is that this severe and unadorned geometry never appears cold. However deliberately the pictures were worked out, inspiration seems to play a greater part than calculation. Squares, rectangles, triangles and trapeziums are as satisfying as flowers or landscapes in the work of other artists.

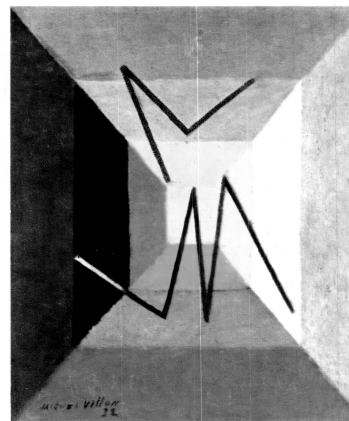

VILLON
Race Horse
1922

VILLON
Joy
1932

VILLON
Ocean Deeps
1945

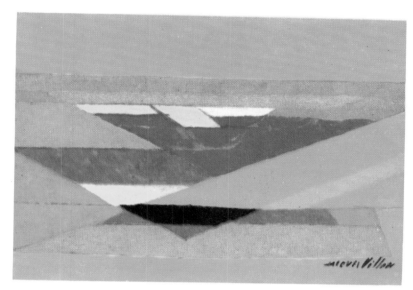

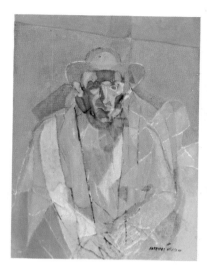

VILLON
Portrait of the Artist
1949

VILLON
Orly
1954

VILLON
The Poet

By 1939 Villon himself was turning increasingly to landscape. The war forced him to leave Paris and so gave him the opportunity to paint more often in the light of the open air. This did not, as it turned out, mean that the Impressionist in him outstripped the Cubist. Instead, both tendencies developed in concert and reached a similar state of perfection. Villon's painting grew more lyrical at the same time as his taste for abstraction and order became more marked. Even irregularly shaped motifs like trees and rocks were built up of geometrical lines in a highly organized structure. The colouring was equally deliberate. It was based on the colours to be observed in nature, but with the addition of a whole range of other colours that came straight out of Villon's spell-binding imagination.

His skies are mauve, orange and emerald. In precisely demarcated shapes, he places touches of black, pink and violet side by side with the acid pale-green tints of spring. And yet somehow the artificial colours look as right in the landscape as the greens, yellows and ochres. They are chosen with exquisite sensitivity and placed with unerring accuracy. Villon's colour harmonies are almost unequalled. Among modern painters he is one of the most skilful and resourceful colourists, as well as being a master of subtle construction.

VILLON
Au Val de la Haye

VILLON
Portrait of Marcel Duchamp

Futurism

BOCCIONI
Those who go away
1911

Although its first manifesto, drawn up by the poet Marinetti, was published in Paris in 1909, Futurism was strictly an Italian movement, and even at its height had few adherents. The following year, there were only five names attached to the *Manifesto of Futurist Painters* which was published in Milan: Boccioni (1882-1916), Carrá (1881-1966), Russolo (1885-1947), Balla (1871-1958) and Severini (1883-1966). Their intention, according to Marinetti, was "to glorifiy the aggressive movement, the feverish insomnia, the double time, the somersault, the slap on the face and the blow of the first." The painters echoed him, violently attacking the veneration of the past. "Can we any longer ignore," they demanded, "the frenzied activity of the cities, the new psychology of noctambulism, those febrile figures, the rake, the tart, the tough and the drunk?"

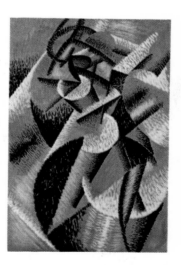

SEVERINI
Dancer
1913

"A galloping horse has not got four hooves," their manifesto went on, "it has twenty and their movements are triangular." In practice, in attempting to juxtapose all the different phases of a movement, the Futurists tended to fragment it and slow it down rather than show it in its full intensity. We are offered dispersed pieces of body and not bodies in action. This fragmentation undoubtedly shows that the movement was strongly influenced by Cubism, which was actually a more genuinely revolutionary idiom than Futurism ever could be. However, the Futurists did have a distinctive approach of their own, and certainly succeeded in one of their objectives —they do convey the clash of opposing forces at war in a shaken world. Outside Italy their influence was barely felt, but in Italy itself Futurism was important because it marked the revival of living painting.

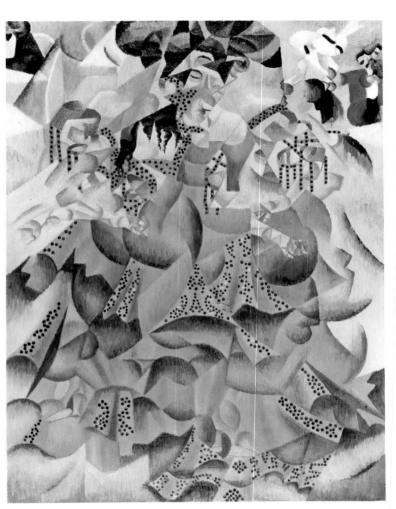

BOCCIONI
Elasticity
1912

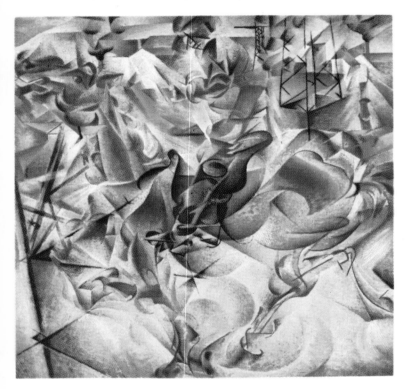

BALLA
Dynamism of a Dog on a Leash
1912

BALLA
Mercury
Passing before the Sun
1914

Expressionism

MUNCH
The Cry
1893

Few groups of painters are as varied in composition as the Expressionists. They shared one fundamental aim: to externalize their most profound feeling, which they did principally by distorting the forms of visible reality. In addition, their work had a distinctive flavour —bitter, emotional, and often tormented. Beyond this, it is almost impossible to generalize. Some were so eager to unburden themselves that they ignored technique, others never sacrificed the plastic beauty of their painting. Some remained faithful to chiaroscuro, modelling and traditional spatial perspective, other used pure colour, still others were influenced by Cubism. An additional complication is that the movement spread across many countries, each with its own local variations.

Expressionism reached its most extreme form in Germany, and it has often been regarded as an essentially German phenomenon, corresponding to some-

PICASSO
Lascivious Play
1968

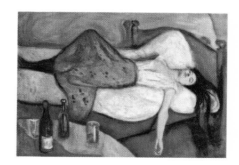

MUNCH
The Day after
1894-95

117

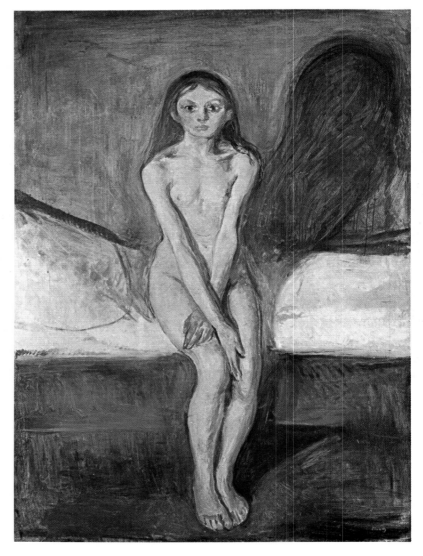

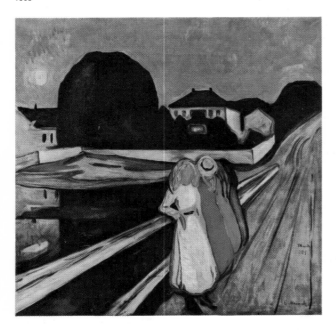

thing inherent in the German temperament. In fact the movement started else-where. As we have seen, its earliest exponents (among modern painters) were Van Gogh, who was Dutch, James Ensor, who was Belgian, and Edvard Munch, who was Norwegian. And the forerunners of the movement include all those painters in France who reacted against Impressionist realism.

Munch (1863-1944) himself lived for a period in Paris, where he admired Van Gogh, Gauguin, Seurat, Lautrec and the Nabis. His first exhibition in Berlin, in 1892, caused a major scandal but established his reputation in Germany, where he soon exercised a profound influence on the younger gene-ration of painters. Pessimistic, morbid and anxious by nature, Munch was tor-mented by man's essential solitude, whether in the vastness of nature or the teeming crowds of the big cities. Women attracted and frightened him at the same time. They were the means to an ecstasy that was inevitably followed by

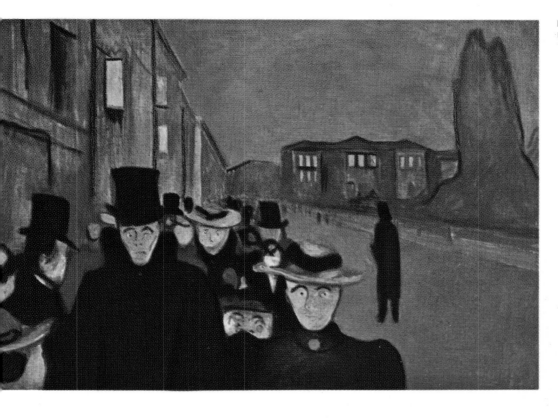

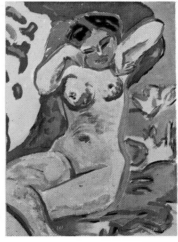

conflict, regret and bitterness. They might sometimes take on the appearance of a madonna or a goddess, but underneath it they were vampires.

I have already mentioned that Munch's style was influenced by Art Nouveau. The works dating from the end of the last century are characterized by long, curving, melancholy lines and the use of symbolic colour. Munch would have agreed with Van Gogh in wanting to ''express in red and green the terrible passions of human beings.'' In fact his own colours were in general more modulated, and even when more vivid tones were introduced, tended to give an effect of nostalgia.

Munch's most characteristically Expressionist paintings were executed before 1909, when he left Germany to return to Norway. Back in his own country, he seemed more relaxed. His palette lightened, and the texture of the paint was so fluid that the canvases looked almost like watercolours. Apart from copying earlier works, Munch painted mostly nudes, children, peasants and workmen, who, if not exactly joyful, were not as tormented as before. Only his self-portraits show that he was not as calm as his other works tended to suggest.

It was in Dresden in 1905 that the group was formed that gave German Expressionism its impetus. Known as Die Brücke (The Bridge), the group at the

start comprised only four artists, all in their early twenties —Ernst-Ludwig Kirchner, Erich Heckel, Karl Schmidt-Rottluff and Fritz Bleyl. They were later joined by, among others, Max Pechstein, Otto Mueller and, briefly, Emil Nolde. Drawing their principal inspiration from post-Impressionist, Negro and Pacific art, and old German wood cuts, they used colours which show a certain Fauve influence. They knew Van Dongen, but were more inclined to follow the example of Vlaminck. They favoured strong, piercing, strident clashes of colour and had no interest at all in subtle harmonies. Their hard-edged, stiffly angular forms derived from their experience of wood cuts. In 1911, Heckel, Kirchner and Schmidt-Rottluff left Dresden and joined Otto Mueller and Pechstein in

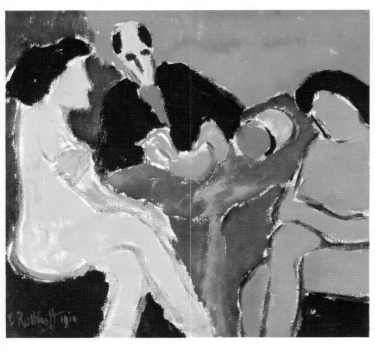

SCHMIDT-ROTTLUFF
Rest in Studio
1910

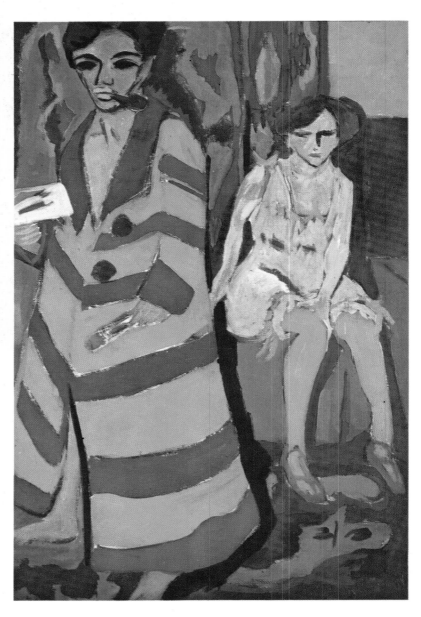

KIRCHNER
Self-portrait with Model
1907

120

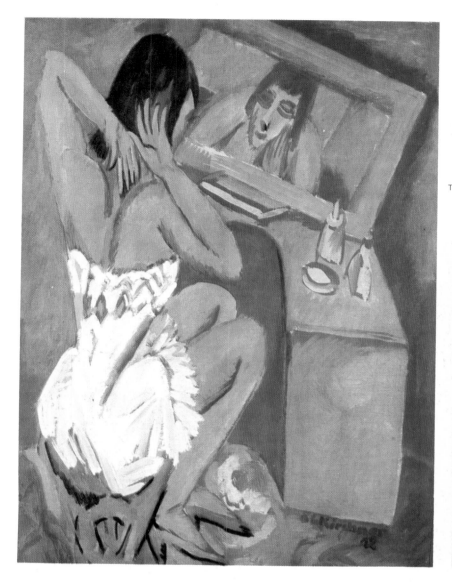

KIRCHNER
Woman in Mirror
1912

HECKEL
Two Men sitting at Table
1913

KIRCHNER
Poster for an Exhibition

Berlin. Directly or indirectly influenced by Cubism, their colours became more muted, their forms more geometrical and their composition more severe. The Brücke survived as a group until 1913, but even before that the individual artists had begun to develop in different directions.

The dominant personality of the group was Kirchner (1880-1938), an artist whose restless and uneasy temperament is revealed in his nudes, portraits and landscapes. That quality is discernible even in his Berlin pictures, which are probably the most harmonious he ever produced. Inspired by what he observed in the city streets, he painted scenes of a superficial but exciting world where bewitchingly fashionable creatures encounter gentlemen dressed with stiff formality. Kirchner's restlessness never entirely disappeared, even after 1917 when he went to live in Switzerland and began to paint mountain landscapes and scenes of the peaceful life of the peasants and shepherds.

121

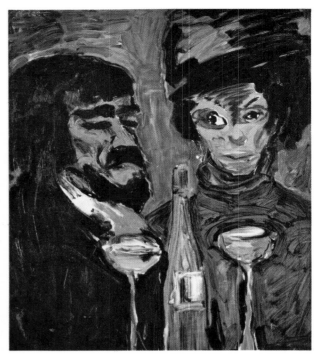

NOLDE
Marsh Landscape
1916

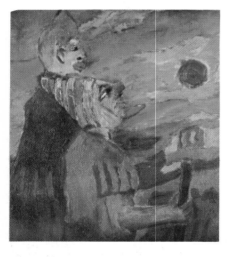

NOLDE
The Tramps
1910-15

Heckel (1883-1970) could appear as disturbed as Kirchner on occasion (some of the figures from his Berlin period are haggard and tormented in the extreme), but in general his style was not as impulsive or agonized. Some of the Dresden works even show an interest in the techniques of pure painting. After 1920 his work became rather conventional and lost much of its interest.

The painting of Schmidt-Rottluff (1884-1976) is characterized by its sustained colour and strong and simplified drawing. His figures and objects are broadly geometrical but have a certain weight to them. Gestures are stiff and the faces are unsmiling and even surly. In the 1920s his work too lost some of its experimental and Expressionist qualities but remained in general structured and robust.

Nolde (1867-1956) is in the most extreme vein of German Expressionism. Influenced initially by the work of Munch and Van Gogh, in about 1909 he began to paint violent expressions of his religious visions and scenes drawn from the wild excesses of his imagination. His aim was always to shock, and no colour was too violent or too crude. When he painted subjects like *Pentecost, The Last Supper or The Life of Mary the Egyptian,* he made the characters into dumb-struck yokels. He depicted the degenerate clientèle of the Berlin night-clubs. Even the flat landscapes of his native Schleswig-Holstein were shown beneath vast oppressive skies full of melodramatic contrasts of light and dark. In addition, he would either fragment his forms or draw them very approximately, so that they were almost like crudely assembled caricatures. Nolde also

painted a large number of watercolours which, although they are similar to his oils, do not have the same violent colouring. Instead of clashing, the tones blend together and are quite airy or velvety in texture.

The Austrian, Oskar Kokoschka (born 1886), developed Expressionism into a style of considerable psychological as well as artistic interest. He studied in Vienna in the early years of this century and was initially influenced by Klimt and the *Jugendstil*, but the flowing decorative line of Art Nouveau rapidly gave way to a more emotional expression of feeling, reflected in sharper, more complex drawing. He is probably best known for his portraits. Between 1910 and 1924, his models were usually friends from Vienna, Berlin and Dresden: the writers, Karl Kraus, Peter Altenberg and Walter Hasenclever; the architect Adolf Loos; Herwarth Walden, the director of *Der Sturm,* the Berlin magazine and gallery; and Alma Mahler, the widow of the composer. In their faces Kokoschka divined their aspirations, their complexes and their destinies, seeing through the mask they wore in everyday life. His aim was to show the innermost reality of his subjects, stripped of all pretence.

At the same time he revealed a lot about himself. Rarely has any painter had such a strong sense of man as a doomed creature, at the mercy of obscure forces buried deep within his being. One thinks of Freud, who developed his theories of psychoanalysis in the Vienna of Kokoschka's youth. In around 1910, Kokoschka's style had a graphical angularity and tension, and even when colour

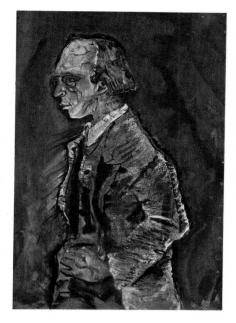

KOKOSCHKA
Portrait of Herwarth Walden
1910

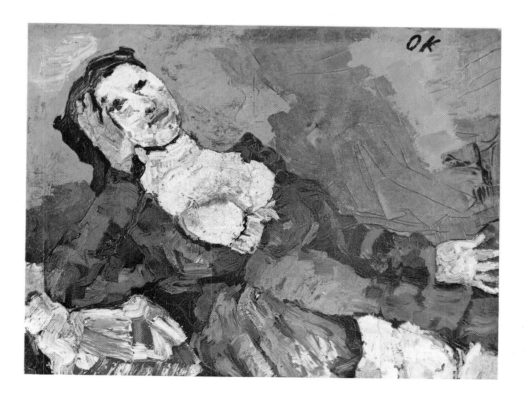

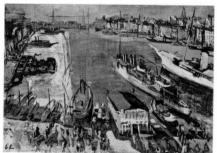

KOKOSCHKA
Marseilles
1925

KOKOSCHKA
Woman in Blue
1919

123

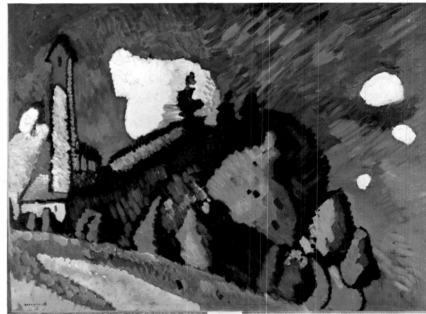

JAWLENSKI
Woman with Bangs

KANDINSKY
Landscape with Steeple
1909

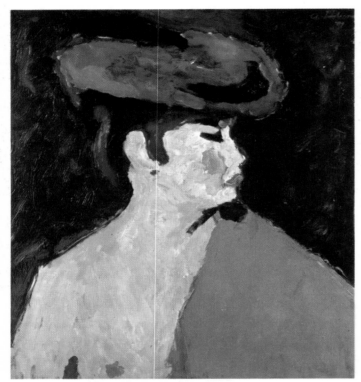

JAWLENSKY
The Red Shawl
1909

became a more important element in his work his touch never lost a certain nervous intensity. Between 1924 and 1931 he travelled extensively and painted alpine landscapes and panoramic views of cities (Paris, Madrid, London, Amsterdam, Venice, Istanbul...) which are distinguished by their expansiveness, their visionary character and their baroque rhythms. These baroque tendencies became increasingly marked in his later works, as colour lightened and became decorative and lines fragmented nervously.

It is customary to include among the Expressionists the painters who founded the New Artists Federation in Munich in 1909, two years later to become the famous Blaue Reiter (Blue Rider) group. The works of the Russian painters, Alexej von Jawlensky and Wassily Kandinsky, in particular, are full of a spirit of romantic impetuosity. But, more than most, the Munich group looked to France. Jawlensky and Kandinsky had lived for a time in Paris and been greatly impressed by Matisse. Their German friends Franz Marc, August Macke and

MACKE
Walkers before the Blue Lake
1913

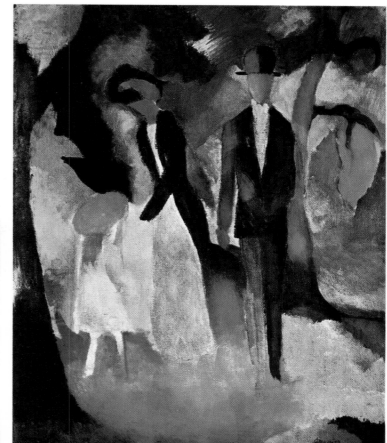

KANDINSKY
Lyric
1911

MACKE
Sunny Walk
1913

KANDINSKY
Improvisation 14
1910

125

MARC
Horse in a Landscape
1910

MARC
Horses resting
1912

MARC
The Blue Horse
1911

Paul Klee knew Delaunay. Marc and Macke were both killed in the First World War, but not before they had achieved a substantial body of work —Macke (1887-1914) with his sober yet appealing column-like figures, and Marc (1880-1916) with his animals set in a pure world of poetic or religious legend. Klee and Kandinsky, as we shall see, are among the most original and creative painters of modern times.

Lyonel Feininger (1871-1956) exhibited with the Blaue Reiter painters in 1913, and also knew Delaunay. His taste for the discipline and clear compositions of Cubism remained with him all his life, though his sensitive treatment of light and his delicate and mysterious colouring could give even the solid geometry of ships and houses an ethereal transparency.

After the First World War, Expressionism still remained a living force. The upheavals of the war led artists like Max Beckmann, Otto Dix and George Grosz to see the world differently from, say, Kirchner or Nolde, but their work was still essentially Expressionist in character. Less individualistic than their predecessors and more concerned to give a cogent account of social realities, they were generally more realistic in their approach, and their canvases provide a piercingly accurate reflection of life in the post-war Germany of the nineteen twenties.

Grosz (1893-1959) like Dix, had briefly been associated with the Dada group, but he was pre-eminently a satirist who used his drawings to pour scorn on the personalities and spectacles he despised. Dix (1891-1969) painted war scenes, cripples, prostitutes, workers and intellectuals, implacably underlining how each figure had been marked by life with a face and body of striking ugliness. His

GROSZ
The Hors d'œuvre
1929

GROSZ
The Subversives fall
and the Uniform takes over

BECKMANN
The Caravan
1940

BECKMANN
Portrait of the Artist and his Wife
1941

style is minutely detailed in the manner of the German masters of the fifteenth and sixteenth centuries, but he has a hard, dispassionate quality entirely his own.

Beckmann (1884-1950) has a more compact and less biting style. In about 1920, his figures tended to be schematic and reduced in scale, usually appearing in some dramatic or weirdly incongruous situation. Three years later these skimpy forms gave way to more ample volumes and the colouring became stronger and harsher. The subjects were either observed —a man in a smoking jacket or a woman in evening dress— or, after 1932, imaginary scenes of Greek mythology or Christian legend. Whatever the motif, the drawing is generally crude, the colours grating, and the mood heavy and morose.

Germany was not the only country in which Expressionism had a new lease of life after the war. There were vigorous off-shoots of the movement in Belgium, Holland and Luxemburg. In France too there were works in the Expressionist manner, not only by well-known artists such as Rouault and Vlaminck, but also by a younger generation that included Soutine, Gromaire, Goerg and La Patellière.

Belgian Expressionism was not only a post-war phenomenon. It extends back to the Ostend painter James Ensor (1860-1949), who was one of the fore-runners of the whole movement. For his work up to the age of forty, he must be considered one of the finest painters of his generation, and also one of the most radical. His famous *Entry of Christ into Brussels* dates from 1888, the year when Van Gogh went to Arles, and Gauguin was still struggling to find his style at Pont-Aven. Already Ensor had found his distinctive themes and style. He was a moralist, and to demonstrate the drab, pitiable and grotesque condition of his fellow men, he reduced them to skeletons dressed in rags, or gave them carnival masks that served only to reveal and accentuate the appalling truth of their real nature. He liked to imagine absurd situations, and in one picture grouped around a stove "skeletons trying to get warm", and in another, skeletons quarrelling over a herring. But Ensor's liking for caricature never made him neglect artistic considerations. Although strident he was never crude, and his colouring is varied and richly satisfying.

ENSOR
Carnival
1888

ENSOR
Entry of Christ into Brussels
detail
1888

128

The exponents of Flemish Expressionism in the twenties, Constant Permeke, Gustave de Smet and Fritz van den Berghe, had neither Ensor's light palette nor his sardonic wit. Brown dominates their work, and they enjoyed using dramatic contrasts of light and dark. If no strangers to pessimism and anxiety, they were nervertheless much less tormented than their German counterparts. In the heavy impasto of Permeke (1886-1952), we find all the colours of a freshly ploughed field, or of flooded water-meadows, or the North Sea tossed by a storm —and it can capture precisely the down-to-earth atmosphere of a rough village house or even a stable. Forms are massive and crude, drawn by an impetuous and brutal hand, but the colour harmonies are unusual and the paint is richly textured.

Gustave de Smet (1877-1943) was anything but impetuous. His drawing is geometrical and his composition careful to the point of seeming contrived. His colours, though subdued, have a muted warmth, and there is an attractive sense of the quiet security of country life.

Van den Berghe (1883-1939) is more challenging than De Smet but not as fierce or impatient as Permeke. His work always makes some sort of judgment on his fellow men and searches out their weaknesses —unsatisfied desires, strange yearnings and obsessions. After 1925 his painting became more Surrealist than Expressionist, and his canvases were peopled with flabby, fat monsters, straight out of the subconscious. These weird, nightmarish creatures became practically the exclusive subject of his work.

There are links between the Flemish Expressionists and their counterparts in Holland. First, both groups derived much of their subject matter from rural life.

129

Secondly, during the war De Smet and Van den Berghe came under the influence of the Dutch painter Sluyters; and later other Dutch painters like Chabot, Gestel and Kruyder, in their turn, were influenced by Permeke.

The Luxemburg painter Joseph Kutter (1894-1941) has a unique position among the Expressionists. He is neither coarse, nor barbaric, nor rustic. He is energetic rather than brutal. And if he underwent great emotional upheavals, he never expressed them in a convulsive or chaotic style. Even in his *Clowns,* which is a poignant reflection of his own suffering, he never for a moment neglected aesthetic considerations: his forms are well constructed and his colours are rich and varied.

KUTTER
Clown

ROUAULT
Pierrot
1948

130

Georges Rouault

It has often been said that as a general rule the French detest Expressionism. And it is true that the movement found few adherents in their ranks. Yet it was a Frenchman who gave the most authoritative account of Expressionism, Georges Rouault (1871-1958).

Rouault was contemporary with the Fauves and, like them, discovered his personal style in the early years of this century. Profoundly Catholic, and indeed, profoundly Christian, he could not bear to see all the ugliness, injustice and misery that surrounded him, without castigating it and proclaiming to the world his angry sympathy for its victims. There can be nothing more abject than his *Prostitutes*, appalling incarnations of his own repugnance at the idea of venal love. Nothing more vicious than his *Judges* with their bloated fat faces and heavy folds of flesh, incapable of being moved by any plea of humanity. And his *Clowns* are wretched creatures. Life has mutilated their faces, putting in their eyes black for sorrow and red for spite.

There is in Rouault a popular and condemnatory spirit akin to Daumier's. He also has a positively Goyaesque sense of the grotesque as something, not merely ridiculous, but shattering and terrible. There is too something reflective and fraternal in his work that is reminiscent of Rembrandt. And in other respects he is in the tradition of Byzantine and Gothic art, being the first painter for centuries to produce a truly moving image of Christ flagellated and crucified. He reacted passionately against the insipidity of pious art and offered in its place a vision as authentic as those of the great eras of religious faith. The Christ he gives us is neither the Christ of the church-goer nor that of the bigot. It is

ROUAULT
Before the Mirror
1926

ROUAULT
The Small Family
1932

ROUAULT
The Apprentice
1925

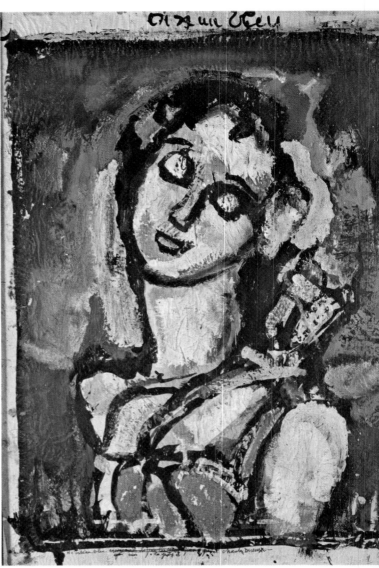

ROUAULT
The Blue Bird

ROUAULT
Christ and the Fishermen

ROUAULT
Christian Nocturne
1952

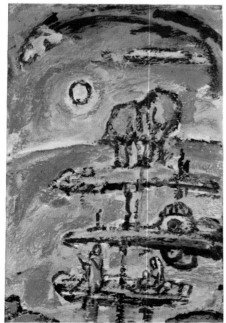

the Christ who inhabits the inflamed soul of the mystic, who frequents the poor and those who thirst after justice. If Rouault was passionate when he painted figures, he was equally so in his landscapes. Whether they are of a legendary Palestine or some stifling industrial suburb, they draw their burning reality from the visions and meditations of the artist.

Rouault's paintings may be deeply felt, yet they are far less impulsive than they might appear. Even the early works, with their whiplash drawing, are too rich in subtlety and significance to be merely spontaneous outpourings. Rouault never neglected his technique. Some of his subjects were sensational, but never was this reflected in the texture of his paint or the harmonies of his colours. His palette is bright without being in the least gaudy, and his paint is both thick and luminescent. Sometimes the colours seem to shine with a light that comes from behind the picture, so that they glow with the dark brilliance of a stained-glass window in the dying light.

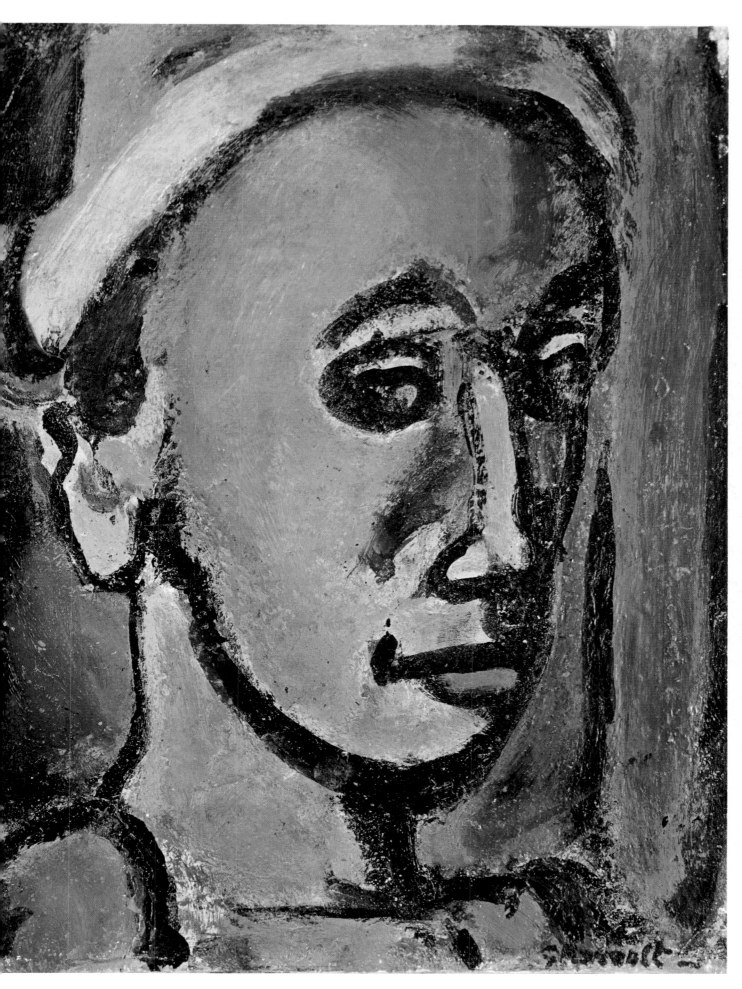

ROUAULT
Dreamer

Amedeo Modigliani

It is questionable whether one should include Modigliani (1884-1920) among the Expressionists at all. If one is to do so, it must be with the reservation that his painting shows not the least hint of excess.

An Italian, who went to Paris in 1906, Modigliani associated with the Cubists and their friends and, like them, studied Cézanne and Negro sculpture. He differed from them in wanting to achieve the simplification of form, not its disintegration. In addition, his principal means of expression was always line, a line that is long and supple, rather languid and lifeless. Although more melancholy and mannered, it is essentially the line of the Sienese School of the fourteenth century, of Baldovinetti and Botticelli. Modigliani's colours merely take up their places in the compartments the line traces out for them. They add little to the picture in themselves except a further touch of melancholy, and occasionally in the nudes a muted and artificial splendour.

Modigliani had little interest in landscape and none at all in still-life. He was drawn to human beings and the uselessness and pain he saw in their existence. Nearly all of his subjects belong to this race of tired, nervous, anxious and vulnerable beings. They sit stiffly before us, inviting us to contemplate their sadness and the difficulties of their life. Even the nudes, though certain of them display their not inconsiderable charms with pride, give little hint that they have experienced any other caress than that of the sinuous flourish within which the artist has elegantly enclosed them.

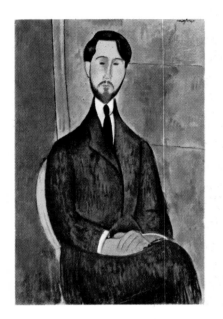

MODIGLIANI
Portrait of Zborowski

MODIGLIANI
Reclining Nude

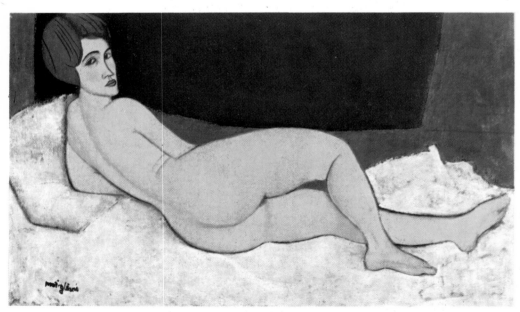

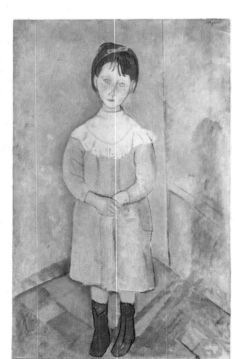

MODIGLIANI
Young Girl in Blue

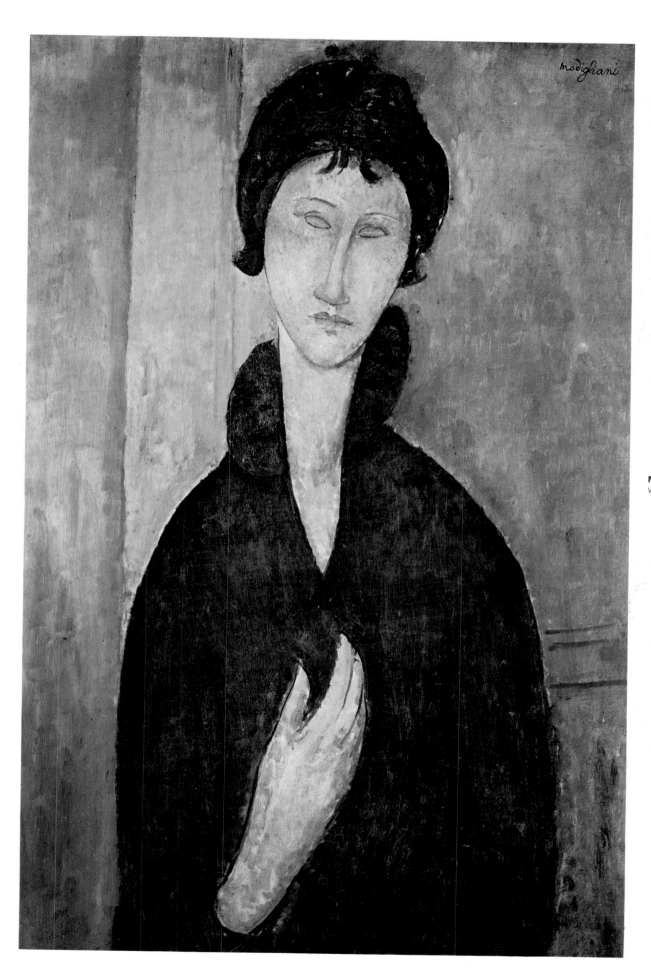

MODIGLIANI
Woman with Blue Eyes

135

MODIGLIANI
Lunia Czechowska

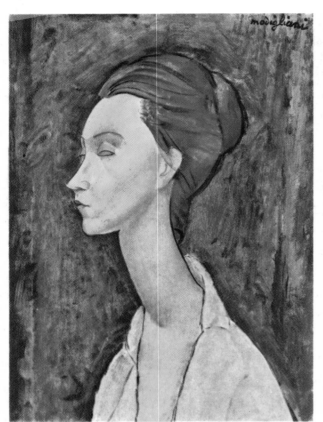

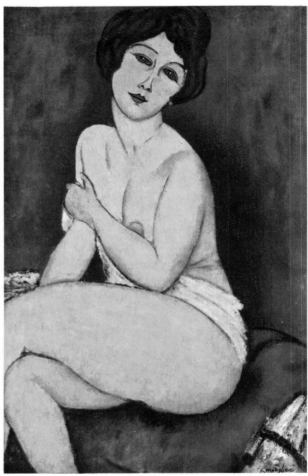

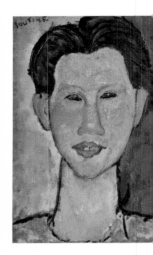

MODIGLIANI
Portrait of Soutine
1917

MODIGLIANI
Seated Nude
1917

SOUTINE
Windy Day in Auxerre

Chaïm Soutine

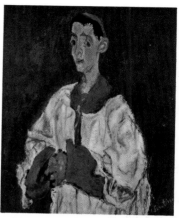

With Soutine (1894-1943) we enter a very differend world. A Lithuanian Jew, he spent his childhood in a ghetto in Czarist Russia, amid destitution and fear. That fear and starvation accompanied him when he fled his native village and went to study at the Vilna Academy. In 1913 he reached Paris, a tortured man, scarred by his experiences. This never changed, even ten years later, when his circumstances had begun to improve and there was no obvious reason to regard himself as a "doomed artist." Whatever he touched with his brush, he transferred to it his own fears and expectations of catastrophe.

If Soutine paints a landscape, he makes the houses reel or turns them upside down, and lashes the trees with gusts of wind that practically uproot them. Steep roads launch up against the sky and are swallowed up in the void. Even the sunny landscapes of the South of France seem to groan under the talons of a sadist. If he paints a human figure —a woman, a choir-boy or a page-boy at Maxim's— he makes the face look haggard and demented. Some of the faces look as if they have been skinned or smeared with fresh blood, as though in mockery of their deathly pallor. Eyes gleam with madness, or look shifty, or hypocritically sweet. The bodies are sickly and deformed, desiccated and decaying. Hardly ever is there even the remotest touch of warmth in the way the artist looks at his pitiful creatures. He records their downfall, their cruelty and their solitude, which is as agonizing and irredeemable as his own. He records it, but he does not protest. Soutine is of a race that has learned to accept suffering. If he paints animals, they are animals turned to meat —a side of beef, a plucked pheasant or a skinned rabbit— bloody or anaemic flesh on the verge of putrefaction.

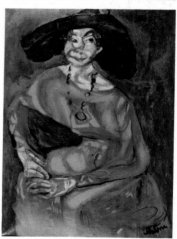

Yet this nihilism is compensated for by the life with which Soutine endows, not his form (which is fragmented but otherwise realistic), but his colouring and his pigment. It is a tainted life, certainly, but it can throb with a rich beauty of its own. Against violent reds and nocturnal or murky blues, there appear tender pinks (albeit those of decomposing matter), or whites tinged with blue and yellow. The utmost delicacy and delight emerge from things that cannot fail to arouse shock and pain.

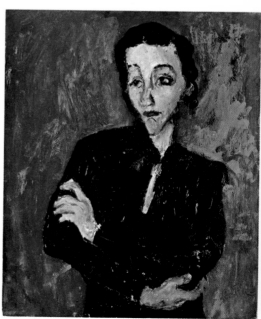

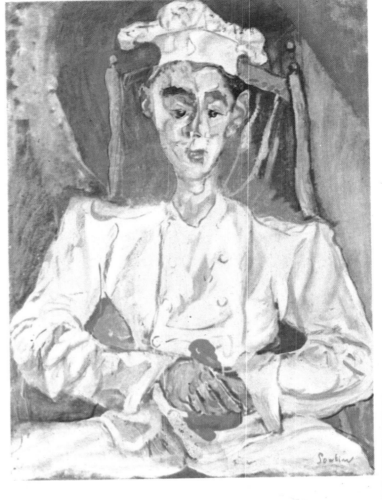

SOUTINE
The Red Staircase

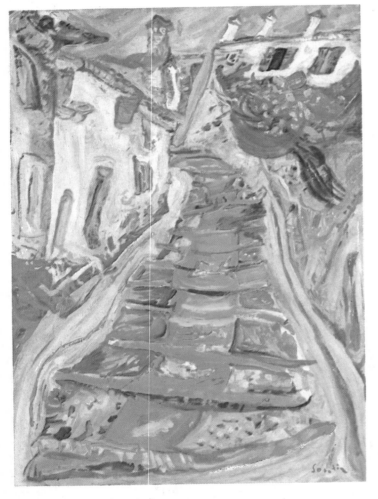

138

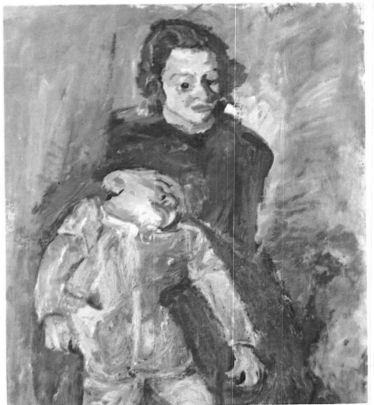

SOUTINE
Maternity

Marc Chagall

While twentieth-century painting has generally rejected narrative outright, in Chagall (born in 1887) we have an artist who tells a story in every one of his pictures. But that does not mean that Chagall is outside the mainstream of modern art. Everything in his work shows that it is of today —the form, the colours, the mood, even the love of invention that is one of the most characteristic features of contemporary painting.

Whereas with other painters invention is primarily a matter of manipulating colour and form, with Chagall it is applied to the relationships between human beings, animals and objects. They meet together in a world where the laws of physics no longer apply, and where divisions in nature and time have been abolished. Things which are normally quite separate are brought together and combined as if it were the most natural thing in the world. Memories from the past mingle with present reality. Inanimate objects become alive. Bunches of flowers, a candelabra or a clock (which may have wings) start to fly. To accommodate a woman leaning out to look into the street, a house enlarges its window to extend right across its frontage. And as Chagall is beyond the constraints of naturalism, he distributes his colours with equal freedom. If an acrobat has the head of a yellow cockerel with a green comb, there is no reason why he should not have one hand yellow, the other red, and blue legs.

The only truth that matters to Chagall is emotional truth, and all his unbridled fantasy is directed to the expression of its complex and irrational reality. His

CHAGALL
The Green Violonist
1918

CHAGALL
The Anniversary
1915-23

CHAGALL
Man drinking
1911

139

CHAGALL
Young Girl with a Horse
1929

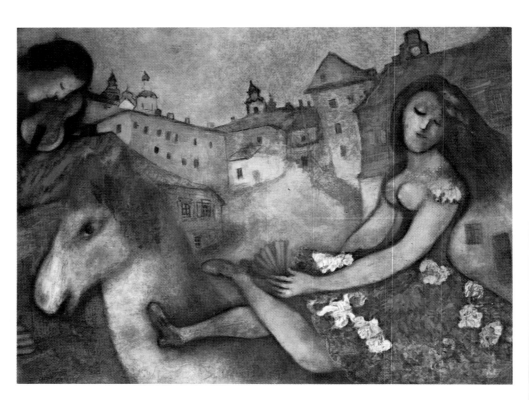

CHAGALL
Les Mariés de la Tour Eiffel
1938-39

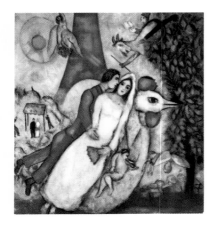

CHAGALL
The Fall of the Angel
1923-47

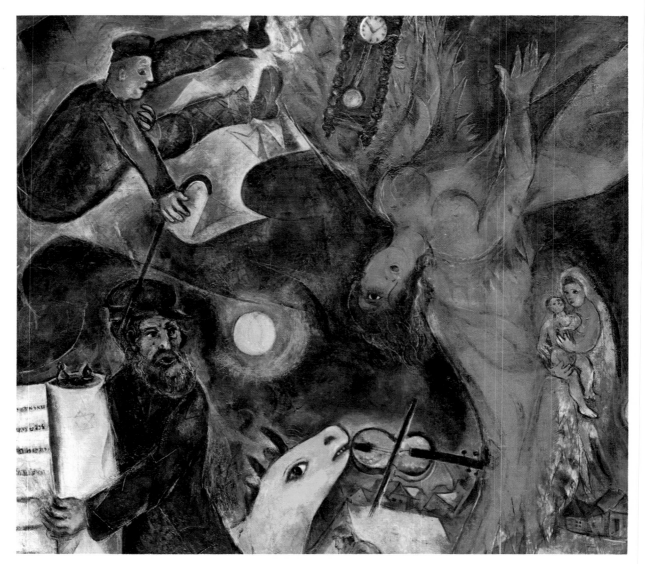

140

distortions, his animals made up of elements of different creatures, his manipulation of time and space, all these are his means of conveying his feelings to us. He shows us the pleasures and pains of his Jewish childhood in Vitebsk, confesses the delights he found in marriage, admits the tenderness of his feelings for domestic animals, expresses his sorrows, his obsessions and his worries. His art is his intimate autobiography. Thus it is not surprising that the experience of the last war, which forced him to take refuge in America, deprived his work of its nostalgia. It became overshadowed by tragedy and the colouring took on a quality of nervousness and desperation.

CHAGALL
Mosaic
detail
1970

Metaphysical Painting

CHIRICO
Premonitory Portrait
of Apollinaire
1914

Giorgio de Chirico

The Italian painter Giorgio de Chirico (1888-1978), who went to live in Paris in 1911, also tries to transport us to another world, but it is a very different world from Chagall's. And the methods he uses are not those that characterize the rest of modern painting. At a time when his contemporaries were discarding Renaissance perspective, he perceived a "disturbing relationship" between perspective and metaphysics, and he made startling use of it. His style is both original and effective. Objects are identifiable and familiar, yet mysterious and disconcerting at the same time. There is something disturbing about his logically constructed piazzas, with their surrounding fake porticoes and buildings, because they are so utterly empty. There is an obsessive quality to the shadows falling sharply in the melancholy light. The statues are half-way between being marble images and living creatures —they look as if at any moment they could come down from their pedestals towards us, or they might instead become cold and petrify in attitudes of frozen indifference. No less disquieting are the dummies that, in about 1915, replaced the figures, the interiors with their meaningless scaffoldings of wooden laths, or the realistic images of the biscuits the painter discovered in a ghetto in Ferrara.

There is only one context in which such impossible encounters with objects can seem quite natural, and where obscure meanings are masked in images of startling clarity, and that is in dreams. Chirico was by no means the first artist to be influenced by dreams, but he was one of the first twentieth-century painters to make them a central feature of his work. In the twenties Chirico himself turned to a more literary and academic style, but so-called metaphysical painting was taken up and developed by the Surrealists.

CHIRICO
The Enigma of Fatality
1914

CHIRICO
Love Song
1914

CHIRICO
Hector and Andromache
1917

CHIRICO
Melancholy of a Beautiful Day
1913

CHIRICO
The Great Metaphysician
1917

MORANDI
Still-life
1918

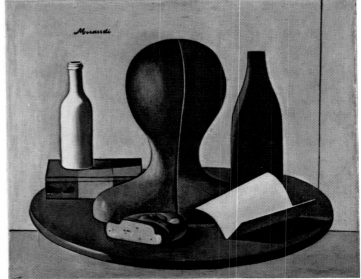

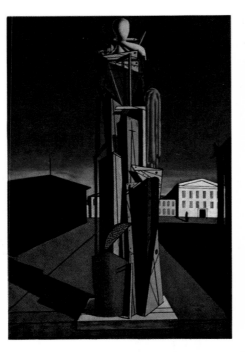

CARRA
Hermaphroditic Idol
1917

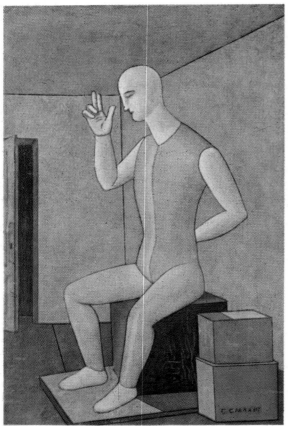

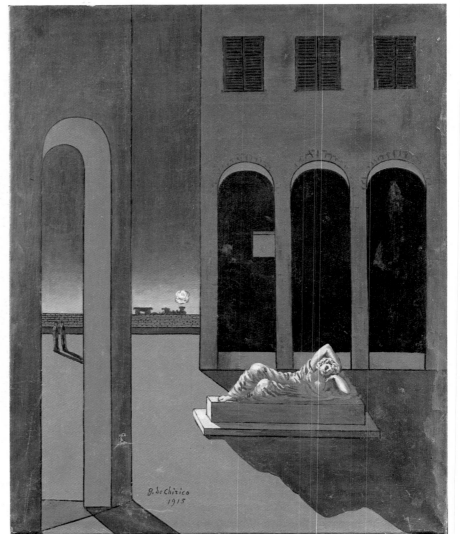

CHIRICO
Melancholy
of an Autumn Afternoon
1915

During the First World War, two other Italian painters, the ex-Futurist Carra and Giorgio Morandi (1890-1964), absorbed many of Chirico's ideas. There is a sense in which Morandi remained a metaphysical painter for the rest of his life. It is true that in 1920-21 he abandoned the very strict and rigid drawing that had reflected the influence of Chirico on his still-lifes after 1918. But in his new manner, he gave the objects softened contours that seemed to fight shy of definition for fear of imprisoning or paralysing their fragile life, and he clothed them in delicate and subtle colour and dreamy, caressing light. His bowls, bottles, carafes, lamps and boxes are mysterious objects, and their strangeness is enhanced by the silent calm of their surroundings.

CARRA
Metaphysical Muse
1917

CHIRICO
The Enigma of the Oracle
1910

Dada and Surrealism

ERNST
The Sap rises
1929

ARP
Painted Wood
1917

The Dada group was not restricted to painters. In Zurich, where the movement acquired its name in 1916, the leading lights were the Rumanian poet Tristan Tzara, the German writers Hugo Ball and Richard Hülsenbeck, the Alsatian painter and sculptor Hans Arp and the Swiss artist Sophie Taeuber. Two painters from France, Marcel Duchamp and Francis Picabia, spread the movement to New York, while in Paris its champions were mainly poets, André Breton, Aragon, Éluard, Soupault and Ribemont-Dessaignes. In Cologne it was represented by Baargeld, Max Ernst and Arp; in Berlin by Baader, Dix, Grosz, Hülsenbeck, Hausmann, Hannah Höch and Heartfield; in Hanover by Kurt Schwitters. Dada developed in different ways in the different centres. In Berlin it became political, elsewhere it was restricted to artistic and cultural spheres. Its principal objective was to attack established values. It proclaimed the uselessness of reason, logic and science, listing their failures. Had they prevented war? Had they not, on the contrary, prolonged it and added to its horrors? Dada also attacked the bourgeois concept of art, either to replace it with a new concept based on the creative power of chance and the irrational, or to destroy the whole notion of art altogether. The latter position was held notably by Marcel Duchamp (1887-1968). He wanted to demonstrate that any ready-made object could be considered as a work of art. He therefore bought a urinal, signed it with the name of R. Mutt, a manufacturer of sanitary ware in New York, entitled it *Fountain* and sent it to an exhibition of the Society of Independent Artists in New York in 1917. In the same spirit he drew a moustache on a reproduction of the *Mona Lisa* and exhibited it in Paris in 1920 with the obscene caption LHOOQ. Picabia (1879-1953), who is close to Duchamp, painted or drew "ironic machines", absurd but precise mechanisms such as *A Compressed Air Brake* or *Machine for Cracking Peach Stones*. Both these artists were capable of producing fine paintings, but obviously creative activity of that

kind was no longer what concerned them; they wanted to show that they rejected the ideas and idols of contemporary society, whether by mocking technology, or sending up its products, or making an absurdity of the kind of art admired by a blind public merely because it was in a famous museum. They were anti-art, in other words. Duchamp himself virtually abandoned painting, while Picabia used his pictures as a vehicle for his provocative wit.

The opposite position is well illustrated by Arp: "We looked for an elementary art, which we thought would save people from the terrible madness of these times. We aspired to a new order which was capable of re-establishing the equilibrium between heaven and hell." He produced a variety of collages and reliefs, intending to expand the nature of art, not to deny it. Other works that are of interest as artistic creations were produced by Sophie Taeuber, Max Ernst, Hannah Höch, Raoul Hausmann, Dix, Grosz and Heartfield.

The Dadaists were fond of collage, and those of Schwitters (1887-1948) are particularly fine. Using bits of paper, string, wood and metal, feathers, etc., this very individual artist created non-figurative compositions that show a great deal of sensitivity as well as disciplined originality. He never in the least doubted the value of art and continued his experiments until long after Dada was dead.

It was in Paris in about 1922 that Dada was overtaken by a new movement which refused to adopt the purely negative stance of the old one. After a term

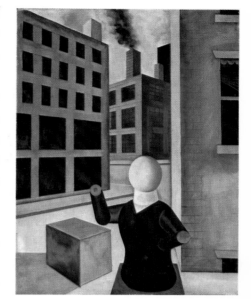

GROSZ
Without Title
1920

PICABIA
Amorous
Parade
1917

DUCHAMP
Chocolate
Grinder
1913

SCHWITTERS
Construction Merz 25 A
1920

HAUSMANN
Abstract Idea
1918

ERNST
The Pleiads
1920

DUCHAMP
Why not sneeze
1921

148

used by Guillaume Apollinaire, it was dubbed Surrealism. Once again there were poets as well as painters and sculptors, and it was the poets who gave the movement its direction. Like Dada, Surrealism put its faith in the irrational, but its purpose in so doing was quite different. Following Freud, it aimed to make a systematic exploration of the subconscious and so to shed a revealing light on the hidden depths of the mind. It was therefore interested less in the creation of works of art than in giving birth to documents of psychological significance. As André Breton explains in the *Surrealist Manifesto* of 1924, it favoured "pure automatic writing", "the dictation of thought without any rational control, and free of all aesthetic or moral considerations". Advice better suited to writers than painters —it is quicker to put down on paper the words that pour into one's head than it is to commit to canvas the images that spring into mind. The fact remains that, like the Symbolists with whom they have affinities, the Surrealists were concerned with images. Some indeed demonstrated that they were preoccupied with more important questions than form and colour, by making use of a highly academic realism.

Realistic in detail some of these images may be, but they are not realistic in themselves. Like images in dreams, they reveal the obsessions and complexes of the subconscious. With a kind of persistance of their own they make us face up to the unexpected, the unknown, the monstrous, everything that is disturbing and mysterious.

Surrealism began in Paris, and Paris continued to be its principal centre of activity, but the painters who made the greatest contribution to the movement were not in fact of French origin. Max Ernst came from Germany, Miró and Dali were Spanish, and Magritte and Delvaux were Belgian. Magritte spent no more than a few years in France, while Delvaux worked exclusively in his own country.

Max Ernst (1891-1975) was a Surrealist even before he went to Paris in 1922. His dense, complex painting was the product of a powerful and fertile imagination. In some of the paintings from the early twenties there are realistic passages that reflect the influence of Chirico. Later the style became more modern until, after the Second World War, Ernst was able to draw on his early experiments with form (in the years 1911-20), and bring together what he had learned from Cubism with his experience of abstract painting. Yet the mood of his pictures remained Surrealist, even then, and the fantastic continued to dominate in many of his works. The only realities are those of the imagination and of dreams.

Ernst was by no means exclusively a painter of wonderful visions. In the period 1927 to 1945 in particular, his work is filled with monstrous creatures, cowering in fear or cruelly threatening; the vegetation is either luxuriant and suffocating, or shrivelled and dead. There are a number of paintings of petrified and deserted cities, empty of any life, human or otherwise; sometimes the deso-

ARP
The Man
with three Navels
1920

PICABIA
Optophone
1921

lation of the scene is heightened by the presence of a huge round moon in a cloudless sky.

The compositions of Max Ernst derive their poetry from the operations of the subconscious. In Dali (born 1904), the irrational gives birth to a sort of provocative madness. He has the dexterity of a magician, and his style is an audacious manipulation of elements of traditional technique. His work contains references to Böcklin and Meissonier and is executed in garishly intense colour.

ERNST
The Pink Bird
1956

ERNST
Girls with a Monkey
1927

ERNST
Woman, Old Man, and Flower
1923-24

ERNST
Anti-Pope
detail
1942

ERNST
Echo, the Nymph
1936

ERNST
Petrified City
1937

His subjects are soft watches, which hang limply like dough, half-putrefied human beings and horses, visions inspired by his fantasies and phobias, by eroticism and fear of death. He also painted a series of variations on Millet's *Angelus* in which the figures take on the appearance of ruined buildings; their significance, which he explains in his writings, is entirely personal. He was particularly fond of setting his scenes or objects in landscapes lit by a reddish evening light that casts long dark shadows, making the space between the forms seem intolerably and frighteningly blank.

Shadows and empty spaces play an equally important role in the work of Yves Tanguy (1900-55), but he had none of Dali's theatricality and exhibitionism. His art reflects a private world. A nostalgic light plays over landscapes

DALI
Basket of Bread
1926

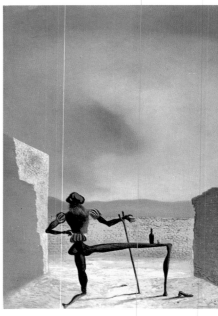

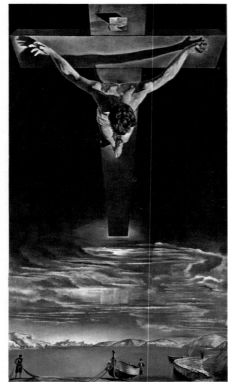

that are bare of life except for weird shapes of bone, arranged together or distributed in a manner that makes their very presence seem a sad absurdity. The subtlety of the colours and the delicacy of the handling show that his work is anything but "automatic writing," and is on the contrary very carefully planned and executed.

The paintings of Magritte (1898-1967) are contrived with equal care. The

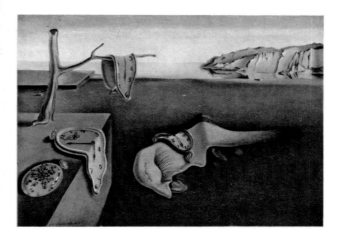

various elements are represented with a coldly meticulous accuracy, but they are placed in such strange contexts that the overall effect is disconcerting in the extreme. The titles which the artist gives to these apparently arbitrary settings or groups of objects do little to explain their significance, and in fact are a riddle in themselves. There is one painting which shows a calm sea under a blue sky, against which Magritte juxtaposes the disproportionately large grey shapes of a woman's torso, a tuba and a cane-bottomed chair. The title is *Threatening Weather* (1929). Or again, there is another picture of a cloudy sky, against which is set the head and shoulders of a man in a bowler hat, his face partly hidden by a freshly picked apple. The title is *The Great War* (1964). The effect is strange and bewildering. In Magritte's work even familiar objects fail to provide reassurance.

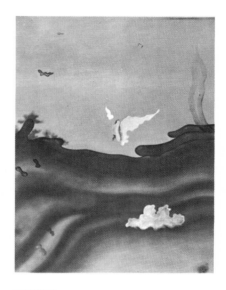

TANGUY
Hope, Four o'clock in the Summer
1929

TANGUY
Infinite Divisibility
1942

MAGRITTE
Human Condition
1935

MAGRITTE
The Great Family
1947

MAGRITT
Memo
19

MAGRITTE
Steps of Summer
1937

156

MAGRITTE
Philosophy in the Boudoir
1947

Delvaux (born 1897) is less stark than Magritte, but his figures seem terribly remote, as though they exist in a world where no communication is possible. They are usually young women, either nude or semi-clothed or formally attired in long dresses. They seem to be sunk in a solitude from which they will never emerge, and their dark eyes are filled with incurable sadness. It is as though their beautiful but bloodless bodies will never know the ecstasies of love. For them it can be no more than a nostalgic memory, exiled as they are in a universe where everything is foreign to them, whether a Greek temple or the Brussels tramway, the suburban street or the old-fashioned salon where they listen impassively to the conversations of dreary pedants.

DELVAUX
Iphigenia

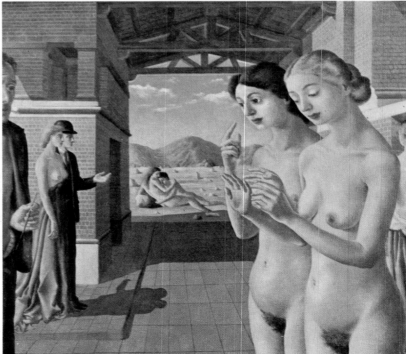

DELVAUX
Hands (Dream)
1941

DELVAUX
Iron Age
1951

BELLMER
Drawing
1965

BELLMER
Balls and Joints
1936

159

MASSON
Brought in by the Storm
1938

It was not until 1934 that Delvaux joined the Surrealists, as a direct result of seeing a particular painting by Chirico. André Masson (born 1896) was part of Breton's original group in 1924. Like Miró or Klee, (who took part in the first Surrealist exhibition held in Paris in 1925), he never lost sight of artistic criteria while he experimented with new techniques. He was one of the few painters who used automatism to interesting effect, at least for a short period. Initially he produced automatic drawings, which have a velocity of line that flows from the hand in the manner of writing. Venturing further in the direction of spontaneous gestures, in 1927 he experimented with throwing sand onto canvases covered in glue. When he painted in oils he was obliged to work more slowly. His brushwork remained impulsive and had a sharp, wounding quality that accorded with his themes, which suggest fights between cocks or fish, bull-fights, massacres or insects laying waste a garden. Even his eroticism was full of aggression. In his later works Masson's line is still tremendously energetic and, although Breton would not have regarded them as orthodox, his pictures are strongly influenced by the irrational world of the subconscious.

The same is true of other contemporary painters who were once in more or less direct contact with the original Surrealist group —Miró, Brauner, Klee, Labisse and Matta, for example. It is also true of later, so-called "informal" artists such as Michaux, Wols, etc. Surrealism's great contribution is that once again it made the recesses of the unconscious mind a proper subject for painting. Artists such as Hieronymus Bosch, William Blake, Redon and Chagall had plumbed its depths before, but time and time again a blinkered realism had denied or forgotten its existence.

MASSON
Amphora
1925

MASSON
Gradiva
1939

160

Paul Klee

Of all the masters of modern painting, Paul Klee (1879-1940) is the painter whose work is the most restrained. It does not have the immediate appeal of Matisse or the power of Léger, nor Picasso's ability to sweep you away with its passion. At first sight it also seems the least convincing, something of a game, and one might be tempted to dismiss it as empty fantasies or pointless exercises.

With Klee, it is necessary to get right into his work and explore it to its full extent to realize that it is a sort of labyrinth, with a new marvel at every turning. No other contemporary body of work has such diversity, or is so rich in invention. None has greater unity and logic in its development. Although it underwent many transformations it did not have the sudden breaks, the leaps forward and back, that characterized Picasso's progress. Klee seemed to grow more in the manner of a plant than a human being. Nothing appeared forced, it emerged

KLEE
Niesen
1915

KLEE
Landscape with Yellow Birds
1923

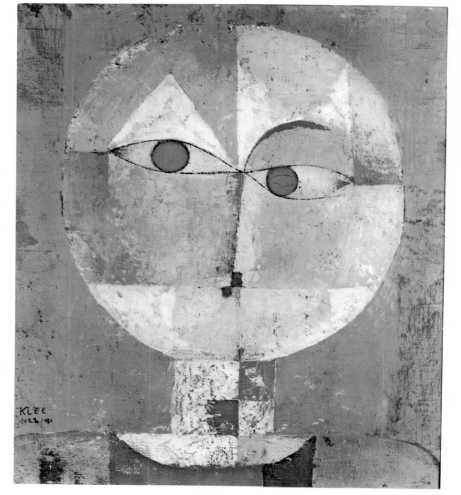

KLEE
Senecio
1922

161

naturally. And yet method and calculation did play an important part in his work.

Although Klee went to Munich in 1898 to study art, it was not until 1914 that he was convinced he was a real painter. Hasty decisions were not in his nature, he advanced slowly, step by step. He mastered line and tone values before he went on to tackle colour. It was only during a trip he made with

KLEE
Head in Blue Tones
1933

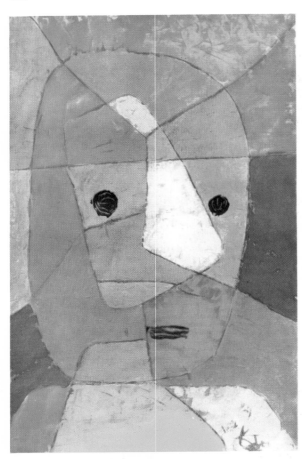

KLEE
Town Decked with Flags
1927

KLEE
Individualised
Altimetry
1930

162

Macke to Tunisia, shortly before the outbreak of the 1914-18 War, that he convinced himself he had a genuine feeling for colour, and was truly launched on his career as an artist.

"Nature," he once said, "is someone else's art, which we should look on as an example that can help us to create something similar with the means available to us in the plastic art." Put another way, he studied nature, not to reproduce its appearance, but in order to understand its laws. In this way he acquired an intimate knowledge of natural life, which he was able to evoke in his work even through shapes that bore no relation to its reality, in other words, in totally abstract painting. He rarely started with a precise motif or idea for a painting. The idea and even the title grew out of the painting, not the other way round. Klee was interested primarily in pictorial composition. When he became a professor at the Bauhaus in Weimar, he made a comprehensive study of the mediums and techniques available to the artist, and his teaching methods were systematic. Nevertheless, his painting never lost its "naïve" and inspired quality as, despite the importance he attached to calculation, he never forgot that "nothing can replace intuition."

He was always particularly careful to keep his technique of elementary purity (hence the "childish" quality of some of his work) but he wanted it to be able

163

KLEE
Old City and Bridge
1928

KLEE
Sailor
1940

to express complex things and to be capable of great subtlety. Hence, his drawing is as varied as his colours. Sometimes the line is thin, rapid and airy, sometimes overstretched and almost feeble, sometimes broad, firm and slow. The tones may be muted and delicately graded, or applied in flat, clear blocks of colour. The touch is thoughtful and deliberate: it can be demonstrative or discreet, even be replaced altogether by the anonymous technique of spray painting. In some works it is the planes of the composition that are emphasized, in others it is the sense of depth, and that too can be suggested in different ways — Klee either creates space with a linear perspective that can be explored by the eye, or he can open up before us a vast unfathomable abyss. But whatever style he uses his work is unmistakable, distinguished always by its subtle blend of imagination and discipline, firmness and grace, by the combination of his poetic inclinations, his love of symbols and his unwavering determination to create an aesthetically satisfying whole.

After 1930 he began to use much larger formats (his canvases had in general been very small up till then) and to include fewer, though more powerful, elements in the composition. His drawing tended towards hieroglyphs, and his colours were more vibrant. Occasionally there was a sense of unease, that was also apparent in his drawings —presumably the effect of the illness which undermined his health for the five years before he died. But in general Klee's world was a world of kindness, affection and harmony. There was a place in it for humour and gentle amusement but not for sarcasm (which had been an element in his engravings of 1903-1905). There was melancholy and fear, but not violence or cruelty or real anguish.

164

KLEE
Death and Fire
1940

KLEE
With the two lost Ones
1938

Joan Miró

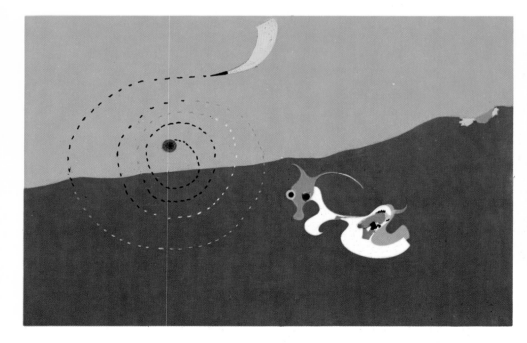

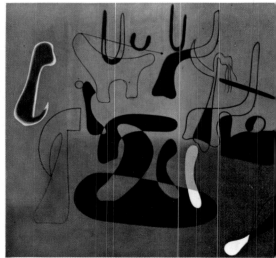

There is no sense of dislocation in turning from Klee to Joan Miró (born 1893); both inhabit a primitive world. Klee goes back to the primitive state of childhood, while Miró—with a relish that is not without humour—enters into the world of prehistoric man. He belongs in spirit with those artists who used to paint on the rocks and pebbles. His sense of fun was already apparent in about 1923-1924, when he reduced every object to a simplified figure, almost a sign, which managed to make a sly comment on the object at the same time as it recorded it. But it was only when he met the Surrealists in Paris in 1924 that he received the stimulus he needed to develop his own style, so spontaneous, carefree and expressive, rooted in the colours and invented shapes that are the distinctive constituents of contemporary painting.

Not without a touch of malice, he drew from his inexhaustible imagination rudimentary and grotesque little figures of men. Their faces bewildered, greedy, vacant or sometimes cruel, they are frequently surrounded by all kinds of strange birds and stylized figures of the sun, moon and stars. In some ways reminiscent of prehistoric idols, like the mother-goddesses of Neolithic times, they are nevertheless ordinary mortals. The humour that helped to create them is their dominant feature. Miró's primitivism is essentially a modern phenomenon, belonging to an era and a civilization governed by the advancement of science and knowledge. It is a form of escape rather than a natural state.

MIRO
Nocturnal Bird
1939

MIRO
Hare
1927

MIRO
Composition
1933

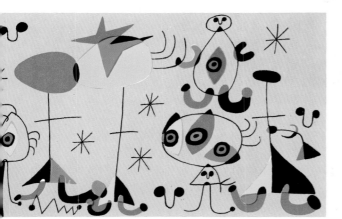

MIRO
Snob Party at the Princess'
1944

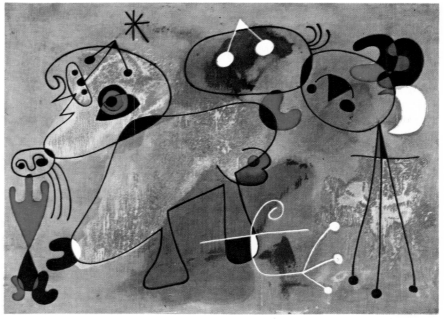

MIRO
Green Background
1949

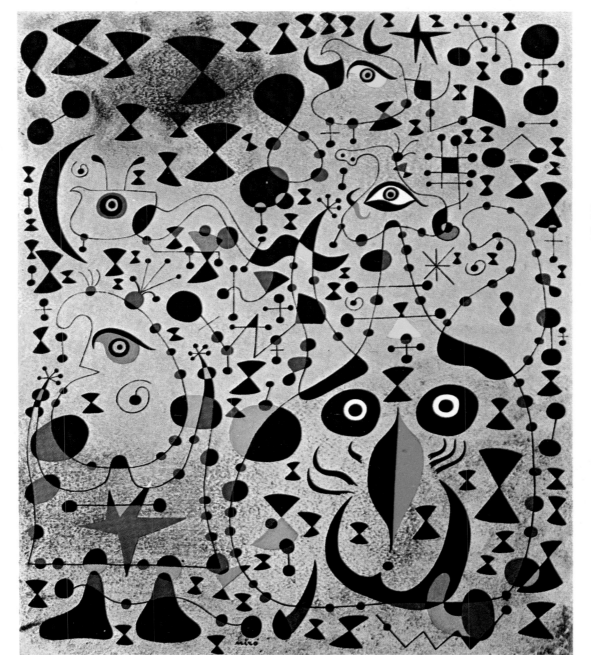

MIRO
The Beautiful Bird explaining
the Unknown to the Loving Couple
1941

167

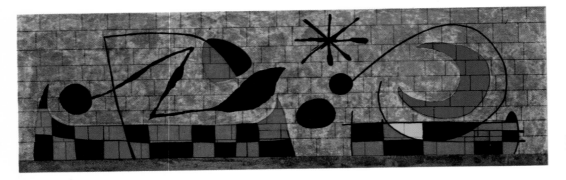

MIRO
The Mauve of the Moon
1951

MIRO
Woman before an Eclipse
1967

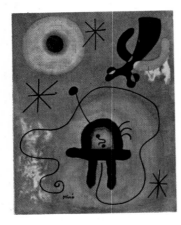

MIRO
Sketch for the Wall of the Moon
1958

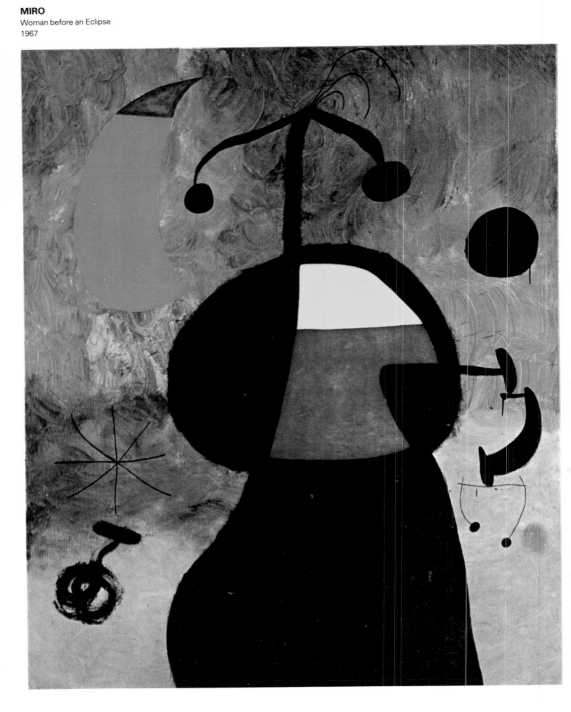

Naive Painting

Henri Rousseau

For Klee and Miró, naïveté was something that had to be rediscovered, but there are other contemporary painters for whom it was something they had never lost, never having received any sort of formal instruction in art. They were not part of the search for a new idiom and do not really belong in the mainstream of modern art. That they have certain affinities with it is, however, undeniable. Their "popular realism" marked just as much of a break with the "optic realism" of tradition as did the deliberate innovations of their contemporaries. And certainly their fresh and fervently observed images are far more moving and satisfying than those of academic painting. It is perhaps not surprising that the greatest of the naïve painters, Henri Rousseau (1844–1910), owed his reputation precisely to the champions and defenders of Cubism.

ROUSSEAU
Self Portrait
1899

ROUSSEAU
Portrait of Pierre Loti
1891

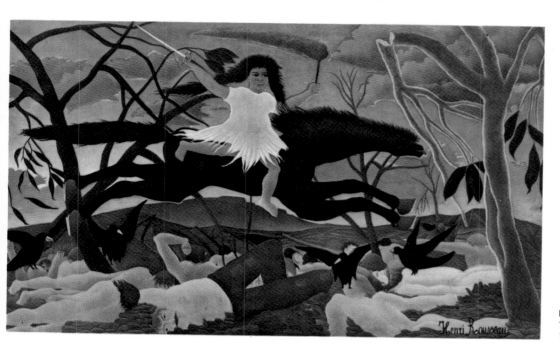

ROUSSEAU
The War
1894

169

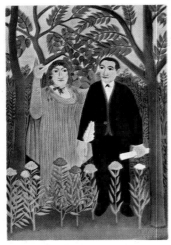

This legendary figure was in many ways a strange and disconcerting character, who remains something of an enigma in spite of all that has been written about him. He was dubbed Le Douanier (the customs officer), although in fact he worked for the Paris city toll. He has been described as a Sunday painter, although he retired at forty to devote himself entirely to painting. Biographical facts have been produced, supposedly showing that he was naïve to the point of absurdity in his life, yet the paintings he created are solidly constructed and magnificently painted, and bear comparison with any of the contemporary masterpieces.

It is true that it is the quality of innocence that one notices first in his work. Yet, surprisingly, his sketches are less ingenuous in manner than his finished canvases. It is possible that his naïveté is more a matter of style than vision. In other words, that it is at least in part, a function of his handling of the definitive versions of his pictures: the clean, highly differentiated forms that he gave to objects, so that each had its own clear identity; and the glossy finish that he particularly favoured. At all events, contemporary of the Impressionists though he was, Rousseau was not attracted to the fleeting and incidental qualities of things, he painted things that existed and could be measured, touched and weighed. It has been said that he actually measured the nose and the forehead before painting a portrait. Yet he painted imaginary landscapes as well as real ones. The evidence is that his luxuriant and poetic virgin forests are not in fact the product of a trip to Mexico, as people have liked to suppose, but were composed of elements taken from the Botanical Gardens in Paris. Whatever the truth of the matter, there is a genuine mystery at the heart of his work. And the precise drawing, the monumental forms and

ROUSSEAU
The Snake Charmer
1907

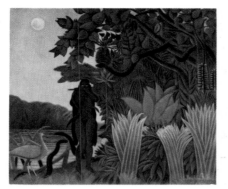

ROUSSEAU
Exotic Landscape
Negro attacked by a Leopard
1907-09

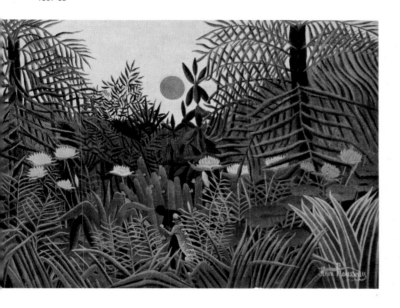

ROUSSEAU
The Footballers
1908

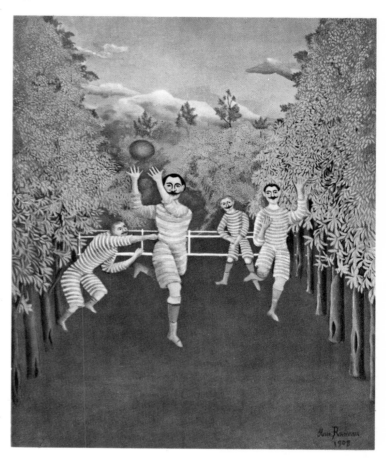

ROUSSEAU
Sleeping Gipsy
1897

171

the crystalline transparency of the atmosphere, instead of dissipating it, make it all the more enthralling.

Without achieving Douanier Rousseau's authority, other contemporary naïve painters present us with visions of a reality so freshly observed that it appears mysterious as well as clearly and obviously itself. Each shows us a quite different world. To give only a few examples: André Bauchant (1873-1958) favoured historical or biblical scenes set in enchanting landscapes; Louis Vivin (1861-1936) painted mainly architectural subjects, constructing each building brick by brick, like a mason; Camille Bombois (1883-1970) chose his subjects from suburban life, and in particular circuses, fairs and buxom women; Séraphine Louis (1864-1934) painted opulent clusters of flowers and fruit picked from some fabulous garden of delights.

Maurice Utrillo

Maurice Utrillo (1883-1955) was not a naïve painter in the sense that Rousseau was, or the others we have discussed. He did not share their wonder at life, nor is his style as simplified or as precise as theirs. He started to paint in 1903, when his mother Suzanne Valadon, herself a painter, encouraged him to take up art as a cure for his drunkenness. His early style was influenced by Pissarro, and later developed into a sort of primitive Impressionism, that is to say, it was Impressionist in manner except that the colours were not broken up and the forms were not blurred. Stylistically he was not an innovator, yet his works of pre-1915 occupy a position in contemporary painting that is unrivalled.

Before Utrillo, no one had viewed the streets of Montmartre with such penetrating melancholy, or painted such a desolate picture of its old walls. He perfectly conveys their rough-cast surfaces, cracking and crumbling and covered in mould and decay. While preserving all their drab ordinariness, the texture of the paint at the same time turns them into something of rare beauty. In addition, Utrillo has a strong sense of composition and orchestrates the masses of the buildings with exquisite poise and balance.

UTRILLO
Le Moulin de la Galette

UTRILLO
Snow on Montmartre
1947

UTRILLO
The Church of Saint-Gervais in Paris
1910

173

The First Abstract Painters

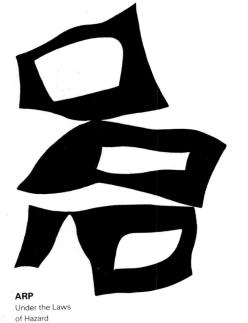

When painting distorts external reality to the point that it is unrecognizable, and when the significance of a picture resides largely in its colours and forms, it might seem logical for painters to sever the last ties with visible reality and opt fairly and squarely for what is known as abstract art. But what seems logical is not always what happens, least of all in painting. In their period of Analytical Cubism, Braque and Picasso came close to making objects disappear altogether, but instead of eliminating them they reconstructed them in different forms. One would not deny that their art lives. Other artists, it is true, have followed the dictates of logic. But not without hesitation, nor, it would sometimes appear, without regrets.

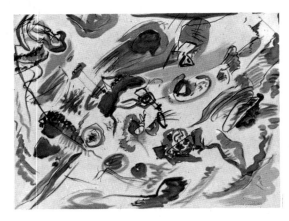

KANDINSKY
First Abstract Composition
1910

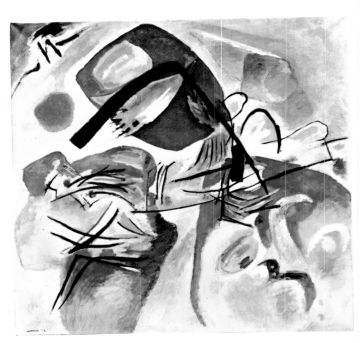

KANDINSKY
With the Black Arc
1912

Wassily Kandinsky

Kandinsky (1866-1944) painted his first abstract work in 1910, but there are echoes of external reality in his pictures up to 1913. This first abstract painting was in fact a watercolour, really little more than a sketch or a stylistic exercise. The artist himself, in acknowledging that objects were inimical to his painting, confessed that he saw "a terrible abyss" opening up before him. And the "abundant possibilities" that he foresaw were accompanied by all sorts of doubts. What could he put in place of the object? Colours and forms, certainly, but how then to avoid them becoming "ornamental?" "It is only after many years of work," he said, "that I am able to paint as I do today."

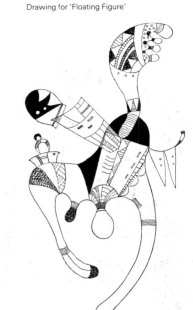

KANDINSKY
Drawing for 'Floating Figure'

KANDINSKY
White Line
1920

KANDINSKY
Black Spot II
1921

It is certainly true that in 1913, when he made that statement, his forms were anything but ornamental. Big, dashing strokes rip across the surfaces, scrawled lines describe jerky twists and turns, vivid colours explode and clash with such abandon that they nearly tear the picture apart. It is like a volcano erupting or a loud and strident piece of music. Indeed Kandinsky confessed a debt to Wagner, whose *Lohengrin* showed him "an unsuspected power" in art. He also apparently considered at that time that "painting is a thunderous

175

KANDINSKY
Inflexible
1929

KANDINSKY
Shrill-Peaceful Pink

collision of different worlds" and that "a work of art comes into being in the same way as the cosmos, through a series of cataclysms which finally, out of the chaotic roar of the instruments, form a symphony called the music of the spheres." It is significant that Kandinsky talks of the cosmos and the music of the spheres. He saw himself as expressing in his works, not only human feelings, but the "secret soul" of the whole of creation. In giving up figurative art his intention was not to turn away from nature but to achieve an even closer union.

KANDINSKY
Looking into the Past
1924

KANDINSKY
On White
1923

KANDINSKY
Accent in Pink
1926

KANDINSKY
Careful Move
1944

After the 1914-1918 War, which took him back to Russia, his painting lost its explosive character. The forms became geometrical and the composition was simplified. This tendency became even more marked in 1922, when Kandinsky was asked to teach at the Bauhaus in Weimar, where planned and careful construction was very much the order of the day. Yet, even though the dramatic tumult had gone from his works, they were still dynamic, even those that were light and gay in spirit, or verging on the decorative. The surface was often animated by bursts of rapid movement, and the forms floated in undefined blank areas like interstellar or microscopic space. The colours were of a sumptuosity that bordered on excess, a legacy of Kandinsky's Eastern origins, even though he spent most of his life as an artist in the West, first in Germany, and after 1933 in France.

177

The other pioneers of abstract art emerged at about the same time as Kandinsky. The first non-figurative works by the Czech artist, Frank Kupka, date from 1910-1911 and were executed in Paris. Shortly after that, Delaunay painted his first *Circular Forms,* the Dutch painter Piet Mondrian began his variations on the theme *Trees,* and Picabia created his *Procession in Seville* and also the two large, rhythmic compositions that he called *Udnie* and *Edtaonisl.* In around 1910, abstract art also made its appearance in Moscow, with the paintings of Larionov and Gontcharova, and in 1915 Kasimir Malevich exhibited his famous black square on a white ground. The new ideas found their champions too among Italian artists, and gave Balla and Severini the impetus to paint some of the most convincing examples of Futurist art. Others followed, such as Magnelli in Florence, Pettoruti, and the future Dadaist Hans Arp. Pioneers these painters certainly were, but not all are of equal importance. For some, abstract painting was no more than a short-lived experiment, and indeed it was not until much later that it attracted serious practitioners in any large number.

Delaunay himself moved away from abstract works for a period of some years. Yet his contribution was among the finest. Even in his figurative compositions, like *Simultaneous Windows,* colour is "both form and subject," and he claimed that he expressed himself through colour "as one might express oneself in music, in a fugue of coloured phrases."

Kupka (1871-1957) also used the term fugue in connection with his work. In around 1912 he painted a *Fugue in Two Colours,* followed by *Solo of a*

GONTCHAROVA
Electricity
1911

LARIONOV
Rayonnism
1911

ARP
Static Composition
1915

MAGNELLI
Painting 0530
1915

PICABIA
Udnie or the Dance
1913

179

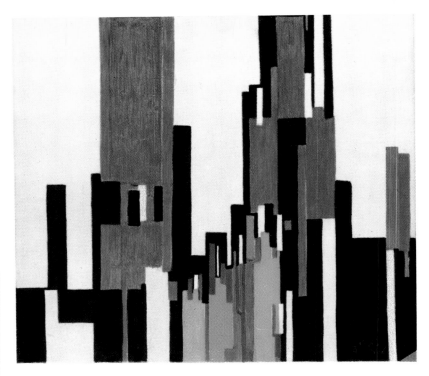

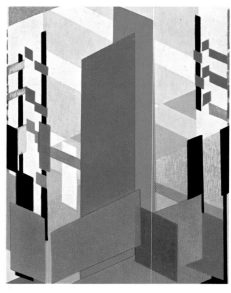

Brown Line. He also painted architectural compositions, experimenting with a variety of approaches. Sometimes he suggests space simply by juxtaposing bands of colour; at other times, planes overlap and intersect to form invented constructions, either flooded by full light, or with light passing mysteriously through. Elsewhere, curved and pointed shapes come towards us in waves, as though they are coming out of the depths of space and time. And there are pictures that are like a profusion of flowers, intense and exuberant. But the lyricism is always kept within bounds. Indeed in some works it is so sternly repressed that the result is cold and mechanical.

The aim of Malevich (1878-1935), the inventor of Suprematism, was to establish in art "the supremacy of pure sensibility," while using only simple, two-dimensional geometric figures. On the face of it, it seems unlikely that he could achieve this with his selection of squares and rectangles, trapeziums and circles, straight lines and curves. Yet he gives them a particular colour, arranges them in a particular order, and they do acquire "sensibility"; dialogues, tensions, rivalries, even plots are set up. The theory is not quite as strange as it at first appears. It is, after all, a well-established fact that the strict geometrical forms of architecture can produce an emotional response.

Before he founded Suprematism, Malevich painted for a period in a style influenced by Léger.

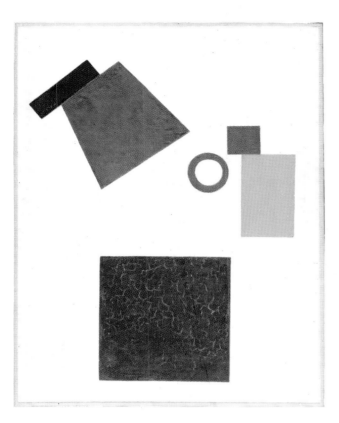

MALEVITCH
Suprematist Composition
1914-16

MALEVITCH
Suprematist Composition
1915

MALEVITCH
Suprematist Composition
1915-16

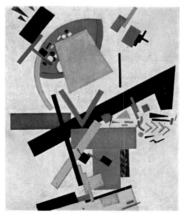

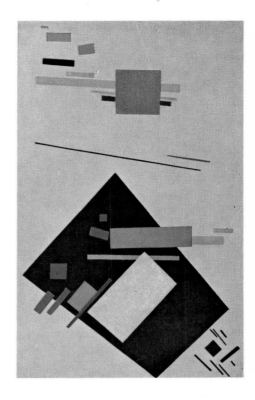

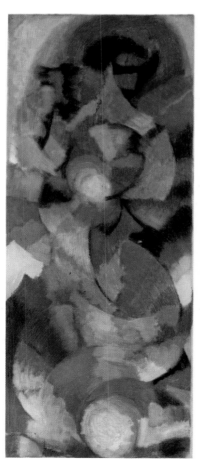

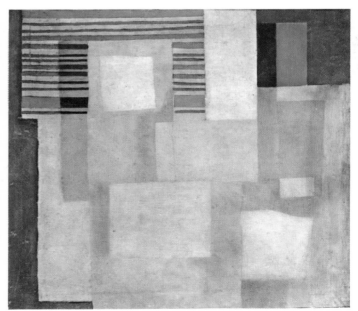

NICHOLSON
Painting (Trout)
1924

MACDONALD WRIGHT
Synchromy
1916

181

Piet Mondrian

Mondrian (1872-1944) went to Paris in 1911, and for a short time was influenced by the Cubism of Braque and Picasso. He moved away from them because he felt the need to carry Cubism to its "logical conclusions," as they had not. All he retained of the object at that stage was a number of indications provided by lines and rhythms, which he disposed on the canvas with the sole objective of creating an autonomous composition. He returned to Holland in 1914, and three years later abondoned all natural forms. He tried to "denaturalize" his art altogether. His published texts, notably in the magazine *De Stijl* which he founded in 1917 with Theo van Doesburg, explain the reasons

MONDRIAN
Composition in Grey, Blue and Pink
1913

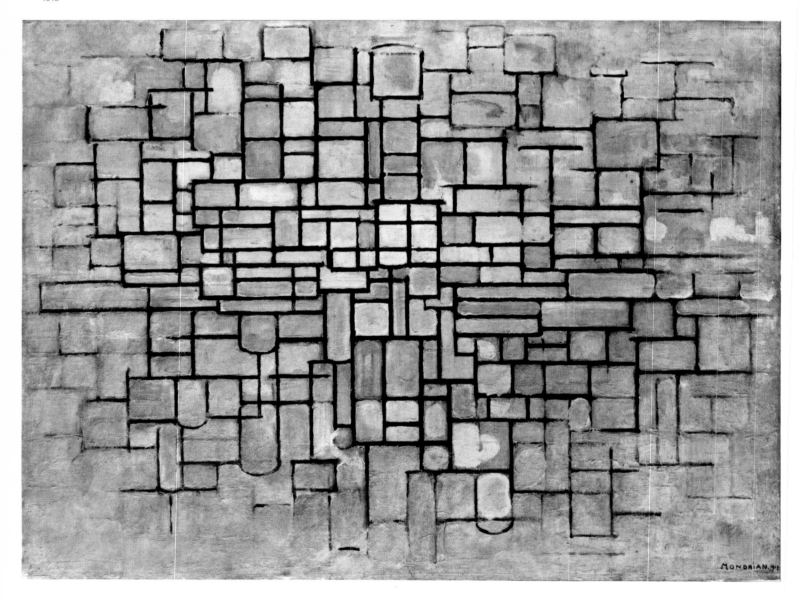

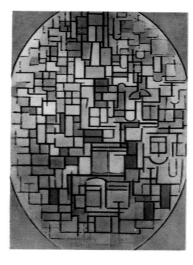

MONDRIAN
Ovale composition
1914

MONDRIAN
Composition III with Colour Planes
1917

MONDRIAN
Composition in Grey Blue
ca 1912

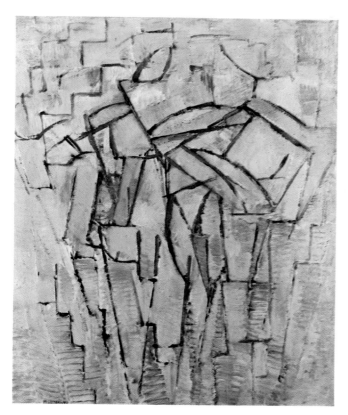

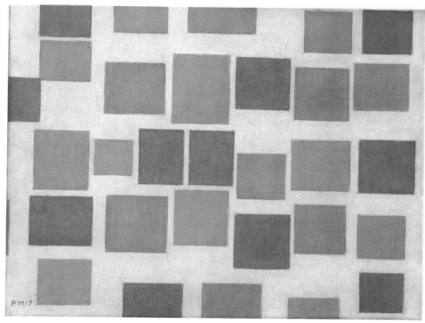

behind this move. For him, pure and unalterable reality lay behind the changing forms of nature; only the relationships of "pure plastic art" were capable of giving expression to this reality. In 1921 he painted in Paris the first picture to embody his new ideas in every respect. It served as a kind of prototype, providing the formula on which all his later works were based.

There was no place in painting of this kind for what we call form. According to the rules of Neo-Plasticism, all that could be shown on the canvas were areas defined by vertical and horizontal lines. Colours were restricted to red, yellow and blue, together with white, black and grey. The three primary colours could not be mixed. They did not all have to appear in any one canvas, and a picture might consist of nothing more than a white surface divided by two

MONDRIAN
Composition in Red, Yellow and Blue
1926

or three lines. The lines were always black, until 1924, when they were coloured. Such was the nature of the discipline Mondrian felt obliged to impose on himself. That it was a discipline there is no doubt. Mondrian's works of 1911-1914 make it abundantly clear that it was not at all because he lacked feeling that he embarked on the restricted path of Neo-Plasticism. It was rather because his puritan streak made him dislike romantic outpourings, and because he wanted to go beyond individuality and the contingent to achieve universality and perfect balance. Yet, however satisfyingly he established a relationship between the various elements he uses, it is difficult not to regret occasionally all that he sacrificed in so doing. There is a certain monotony to his work, even though his experience of New York near the end of his life led him to introduce a dregree of dynamism into his *Boogie-Woogie* series, a frivolity that would previously have been excluded from the rigid angularity of his style. Mondrian represents an extreme. At the other extreme is the lyrical painting of Kandinsky in the years 1910-1920. It is between these two extremes that abstract painting has developed.

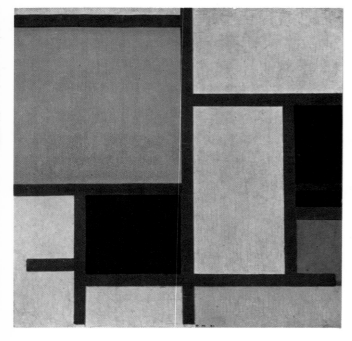

MONDRIAN
Composition
1921

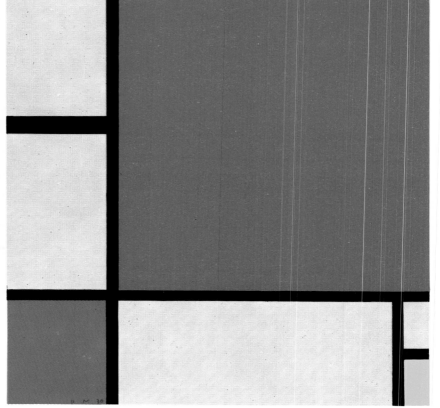

MONDRIAN
Composition in Red, Blue and Yellow
1930

184

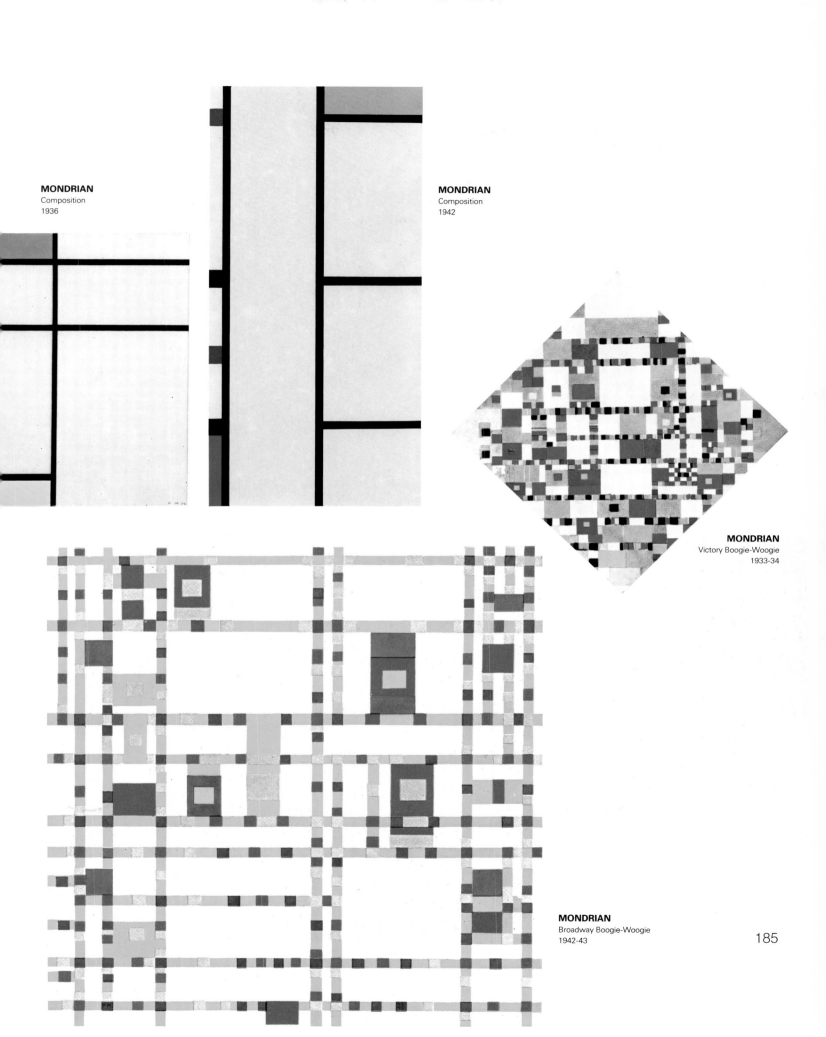

MONDRIAN
Composition
1936

MONDRIAN
Composition
1942

MONDRIAN
Victory Boogie-Woogie
1933-34

MONDRIAN
Broadway Boogie-Woogie
1942-43

185

SCHNEIDER
Painting 42 E
1960

STAËL
Jazz Musicians
1953

POLIAKOFF
Painting
1951

since 1945

France and Europe 1945 to 1960

It is high time to do away with a particularly deep-rooted prejudice. Paris in the post-war years was not the artistic desert it has been made out to be. Yet, and it is a paradox, the sheer proliferation of styles then current, the rapid succession of ephemeral movements of the avant-garde, were in reality the symptoms of a fundamental creative exhaustion, an inability to start again and create new and original art forms. Paris remained the place to which one went to establish or make a reputation, but it gradually became apparent that the real innovations were being made elsewhere, in other European countries (Cobra in the north, and 'informal art' in Spain and Italy), and also of course in the United States, whose economic hegemony and freedom from cultural inhibitions proved to be decisive by the early sixties. Up to that point Paris retained some of its former influence as the traditional breeding-ground for new talents, but quite abruptly that reputation was lost. This sudden decline cannot simply be ascribed to the geographical and practical difficulties of retaining its position as the 'artistic capital of the world'; it was also brought about by a lingering nostalgia on the part of the artists themselves, generally committed to the perpetuation of an intellectual and formal tradition; inadequate and barren confronted to a new set of artistic priorities. The loyalty of these artists to pre-war concepts may in itself have been admirable, but in neglecting to address the fundamental question—how to re-invent the means of their expression in art—they showed a total lack of awareness and a suicidal introversion.

Abstraction had become the dominant mode. Figurative painting was in retreat and, despite the still authoritative voice of Breton, even the experiments of Surrealism were relegated to the second rank—or one particular aspect was singled out, such as the liberating technique of automatic drawing, which was taken up by the partisans of 'hot' abstraction because it accorded well with their expressive, gestural style of painting which was largely prevailing.

HERBIN
Vein
1953

Still other painters looked back to the rigour of Mondrian's Neo-Plasticism and to elements of the Russian avant-garde. Their experiments with 'concrete art' and analytical abstraction rapidly led up to the decorative solutions of Up Art and Kinetic Art. The group dominated by Herbin and Seuphor, who exhibited annually at the Salon des Réalités Nouvelles, split further into two trends: the one following the 'constructivist' path, joined by the South Americans, Soto, Cruz-Diez, Le Parc, Tomasello, and the Co-Mo group as a whole; the other, typified by Agam and Vasarely, exploring polychromatic effects.

The term 'lyrical abstraction' is used to describe a whole variety of artistic procedures, which have in common an allegiance to the theories of Kandinsky and his 'inner sense of form', and a desire to move away from the representation of a contingent reality, to lay stress on the resonance of gesture, drawing and even materials, and so to express the subjective and emotional reality of the artist. The most orthodox of the French exponents of this particular form of abstraction tried to unite Expressionist freedom with compositional discipline, within an essentially classical conception of pictorial space. Artists such as Bazaine, Manessier, Bissière, Schneider, Hartung and Soulages thus arrived at a distinctive synthesis—an initial linear organization of space as a basic framework, overlaid by a more spontaneous, gestural treatment of the coloured surface.

BISSIERE
Composition
1952

188

VASARELY
Vonal
1966

This equilibrium of coloured masses is perhaps seen at its best in the work of Poliakoff and De Stael. The former attains perfect elegance in his handling of broad flat areas of pigment painted either in monochrome or in complementary tones of colour, the patterns suggesting an elaborate type of marquetry. The latter, who never entirely abandoned figurative painting, dissolved and stylized forms in planes of heavy impasto applied with a knife. In much the same vein of semi-figurative painting is Vieira Da Silva, whose linear complexes can be read as references to urban views and perspectives.

Called 'Art autre' by Michel Tapié and otherwise known as 'art informel' or art without form, the matter painting of Wols and Fautrier, and later Tàpies, Burri and Saura, is among the most interesting developments of this period. It took painting in a genuinely new direction. Extending the expressive powers of the pigment or matter, the canvas is occupied by areas of thick impasto, mixtures of paint and sand which, in Fautrier's work, give a tactile, earthy, organic effect. The informal abstraction of Wols derives its

power from a distinctive blend of calligraphy with a systematic use of a heterogeneous variety of materials; the spirit of the Surrealist collage predominates, but the paintings are above all remarkable for the freedom and delicacy with which the picture surface is handled. Perhaps one should also mention in this context the bravura calligraphic displays of Mathieu, conditioned by the rapidity of their execution, and the expressive ideograms of Michaux. Both are representative of the 'informal' artists' desire to express the outpourings of the subconscious in a modern form.

In 1948 the Cobra group was founded in Amsterdam (Cobra: Copenhagen, Brussels, Amsterdam). The original members were Karel Appel, Asger Jorn and Corneille, later joined by Alechinsky, Constant, Heerup, Dotremont and others. Rallying to the battle-cry 'Colour is like a shout,' the Cobra artists pursued the Expressionist traditions of northern Europe, while contributing a determined iconoclasm and dionysiac emphasis of their own. Their painting relies heavily on the use of bright colours, and is characterized by its sheer exuberance, the so-called 'vital force', by its bold deformations of human figures and a devastating love of excess. The Cobra painters did not bother themselves with academic arguments over the relative merits of abstraction or figuration, rather their work demonstrates that in Expressionist-style painting it is energy and drive that are all-important. One can, up to a point, link the flowing curves and more restrained palette of Bram Van Velde with this same desire to depict an internal rhythm, to allow a sort of omnipresent pantheism to express itself—although it must be said that his work is far more sedate and shows more attention to composition.

TAPIES
Gouache

SOULAGES
Painting
1953

FONTANA
Concetto spaziale
1960

FAUTRIER
Sweet Woman
1946

BURRI
Sacco and bianco
1953

WOLS
The wing of the butterfly
1947

191

But it was with Tàpies and Burri that painting finally transcended the traditional processes of oil-painting. Tàpies was the first European painter to negate the illusionist perspective of the picture space. Breaking away from his earlier phantasmagoric, surreal imagery, which he had begun to treat with considerable freedom and increasing abstraction, Tàpies evolved an entirely new vocabulary for painting, coating his canvases with powders of ground marble, mostly in dead colours, and marking them with bold incised lines. After the almost obligatory monochrome period (where again he showed scant respect for the conventions of painting—but which enabled him to neutralize his picture surface), he began to introduce a dense profusion of graphic signs, bearing a clear analogy to the decaying graffiti-covered walls of our modern cities. Tàpies was among the first to conceive the pictorial space as an autonomous entity, having no real centre, no internal organization—simply a surface revealed as its own reality.

FRANCIS
In Lovely Blueness
1955-1957

HARTUNG
Pastel. P.
1960-1966

DEGOTTEX
Aware II
1961

In Italy, Alberto Burri was developing on a parallel course with Tàpies and Millares, although his particular interest was in using materials never previously employed in painting. By making pictures out of worn sackcloth, sheet-metal and scrap-iron, he explored a whole range of new plastic possibilities in art, profoundly influencing the adherents of 'arte povera'.

This elevation of everyday materials, and even junk, to the status of art objects, was taken up and developed theoretically by Dubuffet, who was attracted by notions of alternative or deviant art. Initially a matter painter, he invented the concept of 'art brut', which saw particular virtue in the art of madmen and in untutored children's drawings. By a logical progression Dubuffet himself went on to produce a series of images heavily ironic in tone, consisting of combinations of many different elements, boldly juxtaposed, with colours and forms crudely outlined in heavy contours. This process reached its culmination in the paintings of his Hourloupe period, before he returned again to a more liberal employment of coloured lines.

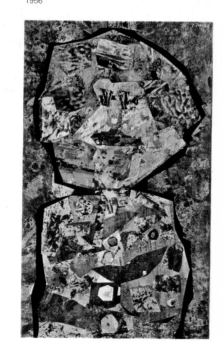

It is largely thanks to Dubuffet that the works of Chaissac have achieved public recognition. Long regarded as unclassifiable, or even as the ravings of a madman, the artistic productions of this solitary individual are like a voracious ingestion of the environment. Chaissac would take the most unlikely items (such as firewood, oil cans, pebbles, doors) and anthopomorphize these, while still respecting their original configuration. The boundaries of perception seem to expand, as distorted figures and grimacing faces loom out, in the travesty of a transformation scene.

The continuation of a figurative tradition owed much to the staying-power of Surrealism, under the vigorous leadership of André Breton. It has to be said

that it proved the only movement capable of surviving the traumas of the war. Even today it is by no means a spent force, diminished only by the catch-all eclecticism of its appeal.

Giacometti was a member of the Surrealist group in the pre-war years, fabricating sculpture-objects; he has since produced the disturbing elongated statues on which his latterday reputation largely rests, and also an imposing series of drawings of powerful melancholy, effectively a life-history of the artist. Brauner has continued his vein of grotesque figures, mounted in profuse off-cuts. Matta and Lam have both evolved an ethnic imagery, painting in a totemic or pagan style with evident erotic connotations.

Balthus remains apart from the main current, both in his indebtedness to academic painting and, above all, in the atmosphere of warped sexuality conjured up in his images. Bacon is the undisputed master of human anguish. The distorted figures in his paintings verge almost on the repulsive and contain a terrible pent-up violence, intensified by the symbolism of their situation.

Finally, there are two sculptors whose work is of continuing importance: Calder and Brancusi. Calder's mobiles are masterpieces of 'anti-sculptural'

CHAISSAC
Composition with a Snake
1951

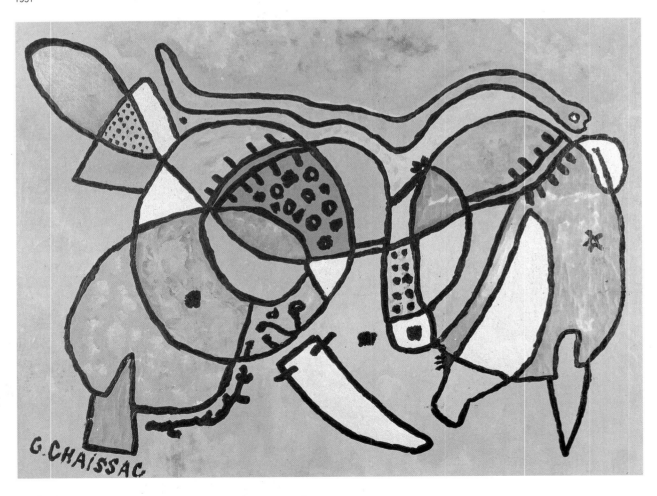

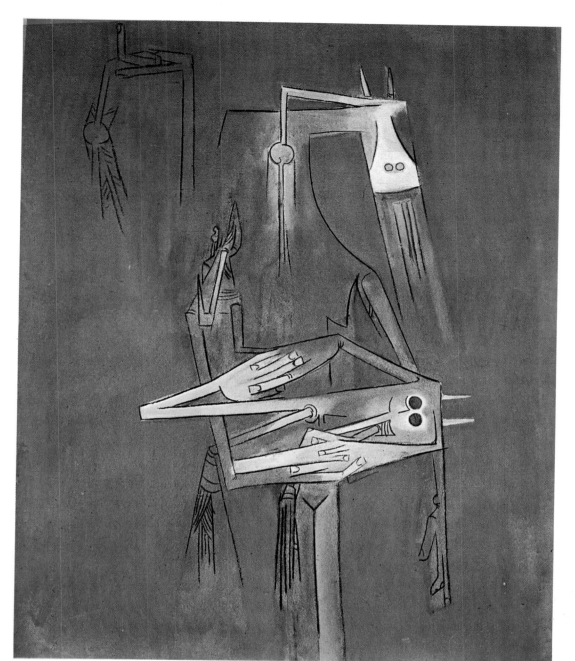

LAM
Motherhood
1965

GIACOMETTI
Woman Standing II
1959-1960

195

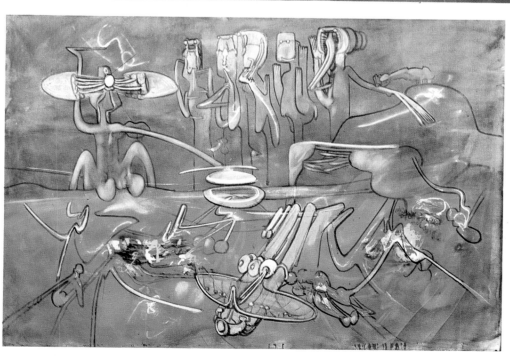

MATTA
Elle Hegramme
to the General Astonishment
1969

BALTHUS
The Turkish Room
1963-1966

BALTHUS
Nude asleep
1973-77

CALDER
Fin

equilibrium, his 'stabiles' of interpenetrating planes demonstrate a sophisticated manipulation of space. Brancusi was more concerned with the relationship between plinth and sculpture, arriving at extraordinary combinations which, in the simplification of their forms, have been enormously influential in the development of sculpture in the United States and elsewhere.

The lure of Paris was still strong for American artists and students, and Kelly, Held, Noland and Olitsky are among those who chose to spend some time in the French capital, taking advantage of the 'G.I. Bills' that authorized ex-soldiers to pursue a higher education. Others such as Francis and Bishop settled in France, attracting a whole colony of expatriate artists, among them the Canadian Riopelle, Joan Mitchell and Shirley Jaffé. Of course, this contact between cultures was a two-way process of mutual benefit, and exhibitions held in Paris and New York bore witness to the way these groups of young painters influenced each other. The first Biennale des Jeunes de Paris was held in 1959—the majority of the exhibitors being abstract painters—, in itself a kind of confirmation of status; also featured were the most recent works of the group later to be known as the New Realists, together with some of Rauschenberg's combine-paintings. If the exhibition appeared at the time to show the triumph of abstraction, with hindsight, its real significance was in signalling the return in force of figurative painting. The Biennale was meant to announce that Paris was still the home of the avant-garde; in fact the initiative had already passed over to the Americans.

BACON
Three Studies for a Crucifixion.
Center Pannel of the Triptych.
1962

United States of America 1945-1960

It would be a truism to say that the American cultural tradition in no way compared with the European. And yet the circumstances were soon created that encouraged the dissemination and conservation, and above all the creation, of a distinctively American art. Since the early years of the century, travel and communications between the continents had become increasingly easy and frequent. At the time of the Second World War a significant number of European artists and theoreticians had emigrated to the United States. And, crucially, the American tax system created the pre-conditions for a soundly based artistic growth. The state demonstrated a commitment to art and artists by setting up the WPA, following the Depression of 1929, its objective being the commissioning of large-scale public works. Most commentators would acknowledge the debt American artists owed to the WPA, and indeed would accept that it had a direct influence on the kind of work they produced—in terms, for example, of monumental proportions and explicit social concerns, if not always expressed in the paintings themselves then in the declared objectives of a majority of the practitioners.

However this sociological interpretation of events is by no means the whole story. It does not in itself explain the specific aesthetic character of the works that emerged at that time, nor does it account for their undoubted and immediate success. The critic Barbara Rose has provided an attractive and widely accepted explanation. She believes that American art in that period was an art of synthesis, and that the great achievement of the American painters was to perform a sort of alchemy of the imagination. (Although in this context it is perhaps not unreasonable to point out that, before the seventies, most American artists and intellectuals were in fact quite recent immigrants.) The 'synthesis' she has in mind is the capacity to retain and use only the most relevant elements of past experience, free from the oppressive awareness of being in a direct line of artistic descent, liberated both in time and geographical space. The American artist was able to work outside tradition and draw on a variety of sources, recognizing indebtedness where appropriate, and so to develop an interpretation that was entirely fresh because detached from historical contingencies.

Arshile Gorky, an Armenian immigrant to the United States, is the transitional figure linking the two continents. He had a profound admiration for Cézanne and Picasso (some of whose drawings he 'reproduced') but he was equally awake to the implications of automatic drawing and its potential for generating new plastic forms. His painting is imbued with a melancholy nostalgia for his native Armenia and is full of metaphysical and autobiographical references. It is also one of the most original contributions to the

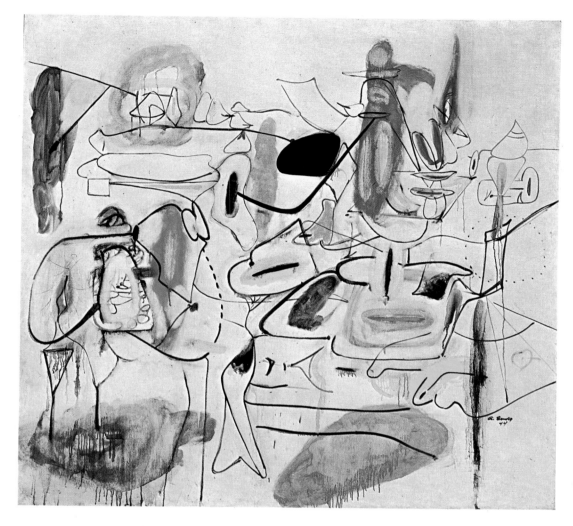

GORKY
Painting
1944

history of art in this century, primarily because it brings drawing and colour into a new dialectical relationship. The drawing takes the form of biomorphic outlines, the colour acts as a violent punctuation in the picture. In taking possession of 'this space that is different every time,' Gorky demonstrates an acute awareness of the physical properties of the picture-space. Gesture and composition unite in expressing the surface integrity of the flat canvas, so that it appears not merely as a support on which the picture is painted but an integrating element in the pictorial experience.

Unwell and disabled by an accident, Gorky committed suicide in 1948. It fell to his former pupils and fervent admirers, Pollock and De Kooning, to develop the ground so admirably prepared for them. Together with Motherwell, Kline, Still and Gottlieb, they became the dominant figures in the movement known as Abstract Expressionism or 'action-painting'—the latter term perhaps a better description of the importance accorded to gesture and movement, the sheer physical exuberance of the act of painting.

POLLOCK
Number I
1948

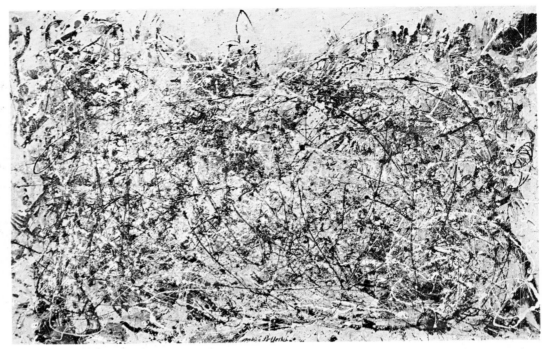

KLINE
White Forms
1955

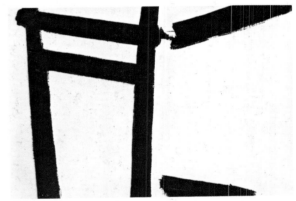

STILL
Painting
1949

DE KOONING
Woman I
1950-1952

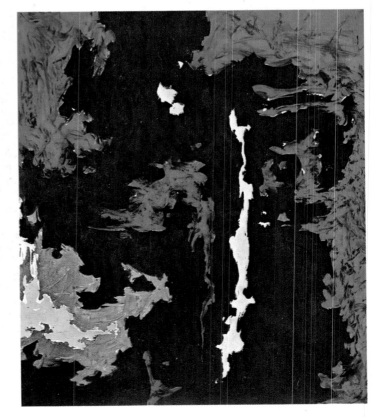

STILL
Painting
1951

POLLOCK
Number 5
1948

MOTHERWELL
Elegy to the Spanish Republic
1954

Pollock's early works were strongly influenced by Picasso and some of the Surrealists, and of course by Gorky (the totem series). He was also fascinated by Navajo sand-paintings, and was one of the first artists to work with the canvas spread out flat on the ground, completing the painting before mounting it on a stretcher. Instead of applying the paint directly, he evolved the technique of projecting or driping it on to the surface from a container with holes in the bottom. With this single act he changed the face of painting. The picture is a mesh of intersecting lines, splashes and blobs, spread in layer upon layer over the whole surface. It becomes an autonomous object, bearing the marks of the artist's movements and gestures as he applies the paint in broad sweeps. The whole operation is performed in a state of extreme tension, depending on the free swing of the artist's gestures as he executes a kind of dance, the rhythm of which is reflected in the dynamics of gushes and lines that cover the picture. All notions of composition or surface hierarchy are effectively suppressed. The 'all-over'—together with its negative counterpart, the monochrome—is the ultimate expression of the picture as an entity in itself. The dangers of sterility inherent to such an approach did not escape Pollock himself, and for this reason, and also to avoid becoming trapped by purely stylistic devices, he began again to intervene more directly in his pictures, reintroducing figures. A road accident brought this new development in his work to an abrupt end, leaving an intriguing question mark hanging over the conclusion of one of the most phenomenal artistic careers of this century.

De Kooning, born in the Netherlands, retained an attachment to Expressionism, his style generally characterized by the dissolving of form into colour, and the superimposition of layers of pigment. In 1952, he created something of a furore by returning to figuration with his series of

Women. Impervious to criticism, he has continued to experiment and to explore radically new ideas, demonstrating an undimmed curiosity and openness to new methods of transcribing reality.

Among the other Abstract Expressionists one should single out Motherwell, much influenced by the example of Matisse, who divides the picture space into large rhythmic zones of saturated colour; also Still, whose paintings are built up of slabs of impasto that look like jagged strips of coloured film; and Franz Kline, whose predominantly black-and-white calligraphic-style painting has affinities with oriental art.

ROTHKO
Number 10
1950

ROTHKO
Sassrom
1958

Another off-shoot of Abstract Expressionism is variously called 'colour-field abstraction' or, by the artists themselves, simply 'minimal art'—'producing the maximum effect with the minimum means.' Painters such as Newman, Rothko, Reinhardt and Morris Louis were influenced by the theories of Gestalt psychology, and experimented with optical illusion and the mechanisms of visual perception; they also shared with the action-painters an appreciation of the autonomy of the physical picture-space; and they developed theories of the role of thematic content in abstract art. The painting itself became an object of study, analysed for its various properties, the ability of the canvas to absorb or diffuse the pigment, or to be blotted out by it altogether. All that could be represented were marks in space, which had no reality beyond that of the pigment of which they were made.

It is a curious fact of recent history that small technical innovations can have disproportionately large effects in other fields. Acrylic paints are a case in point. Their invention and commercial exploitation came at a time when that particular group of artists was poised to take advantage of their specific properties to extend their investigations into pigments and colour effects.

The most representative canvases of Barnett Newman take the form of zones of colour divided vertically by a 'zip' (a band covered with an adhesive strip during the paint application). The paintings are usually large and the sheer scale of the coloured surfaces, and the vibrations set up between them, exercise an odd fascination. The zip works as an activator, a break in the colour-field, so that you are obliged constantly to re-draw the mental map by which you apprehend space, either as a totality or in the relationship of its parts. As a contribution to aesthetic theory, Newman's work is of major importance.

Rothko makes use of superimposed rectangles in hazy space, with no clear distinction between them. The forms appear to float against the background, their edges sometimes shading one into another. True optical illusions, Rothko's paintings seem diffused with a light that irradiates out from the centre, and which is physically arrested only by the frame of the canvas. Their dynamism and chromatic intensity are astonishing.

Reinhardt's solution was to superimpose colour tones. His figures (a cross, or a chequerboard) are built up of squares of the same colour, in such a way that they become visible only from a particular angle, which the viewer is constrained to adopt. His combinations are endlessly fascinating—and achieved with great economy, since they rely entirely on the direction imparted to the pigment as it is being applied.

Morris Louis was particularly concerned with exploring the coating properties of paint and the reaction of acrylics on unprimed and unsized canvas. His paintings fall into two categories: either the wings of the canvas

are streaked by diagonal rivulets of colour, or the colour-channels intermingle and combine, making a fan formation along the vertical axis of the picture surface. Louis described his paintings as 'veils' of colour, stained rather than painted, so that the cloth fibres are saturated with the successive layers of thin, transparent pigment.

The innovations of action-painting, colour-field abstraction and minimalism were all taken up, adapted and extended by other painters in their turn. Some, such as Frankenthaler, Poons and Francis, placed the emphasis on gesture, colour and texture; others stressed construction and the containment and interaction of colour-zones—one thinks in particular of the hard-edge painters with their pre-formed canvases: tondos, triangles or parallelepipeds, and other even more complex geometric shapes. Noland, for example, was famous for his targets, concentric rings painted in

205

irregularly stained colour. Kelly divided space into zones of opposing colours, aiming to strain their relationship to the limits of tension. Frank Stella began by making mazes on square canvases, then went on to decorate these in a variety of colours and develop them into vast friezes with elaborate jutting contours. Gradually he added off-cuts of metal as supports, so that his works became in effect bas-reliefs; and as these have taken on ever more organic and plant-like shapes, with luxuriant colours and complex line-patterns, his painting has became a sort of extravaganza of the neo-baroque. An extraordinarily fertile and original artist, Stella has had a huge influence on the present generation of American painters.

Minimalism had important consequences for sculpture. The works of Sol LeWitt and Donald Judd, for example, rely for their effect on repetition and the use of series. LeWitt used to make empty framework cubes, and subsequently moved on to geometric mural paintings. Judd based much of his sculpture on the spatial applications of the golden section; his 'progressions' consist of series of modules whose dimensions change according to the distance from which they are viewed. Carl André, influenced by Brancusi, has built stacks of wooden beams and made 'pavements' out of metal plates laid horizontally on the ground. Dan Flavin appreciated early on the potential of another new material: neon fluorescent tubing. But he has never altered its basic shape or dimensions in any way, always retaining the standard module in his works. Much influenced by the ideas of Constructivism, he produced a famous neon sculpture called *Monument to V. Tatlin*.

New Realism, Pop Art, Narrative Figuration

It is true of any avant-garde, that once it achieves recognition it creates its own opposition. This is in part a necessary generational conflict, but it is also the consequence of the inevitable process by which new styles of painting are taken up by imitators and turned into formulae. Only the greatest artists transcend time and fashion, the rest are tied to the representational forms typical of their era and do not survive beyond it. At the end of the fifties, a number of events took place simultaneously, signalling a rebellion against the dominant creed of abstraction. New artistic concepts were tentatively explored, new interpretations of 'reality' were under discussion, and although the oppositions forming in France, England and the USA differed in their stylistic and theoretical bias, they were unanimous in attacking abstract art for its lack of relationship to the experiences of real life and for its elitist attitudes.

In *c.* 1955, Rauschenberg and Jasper Johns began to set out their 'neo-dada' programme, not in any particular spirit of iconoclasm or destructiveness but 'envisaging painting as a way to bridge the gap between art and life.' In London, Richard Hamilton organized two exhibitions, 'Man, Machine and Motion' (1955) and 'This is Tomorrow' (1956); they showed a new openness to experience on the part of the artists, an overwhleming concern with the 'signs' of modern life, and an attempt to evaluate the symbolism of consumer goods and the messages of the urban environment. And finally, in 1960, Pierre Restany and the French New Realists issued their first group manifesto.

At first sight the members of the latter group appear to have little in common, but Restany has described certain shared aims that brought the artists together: the 'new realists' all supported the notion of their art as 'a fundamental gesture to appropriate reality,' and they sought 'to elaborate a methodology of perception founded on an acknowledgement of objective modern reality'.

Therefore painters such as Yves Klein, one of the outstanding personalities of the group, were particularly interested in problems of communication. Klein himself was unusual in seeing his work as serving the purposes of a 'cosmic intuition'; he was probably the last artist to cast himself in the role of *deus ex machina*, interpreter and revealer of a metaphysical reality, and founder of a cosmogeny. In 1958, Klein organized the exhibition 'Le Vide' at the Iris Clert gallery; the visitor was invited to contemplate the empty room and find in it the reflection of his own reality. A lover of parables, Klein also 'invented' a blue, based on an industrial pigment, a deep, sky colour, which he used in combination with yellow and gold

JOHNS
Figure 5
1960

KLEIN
Monochrome IKB 3
1960

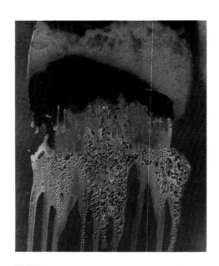

KLEIN
Anthropometry 82
1960

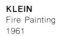

KLEIN
Fire Painting
1961

monochromes. He did not make pretentious academic claims for his picture forms, but aimed rather to provoke in the onlooker the sense of beholding an absolute, of identifying it just for a second with a sweep of azure blue. Similarly with his *Imprints*, made by the action of women's bodies pressing paint onto empty canvases, or again with his fire paintings, invocations of the elements in a ceremony presided over by the artist as demi-god. Klein's work, prematurely brought to an end by his sudden death, was in essence conceptual. His distinctive achievement was to express in an absolutely fresh language (which could on occasion be irritatingly totalitarian) the eternal dilemma faced by the artist: neither a figure of romance, nor the officiate of a religion, but the true intermediary between metaphysical reality and its translation into concrete terms.

Another characteristic of the New Realists was their passion for collecting and hoarding. Arman held an exhibition called 'Plein' at the Iris Clert gallery, a laboured response to Klein's 'happening' of the previous year. On this occasion the visitor had to be content with remaining at the door and trying to take in the collection of objects and rubbish with which the room was, quite literally, full. Arman pushed this particular jest still further by 'collecting' various objects and encasing, for example, rubbish bins and their contents in clear plastic; he would also on occasion lose his temper and break a precious Stradivarius or some Dan masks. This to make a ponderous statement about the alienating status of objects and their innate obsolescence.

Spoerri, an archaeologist of the modern day, actually collected the remains of meals from friends, or left-overs from prisoner's cells, and hung them as 'readymades'. Hains, de la Villeglé and Rotella assembled tattered posters ripped from walls; torn in this way they took on a new significance, somewhere between poetry and social criticism. Tinguely and Nicky de Saint-Phalle were fascinated by Duchamp-like machines. Tinguely's 'metamatics' are absurd mechanisms that can produce abstract drawings, for example, or even self-destruct in a rain of fireworks. César, a late adherent of the group, was trained as a classical sculptor, using iron and bronze. His 'compressions' and later 'expansions' are evidence not so

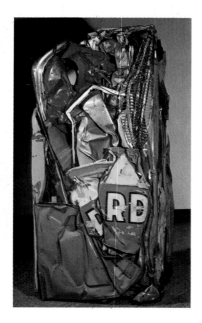

CESAR
Car Compression : Ricard
1962

much of creativity as of the artist's ability to select significant aspects of experience. The compressions consist simply of cars and other vehicles crushed into cubes of scrap-iron by an industrial process, preparatory to being melted down. It is the act of placing them in a different context, so that they can be looked at afresh, that sets up a poetic resonance—owing much to the ambiguous response of the viewing public.

Finally Martial Raysse, the youngest of the group and one of the most inventive. He draws on popular iconography, using the stereotypes of fashion and advertising to create a consciously banal set of images, that comment on the processes and assumptions of the mass-media. At the same time he implicitly undermines the status of the 'art object' by parodying such acknowledged masterpieces as Ingres' *Turkish Bath*.

But, radical though they seemed at the time, the impact of the French 'new realists' does not even begin to compare with that of the English Pop artists, who saw themselves as the anthropologists of their day, or with the extreme pragmatism of the American Pop generation. With two or three exceptions, New Realism was typically French, rhetorical rather than genuinely questioning, not in itself an innovative force but a reaction to changes occuring elsewhere.

It was in England that the term Pop Art was coined, by the critic Laurence Alloway. What he was trying to describe was a new cultural response to transformations in society, expressed in a clear language designed to reach a

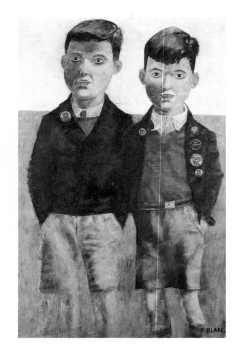

mass public. Working in association with architects and town-planners, the founder group of English Pop artists were principally concerned with making their message intelligible; with the techniques of mass communication; and with 'decoding the signals' of modern urban life. Hamilton is the most representative artist of the group. Much interested in Duchamp, and his way of allowing objects to speak for themselves, Hamilton compiled a sort of inventory of the most typical and significant objects occuring in the average everyday environment. As one can see from his collage-picture *Just What is it that Makes Today's Homes so Different, so Appealing?*, the items are assembled with some humour, and also with affection. That Hamilton was susceptible to the glamour of the mass media is evident too in such pieces as *My Marilyn*, his posthumous tribute to Marilyn Monroe. And it is precisely because the English Pop Art movement as a whole was not concerned to criticize, but from the outset embraced the new social phenomena, that it achieved such widespread popular success.

The second generation of English Pop artists, Blake, Hockney, Jones, Caulfield—many of them graduates of the Royal College of Art—were themselves identified with the contemporary scene. Blake painted music and rock stars, and also designed the cover for the Beatles' *Sergeant Pepper* LP. David Hockney refers constantly in his paintings to his own homo-sexuality and his exotic life-style. At this short distance in time, it is impossible to do more than salute the accuracy of an analysis that has found such potent images to describe the radically changed society of the modern day.

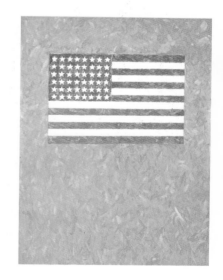

Robert Rauschenberg and Jasper Johns met as students at the Black Mountains College, also attended by Merce Cunningham and John Cage.

Their discussions at that time centred on the need for a new artistic stance vis à vis reality, an openness to the social context and the sights, sounds and images of the environment.

The first act of this visual revolution dates from the day when Rauschenberg rubbed out a drawing by De Kooning (with the artist's permission). Quite literally, he made a *tabula rasa* of 'subjective and personal feelings and perceptions.' He then went on to concentrate on exploring the materials that, for him, constituted reality—in other words the extraordinary collection of objects he assembled in his 'combine-paintings'. Starting from the belief that it was a purely arbitrary decision as to when an object had come to the end of its useful life, Rauschenberg proclaimed the virtues of artistic recycling, a sort of perpetual metempsychosis (somewhat paradoxical, since it depended on the

obsolescence of earlier models). In his view there should be no hierarchy within the picture, since all the elements were of equal importance. They had no particular symbolic function, but were simply recycled 'to avoid waste.' He later included in the combine-paintings silk-screened photographic images, unaccented statements with no narrative or expressive potential, at the same time parodies of the representational forms of the mass media.

But, whatever Rauschenberg may have intended, his works are not in the least cold or remote. On the contrary, they provoke a fascinatingly ambiguous intellectual and emotional response in the spectator, because of the tension between the mechanical processes according to which they are assembled, and the extraordinary vision of reality that they contain.

The paintings of Jasper Johns are similarly double-edged, in that they both make use of and comment on traditional concepts of pictorial space. Johns re-paints such things as American flags and targets, in a way which stresses both the realism of the object represented and the artifice with which it is reproduced. False flags or true paintings? The logical absurdity of the proposition is posed in its most extreme form when he takes, for example, light-bulbs or beer-cans and paints the objects themselves.

ROSENQUIST
Nomad
1963

LICHTENSTEIN
M-Maybe

It is generally accepted that Rauschenberg and Johns are not strictly speaking to be classified as Pop artists, although they precede and prefigure the generation that includes Warhol, Lichtenstein, Oldenburg Rosenquist, Wesselman, Dine and Segal. With them, the American Pop revolution was accomplished. Everyday life was brought into the domain of art—or, if you prefer, art was integrated into society. With an assumed matter-of-factness, these painters made the images of urban life their own, cartoon strips as well as advertising motifs. Their gods and goddesses were the cardboard heroes of the mass media. In his silk-screen prints of Elvis Presley, Marilyn Monroe and Liz Taylor, and the famous Campbell's soup-cans, Andy Warhol did more than draw on the experiences of the advertising world in which he was once employed, he actually used the techniques of mass-reproduction to create his pictures.

These painters did not set out to criticize 'the American way of life', they simply held up a mirror to society and painted what they saw—perhaps in the long run the most damning indictment of all? But the formula was an instant success. If New York completely dominated the world art scene, it was due to the sheer effrontery of these American artists, with their disarming directness and their sense that art could be fun.

ARROYO
Caballero espagnol
1970

EQUIPO CRONICA
Black Stain
1972

MONORY
Irena
1969

What Europe retained from the Pop Art phenomenon was a way of handling the picture surface in flat zones of colour, a way of making a deliberately neutral (or sometimes condemnatory) statement. In France this gave rise to the school of 'narrative figuration', a grouping of socially conscious artists who comment obliquely on social and political issues. Alliaud uses the metaphor of caged animals, imprisoned behind bars in zoos. Rancillac and Télémaque compare and contrast 'typical' objects, such as an umbrella and a sewing-machine, placed together on an operating table. Monory depicts eerie assassination scenes in blue monochrome or, at another period, obscure melodramas in pink monochrome. Erro, uniquely, creates hallucinatory images out of collage and cut-ups. Adami presents a schizoid view of his memories of hotels and books.

The Spanish painters Arroyo and Enrico Cronica are the most interesting exponents of what that country's critics have described as 'the art of chronicling reality'. Their painting mounts a frontal attack on the symbols and values of a society held in abhorrence, functioning as a kind of political manifesto couched in the terms of a lampoon.

The late sixties and early seventies saw the return in force of figuration, in the form of Hyperrealism. As the term implies, the primary objective of these artists was to reproduce reality with absolute precision. The paintings are like photographs, and indeed the artists painted from photos to ensure that their pictures were exact in every detail. In other respects too photography was a major influence, conditioning not only the fidelity of the image but its presentation, in terms of the way the 'shot' was framed or an object viewed from odd angles, or in the use of mirror-images and reflections.

Cothingham's sectional views of signs and Estes' distorted glass windows are fairly typical examples. The realistic sculptures of Duane Hanson and John De Andrea are particularly disturbing as they confront us with life-size human forms.

Chuck Close and Malcolm Morley have been mistakenly classed as Hyperrealists. Close uses the Renaissance technique of 'squaring-up' for his exaggeratedly large portraits, but the grid-size he employs is so fine that the drawings and pictures can be read on many levels, depending on the distance from which they are viewed. Malcolm Morley's paintings are indeed faithful representations of reality, but they are essentially a means of affirming the banality of subject-matter, since à 'copy' of a Vermeer is fundamentally no different from the 'copy' of a tourist leaflet advertising transatlantic crossings. In exploring ideas of image and meaning, in focusing on the artist's subjective choice of his motifs, Morley's work has influenced the direction of a whole new generation of painters.

AILLAUD
Snake and Plate
1966

215

ESTES
Gordon's Gin 1968

EDDY
New Shoes for H M
1974

HANSON
Tourists
1970

216

COLVILLE
Pacific 1967

MORLEY
Pacific Telephone
L.A. Yellow Pages

The Seventies — Conceptual Art

In the broadest sense of the term, conceptual art describes a many sided investigation into the nature of art itself. The conceptual artists talk of the need for 'total art', and at the same time are adamant in their refusal to perpetuate a system which treats art objects as consumer durables. They reject rigid categories, such as painting or sculpture, in favour of hybrid processes ('arte povera') or ephemeral events (happenings, performance art, etc.). Another of their explicit aims is to take art out of the museums and galleries and place it in other contexts (land-art) and other intellectual systems (conceptual art in the narrow sense of the term).

With their aversion to 'market forces' and the subversion of artistic creativity by capitalism, the opposition that crystallized in the early sixties reached its apogee with the events of 1968. However, a movement which was then seen as a liberation rapidly reached an impasse: far from becoming an integral and accepted part of life, art had never been so low in the public estimation or understanding. The paradox was untenable, and it was not long before an alternative market was called into being. If it was impossible to put a price on an action, then the documentary record of that act could be marketed instead, just as though it were a traditional painting.

The 'happening' was intended to sensitize a mass public to the idea of art, using the techniques of drama. Oldenburg, Dine and other Pop artists had already used 'happenings' as a way of extending the life of their pictures. Allan Kaprow was one of the first to stage such events outside the gallery context, in stores, post offices, banks, etc. Implying a criticism of social behaviour, these planned disruptions were usually aggressive in tone, and relied on improvisational techniques to cope with the unpredictable reactions of the public. Performance art adopted much the same approach. The Fluxus group, for example, brought together artists of many different nationalities in the staging of multi-media events and demonstrations intended to be 'cathartic'. They saw themselves as the direct descendants of the Dadaists, and were strongly influenced by Yves Klein and Pietro Manzoni. Other artists attracted to the freedoms, and even anarchy, of performance art include, in the States, George Brecht, Maciunas, Nam June Paik (the inventor of 'video-art') and, in Europe, Vostell, Ben and others. 'Body-art' is perhaps self-explanatory—the 'canvas' of action being the person of the artist himself. Obviously the possibilities here are endless, but there have nevertheless been certain broad tendencies, on the one hand self-mutilation (Gina Pane in France, and the 'initiation masses' staged by Nitsch or Rainer's mortuary-portraits, in Austria), and on the other hand variations on the theme of disguise (Urs Lüthi, Luciano Castelli).

BEN
Art is Useless
1967

LÜTHI
« Tell me who stole your smile »
1974

BEUYS
Coyote
1974

A number of artists have chosen to adopt a more purely investigative or philosophical approach; among these are the true conceptualists, Darboven, Haacke and above all Kosuth, whose work enters the realm of linguistics. He has, for example, exhibited an actual chair, together with a photograph of it and its dictionary definition, thus raising ideas about the paradox inherent in painting (as reproduction), the reality it claims to represent (the disparity between the object and its photograph) and the limitations of what can be known and expressed (the specificity of the object and the universality of the dictionary definition).

Joseph Beuys occupies a unique position as his art takes many different forms and is virtually unclassifiable. He believes that it is the task of the artist to show how art contributes to every sphere of human activity, and his own work therefore attempts to channel the liberating forces of cultural energy in order to set up a constructive dialogue with nature. Beuys' materials have a wealth of symbolic significance: felt, for example, is a good

219

insulator, and it is also made from rabbit fur, and is therefore the tangible expression of a relationship which has been long forgotten. In one of his best-known performances, Beuys explained the whole concept of art to a hare; the animal represents the link between the earth (in which he burrows) and speed and movement (which have to be 'captured'). His 'Coyote' event, staged in 1974 in New York, was designed to be interpreted on many levels. Beuys was shut up in a cage for several days with a coyote, an animal which represents the wild state and also brings to mind the American Indians. The artist's only protection was a big felt blanket in which he cocooned himself, so expressing the notion of captivity and the deprivation of liberty, and also the necessity for rediscovering the natural instincts and truths of which civilized man has been dispossessed.

'Land-art' provides probably the most dramatic illustration of the relationship of the contemporary artist to the natural world. The land-artist intervenes directly to modify the landscape and our perception of it: it ceases to be the model for a painting and itself becomes the canvas. The American-based land-artists—Michael Heizer, Walter De Maria, Christo, Robert Smithson—have taken advantage of the vast tracts of desert land and monumental geographical formations at their disposal in order to demonstrate, on a grand scale, how man can manipulate his environment. Heizer transformed a section of the Nevada Desert by digging a series of random trenches. In a nearby location, Walter De Maria traced an angle over an area of several kilometers, his *Las Vegas Piece*. His most spectacular achievement to date is the *Lightning Field*, an array of brass rods or lightning-conductors spread over a square mile, which sets off fantastic storms and displays of lightning. Robert Smithson, killed when his plane crashed on a reconnaissance trip, is best known for his *Spiral Jetty*, constructed just outside Salt Lake City. Christo, famous for his wrapped objects when he was associated with the New Realists, has encased whole cliff-formations in plastic sheeting, has suspended a curtain across the Colorado Canyon, and also constructed a tarpaulin barrier that runs for hundreds of miles, across several state boundaries, before ending up in the Pacific Ocean.

On a smaller scale, the English artists Richard Long and Hamish Fulton make records of their country-hikes, showing the evidence of human activity (mounds of stones and timber in Long's work, entire landscapes in Fulton's). Their photographs capture the mystery of the places they visit, and the curious absurdity of these modern rites.

CHRISTO
Running Fence
1971-1976

ANSELMO
Untitled
1980

MERZ
Igloo of Giap
1968

LONG
Cornish slate of circle
1981

PENONE
Soffio 6

Of all the many movements concerned to transform and explore traditional notions of art, the Italian 'arte povera' is one of the most interesting and significant developments. The name was coined by the critic Germano Celant at the time of an exhibition held in 1967. It is more than a simple designation of the 'poor' materials characteristically employed by these artists, it also expresses a reaction against American standardization and banality and an attack on the inflated reputation accorded to the pseudo-Pop artists and minimalists, who then reigned supreme. These artists were acutely conscious of the irony of their situation; with all the weight of the Italian tradition behind them, they were nevertheless condemned to work in the shadow of an ephemeral artistic phenomenon which had its roots overseas—to be, if you like, the outlaws or nomads of the art world. In their struggle to invent a new and modern language for art, they had at all times to take account of their national inheritance, while still allowing free play to the subjective expression of the artist in contemporary society. Mario Merz, Jannis Kounellis, Luciano Fabro, Giuseppe Penone and Giovanni Anselmo are among the artists who have blurred the distinction between sculpture and

PAGES
Untitled
1980

223

painting, using junk objects in compositions that are highly referential in their content. The distinctive synthesis they have evolved is among the most aesthetically satisfying contributions of the last twenty years. Merz's favourite image is the igloo, which he often recreates in fragments of glass, thus stressing both the lack of protection it affords and its purely temporary nature as a shelter.

Kounellis uses materials that have a symbolic resonance (scales, fire, gold), although these are usually no more than small punctuations in, for example, the surface of a wall; he too makes a point about the transient nature of all things. Penone constructs tree-trunks out of wooden beams, he has also allowed his breath to condense inside earthenware vessels, and exhibited a self-portrait with mirrors placed over the eyes in such a way that they reflect a landscape. He starts from the premise that the artist can do no more than try to recapture the traces left by his own existence.

In France, the Support/Surface movement set out to explore the possibilities of treating surface and canvas as separate entities. Their experiments with dyeing and folding the canvas rapidly led to an impasse of mannerist formalism, but Claude Viallat and Bernard Pagès, in painting and

GILBERT AND GEORGE
Youth Attack
1982

BOLTANSKI
Theatrical Composition
1981

RAINER
Self-Portrait
1982

225

SMITHSON
Spiral Jetty
1970

226

FLANAGAN
Aauig i guiaa
1965

DI ROSA
The Boss of the El Toro Ranch
1983

BARCELO
The Painter over his Painting
1982

sculpture respectively, have produced some intriguing variations on the theme. Boltanski and Le Gac are the best representatives of the French 'conceptualist' tradition—in so far as that can be said to exist. Both in their different ways favour an art that is fictional, representational and characterized by irony and wit.

Sculpture in the seventies has not been immune to the effects of a general desire to abolish the distinctions between the disciplines. In England, which has a strong sculptural tradition, Barry Flanagan and Gilbert and George have perhaps produced the most apposite contradiction to an older generation of practitioners. In his sculptures, Flanagan asserts his freedom to elect the most improbable materials in a much as is demonstrated their structural system.

Gilbert and George exhibit their own persons as 'living sculptures'. Their faces covered with gold paint, always dressed in the same respectable three-piece suits, they are the embodiment—and the refutation—of the idea that the artist is to be identified with his practice.

Of the American sculptors, Robert Morris and Richard Serra are the most noteworthy. Morris was influenced initially by the Minimalists and for a time worked as a land-artist, though he always placed a greater emphasis on construction than his contemporaries. He has since concentrated on felt sculptures, which occupy a position somewhere in between the two-dimensional image and the full-relief of sculpture in the round. Serra's constructions are monumental pieces made of iron plates, balanced in position by their own weight; he also uses long, curved sheets, which he places in an urban environment in such a way that they sometimes follow the contours of the ground and sometimes deviate from it.

The Present Day

The direction art appears to be taking today demonstrates all too clearly the impossibility of predicting the future as a linear development of the past, indeed it calls into question the whole notion of an avant-garde. The wheel has come full circle. Once again there is a marked emphasis on painting, an insistence on the unique contribution of the individual artist, often working in an autobiographical context. And yet, as this new strategy develops, it seem to be covering the very same ground as before: while declaring the impossibility of making any further progress in the entrenched art-forms of the previous era, the adherents of the various neo-, trans- or post-modern movements merely advance new versions of the arguments put forward by their predecessors. No doubt market forces exercise a powerful logic of their own, demanding at least a semblance of conformity.

And yet in certain respects circumstances have changed, and changed fundamentally. The artists of today find themselves in a very difficult situation, following decades of formal experimentation in which it seems that everything that can be said has been said, every possible avenue explored. That there has been a return to figurative painting is not in doubt. But it is clearly far too soon to make any objective assessment of the merits or de-merits of this revival. The arguments continue, with every point hotly debated by the opposing factions. However, it is surely not unreasonable, even now, to ask that the individual artist should give an account of his work, justify it in terms of its semantic, psychological and sociological context. On that basis it then at least becomes possible to isolate certain characteristic features of a body of work, and to discuss it in terms of its 'organic' relationship to art history as a whole, and national or regional cultural traditions in particular.

In this perspective one can highlight, for example, the distinctively German theme of the act of redemption, an expiation of the horrors of the Hitler era, through the reinterpretation (implicitly critical or otherwise) of the romantic mythology favoured by the poets and musicians of the late nineteenth century. Lüpertz and Kiefer are the prime examples of artists working in this particular vein, the former by introducing images of war into the subject-matter of his paintings, the latter by creating a pantheon of harsh deities as a metaphor for creative genius. Baselitz, Penk and Polke share these preoccupations to a degree, but their approach is more oblique and individualistic. Baselitz paints the images in his pictures, literally, upside-down, so creating afresh the language of pictorial illusion. Penk employs stylized images and pictograms which resemble street-graffiti. Polke's paintings are built up by a process of fragmentation and superimposition, a

means both of neutralizing the symbolic force of the image and of commenting on its precariousness.

The Italians of the 'trans-avant-garde' differ from the Germans in using elements of classical style, a reaction against the cultural assumptions of Expressionism. References to Renaissance painting abound. Their pictures have achieved instant success, resulting, for the most part, in a stilted and precocious mannerism from which only Cucchi and Clemente escape, by the sheer conviction with which they present their autobiographical material.

The American artists, based mostly in New York, find themselves for the first time in the position of reacting to an established tradition rooted in their own culture. Showing the same pragmatism as the older generation, Schnabel, Salle, Longo, Borovsky and others have opted for visual impact rather than theoretical depth. Schnabel frees the painted image from the picture surface by first creating a collage layer of broken crockery. This double surface is intended to be the tangible expression of the processes of memory, operating selectively on a number of different levels. Salle combines images with a variety of different objects. Longo constructs big machines of coldly clinical efficiency, which are made up of elements produced in various different media, thus commenting on the duality of craft and technology. Borovsky creates whole environments designed to be experienced from within, in a stunning assault of painted images, sculpture, video, tape-recordings and swirling slide projections.

Awareness of tradition has been crucial in the development of the current generation of artists in Spain, who are producing some of the most interesting and thoughtful work to have emerged recently in Europe. Painters such as Campano, Sicilia and Barcelo are using figuration, and Broto employs the techniques of abstraction, to develop a Spanish style of painting that, after a long period of isolation, is again receptive to international influences. Their work is, in general, expansive and expressive in character, and draws much of its power from the traditions of icon-painting.

In England, sculpture is still very much to the fore. Tony Cragg is in a direct line of descent from the English land-artists, although he works in an urban context. Woodrow too is concerned to redefine the terms of urban life, by manipulating and recycling domestic utensils. Richard Deacon operates within a more overtly classical tradition, that owes much to Barry Flanagan and an earlier generation of sculptors.

Finally, in France, there has been a split between two generations of artists, as a result of which the relatively new Figuration-Libre movement has 'come through the middle' and achieved a rapid success. Combas, Di Rosa, Boisrond and Blanchard are among those who have benefited from a public unwillingness to tolerate any longer the torrent of rhetoric unleashed

HARING
Untitled
1982

GAROUSTE
Orion and Cédalion
1982

BLAIS
« Sur le retour »
1982

231

simultaneously by the painters of Support/Surface and the adherents of 'narrative figuration', in a long and bitter conflict that has effectively denied France any international influence for over a decade. In this artistic wasteland, the raw exuberance and frontal approach of Figuration-Libre have been greeted with relief. To what extent that success is genuinely merited remains to be seen; at all events, there is a clear moral to be drawn from these sorry events.

The simplifications of Figuration-Libre, and the trappings of academism assumed by the various splinter-groups that have arisen in its wake, have in their turn summoned up a movement of opposition. Garouste and Alberola, for example, paint in an infinitely more subtle and sophisticated style that abounds in complex references; although their themes are drawn from fiction and mythology, they introduce an element of manipulation and irony that owes much to conceptualism, even though they would not themselves acknowledge it as an influence. Other painters have tended to pursue their own individual paths—no doubt a further symptom of the lack of coherence in recent years. To mention only a few: Lavier covers various objects in a thick layer of paint, so casting doubt on the way they are to be classified; Rousse uses photographic processes to record the images he paints in abandoned buildings; Bouillon creates environments with strongly primitive overtones; and Blais places images of doleful puppet-like figures against a background made of posters torn into random strips.

BASELITZ
Elke VI
1976

list of the illustrations

The Museums and Public Collections where the reproduced works are kept have been mentioned in the list of illustrations. **M.N.A.M. Paris** is the Musée National d'Art Moderne, Centre Pompidou, Paris. Private Collections have not been mentioned.

AILLAUD : Snake and Plate. 1966 — 215
ALECHINSKY : Swimming. 1955. — 190
ANDRÉ : Blacks Creek. 1978. *M.N.A.M. Paris* — 203
ANSELMO : Untitled. 1980. *F.R.A.C. Nord* — 222
APPEL : Cry of Freedom. 1948. *Stedeljik Museum, Amsterdam.* — 190
ARROYO : Caballero Espagnol. 1970. *M.N.A.M. Paris.* — 214
ARP : Painted Wood. 1917 — 146
 The Man with three Navels. 1920 — 149
 Positioned According to Chance Laws. — 174
 Static Composition. 1915. — 179
BACON : Three Studies for a Crucifixion. Center Pannel of the Triptych. 1962. *S.R. Guggenheim Museum, New York.* — 197
BALLA : Mercury Passing before the Sun. 1914. — 116
 Dynamism of a Dog on a Leash. 1912. — 116
BALTHUS : The Turkish Room. 1963-66. — 196
 Nude Asleep. 1973-77. — 196
BARCELO : The Painter over his Painting. 1982. *F.R.A.C. Midi Pyrénées.* — 228
BASELITZ : Elke VI. 1976. *Musée d'Art et d'Industrie, Saint-Etienne.* — 233
BAUCHANT : Fête de la Libération. 1945. *M.N.A.M., Paris.* — 172
BEARDSLEY : Isolde. ca 1890. — 69
BECKMANN : Portrait of the Artist with his Wife. 1941. *Stedelijk Museum, Amsterdam.* — 127
 The Caravan. 1940. — 127
BELLMER : Balls and Joints. 1936. — 159
 Drawing. 1965. — 159
BEN : Art is Useless. 1967. *Musée d'Art Contemporain, Nîmes.* — 218
BEUYS : Coyote I like America and America likes me. Performance, New York. 1974. — 219
BISSIERE : Composition. 1952. — 188
BLAIS : Sur le retour. 1982. *F.R.A.C. Marseille.* — 231
BLAKE : ABC Minors. 1965. *Ludwig Collection. Aachen.* — 210
BOCCIONI : Those who go away. 1911. — 115
 Elasticity. 1912. — 116
BOËKLIN : Island of the Dead. 1880. *Museum der Bildenden Kunst, Leipzig.* — 63
BOLTANSKI : Theatrical Composition. 1981. — 225
BOMBOIS : Dancer taking a Curtain Call. 1926. — 172
BONNARD : Woman with black Stockings. ca 1905. — 71
 Getting out of the Bath. ca 1930. — 71
 Poster for la Revue Blanche. 1894. — 71
 View of Le Cannet. 1924. — 72
 Nude in the Bath. 1944-46. — 72
 Seascape. — 73
BOUDIN : The Beach at Trouville. 1863. — 15
 Le Bassin du Commerce, Le Havre. *Musée du Havre.* — 15
BRAQUE : Glass and Violin. 1912. *Kunstmuseum, Basel.* — 90
Hommage to J. S. Bach. 1912. — 90
 Fruit-dish, Pipe and Glass. 1919. — 90
 Aria by Bach. 1912-13. — 92
 The Guitarist. — 93
 Female Bust. 1937. — 101
 Three Lemons. 1942. — 101
 Cabins, small Boats and Pebbles. 1929. — 101
 The Duet. 1937. *M.N.A.M. Paris.* — 102
 Washstand by a Window. 1943. — 102
 Tea-pot with Lemon. — 102
 Still-life. 1929. — 102
 Bird. 1962. — 103
 Engraved Plaster. 1948. — 103
 Notebook. — 103
 The Palette. 1941. — 104
 Still-life. 1939. — 104

Woman's Head. 1942. 104
The Red Gueridon. 1943. 104
BURRI : Sacco and Bianco. 1953. *M.N.A.M., Paris.* 191
CALDER : Fin. *M.N.A.M., Paris.* 196
CARRA : Hermaphroditic Idol. 1917. 144
Metaphysical Muse. 1917. 145
CASSATT : The Little Sisters. 1885. 61
CESAR : Car Compression : Ricard. 1962. 208
CÉZANNE : The Card Players. 1890-95. *Musée d'Orsay* 37
L'Estaque. 1878-79. *Musée d'Orsay.* 37
Portrait of Madame Cézanne. 1883-87. 37
Young Man with a Red Waistcoat. 1890-95.
Coll. E. Bührle, Zurich. 37
The Blue Vase. ca 1885-87. *Musée d'Orsay.* 38
Still-life with Onions. 1895. *Musée d'Orsay.* 38
Basket of Apples. 1890-94. *Art Institute, Chicago.* 38
Man with a Pipe. 1890-92. *Courtauld Institute, London.* 39
Self-portrait. 1880. *Kunstmuseum, Berne.* 39
La Montagne Sainte-Victoire. View from Lauves.
1904-06. *Kunsthaus, Zurich.* 40
CHAGALL : The Green Violonist. 1918.
S. R. Guggenheim Museum, New York. 139
Man Drinking. 1911. 139
The Anniversary. 1915-1923.
S. R. Guggenheim Museum, New York. 139
Les Mariés de la tour Eiffel. 1938-39 140
Young Girl with a Horse. 1929. 140
The Fall of the Angel. 1923-47. *Kunstmuseum, Basel.* 140
Mosaic. Detail. 1970. *Musée Marc Chagall, Nice.* 141
CHAISSAC : Composition with a Snake. 1951.
Musée de l'Abbaye de Sainte-Croix, Les Sables d'Olonnes 194
CHÉRET : Loïe Fuller. 1893. 63
CHIRICO : Premonitory Portrait of Apollinaire. 1914. 142
The Enigma of Fatality. 1914. 143
Love Song. 1914. 143
Melancholy of a Beautiful Day. 1913. 143
Hector and Andromache. 1917. 143
The Great Metaphysician. 1917. 144
Melancholy of an Autumn Afternoon. 1915. 144
The Enigma of the Oracle. 1910. 145
CHRISTO : Running Fence. 1971-76. 221
COLVILLE : Pacific. 1967. 217
CONSTABLE : Weymouth Bay. 1816. 19
Brighton Beach. 1824. 20
CROSS : The Wave. ca 1907. 41
The Port of Toulon. 43
DALI : Giraffe on Fire. 1935. *Kunstmuseum, Basel.* 152
Crucifixion (Corpus Hypercubus). Détail. 1955.
Metropolitan Museum, New York. 152
Soft Construction with Boiled Beans. 1936.
Museum of Art, Philadelphia. 152
Basket of Bread. 1926
Coll. A. Reynold Morse. Salvador Dali Museum, St. Petersburg, Florida 153
The Persistence of Memory. 1931. *Museum of Modern Art, New York.* 154
The Christ of Saint-John of the Cross. 1951. *Art Gallery, Glasgow.* 154
Mae West. 1934-36. *Art Institute, Chicago.* 154
The Ghost of Vermeer which can be used as a Table. 1934. *Coll. A. Reynold Morse. Salvador Dali Museum, St. Petersburg, Floride* 154
DEGAS : Three Dancers. ca 1876. 14
At the Café also known as l'Absinthe. 1876. *Musée d'Orsay.* 33
Portrait of a Young woman. 1867. *Musée d'Orsay.* 33
Race Horses at Longchamp. 1873-75. *Museum of Fine Arts, Boston.* 33
Women ironing. ca 1884. *Musée d'Orsay.* 34
Carlo Pellegrini. 1876-77. *Tate Gallery, London.* 34
The Carriage at the Races. 1870-73. *Museum of Fine Arts, Boston.* 34
The Star, or Dancer on Stage. ca 1878. *Musée d'Orsay.* 35
Study of a Dancer. 1874. 35
Dancer adjusting her Shoe. 35
Dancers. 1899. 36
The Tub. 1886. *Musée d'Orsay.* 36
DEGOTTEX : Aware II. 1961. *M.N.A.M. Paris.* 192
DE KOONING : Woman I. 1950-52. *M.O.M.A., New York.* 200
DELAUNAY : The Cardiff Team. 1912-13 *Stedelijk van Abbe Museum, Eindhoven.* 110
Runners. 1926. 110
Rhythm. 1936. 111
Paris 1937. Air, Iron and Water. 1937. 111
Rythme, joie de vivre. 111
Simultaneous Disc. 1912. 178
Windows. 1912. 178
SONIA DELAUNAY : Composition. 1952. 111
DELVAUX : Iphigenia. 158
Hands. 1941. 158
Iron Age. 1951. *Musée des Beaux-Arts, Ostend.* 159
DENIS : The Muses. 1893. *M.N.A.M. Paris.* 66
DERAIN : Sun reflected on Water. 1905. *Musée de l'Annonciade, Saint-Tropez.* 76
Woman in Chemise. 1906. 76
Hyde Park. 1906. 79
DINE : Two Palettes. 1963. 211
DI ROSA : The Boss of El Toro Ranch. 1983. *F.R.A.C. Rhône-Alpes.* 228
DUBUFFET Extremus Amibolis. 1956. 193
Mass of the Earth. 1959-60. *M.N.A.M. Paris* 193
DUCHAMP : Chocolate Grinder. 1913. *Museum of Art, Philadelphia* 147
Why not Sneeze, Rose Sélavy. Ready made. 1921. 148
DUFY : Portrait of Michel Bignou. 1934. 85
Seascape. 85
Interval. 1945. 86
The Red Violin. 1948. 86
Console with Yellow Violin. 1949. 86
Anemones. 87
Ascot. 87
Regatta. 1938. 87
EDDY : New Shoes for H.M. 1974. 214
ENSOR : Carnival. 1888. 128
Entry of Christ into Brussels. Detail. 1888. 128
EQUIPO CRONICA : Black Stain. 1972. *Musée Cantini, Marseille.* 214
ERNST : The Sap rises. 1929. 146
The Pleiads. 1920. 148
The Pink Bird. 1956. 150
Girls with a Monkey. 1927. 150
Woman, Old Man, and Flower. 1923-24.
Museum of Modern Art, New York. 150
Anti-Pope. 1942. *Fondation Guggenheim, Venice.* 151
Echo, the Nymph. 1936. *Museum of Modern Art, New York.* 151
Petrified City. 1937. *City Art Gallery, Manchester.* 151
Gordon's Gln. 1968. 223
ESTES : Gordon's Gin. 1968. 216
FATTORI : The Rotunda at Palmieri. 1866. 62
FAUTRIER : Sweet Woman. 1946. *M.N.A.M. Paris* 191
FLANAGAN : Aauig i guiaa. 1965. *Tate Gallery, London.* 227
FLAVIN : To Donna. 1971. *M.N.A.M. Paris* 206

FONTANA : Concetto spaziale. 1960 **191**
FRANCIS : In Lovely Blueness. 1955-57. *M.N.A.M. Paris* **192**
GAUGUIN : The Yellow Christ. 1889-90. *Albright-Knox Art Gallery, Buffalo.* **48**
 The Vision Following the sermon. 1888. *National Gallery of Scotland, Edinburgh.* **48**
 La Belle Angèle. 1889. *Musée d'Orsay.* **48**
 Arles, Les Alyscamps. 1888. *Musée d'Orsay.* **49**
 Tahitian Women on the Beach. 1891. *Musée d'Orsay.* **49**
 Vahiné with Gardenia. 1891. *Glyptotheque, Copenhagen.* **50**
 Riders on the Beach. 1902. *Folkwangmuseum, Essen.* **50**
 Tahitian Women with Mango Blossoms. 1899. *Metropolitan Museum, New York.* **51**
 Tahitian Girl with a Fan. 1892. *Folkwangmuseum, Essen.* **52**
 Tahitian Women on the Beach. 1891-92. **52**
 Otahi (Loneliness). 1893. **52**
GIACOMETTI : Woman Standing II. 1959-60. *M.N.A.M. Paris.* **195**
GILBERT AND GEORGES : Youth Attack. 1982. **224-225**
GONTCHAROVA : Electricity. 1911. **179**
GORKY : Painting. 1944. **199**
GRIS : Vase of Flowers. **105**
 Still-Life with Oil-lamp. 1912 **105**
 Still-Life Siphon. 1916. **105**
 The Album. 1926. **106**
 Bag of Coffe. 1920. **106**
 Still Life with Dice. 1922. **106**
GROSZ : The Subversives fall and the Uniform takes over. **127**
 The Hors d'œuvre. 1929. **127**
 Without Title. 1920. *Kunstsammlung, Dusseldorf* **147**
HAMILTON : Interior II. 1964. *Tate Gallery, London* **210**
HANSON : Tourists. 1970. **216**
HARING : Untitled. 1982. *Boymans-van Beuningen Museum, Rotterdam.* **231**
HARTUNG : Pastel P. 1960-66. **192**
HAUSMANN : Abstract Idea. 1918. *Museum des 20 Jahr-underts, Vienna.* **148**
HECKEL : Two Men sitting at Table. 1913. **121**
HERBIN : Vein. 1953. **188**
JAWLENSKY : Woman with bangs. 1913. *Stadtmuseum, Wiesbaden.* **124**
 The Red Shawl. 1909. **124**
JOHNS : Figure 5. 1960. **207**
 Flag on Orange Field. *Wallraf-Richartz Museum, Köln* **211**
JONGKIND : The Beach at Sainte Adresse. 1863. *Musée d'Orsay.* **16**
 Sun setting on the Meuse. ca 1866. **16**
JUDD : Progressions. 1972. *Musée d'Art et d'Industrie, Saint-Etienne* **203**
KANDINSKY : Landscape with Steeple. 1909. **124**
 Lyric. **125**
 Improvisation 14. 1910. **125**
 First Abstraction. Watercolour. 1910. **174**
 With the Black Arc. 1912. *M.N.A.M. Paris.* **174**
 Drawing for « Floating Figure ». **175**
 White Line. 1920. **175**
 Black Spot II. 1921. *M.N.A.M. Paris.* **175**
 Inflexible. 1929. **176**
 Shrill-Peaceful Pink. 1924. *Wallraf-Richartz M., Köln.* **176**
 Looking into the Past. 1924. **176**
 Accent in Pink. 1926. **177**
 On White. 1923. **177**

Careful Move. 1944. **177**
KELLY : Red Curve IV. 1973. *Musée de Grenoble.* **206**
KHNOPFF : Portrait of the artist's Sister. 1887. **66**
KIRCHENER : Young Girl in a Meadow with Flowers. 1908. **119**
 Young Girl on a blue Sofa. Fränzi. 1907-08 *Minneapolis Institute of Art.* **119**
 Self-portrait with Model. 1907. *Kunsthalle, Hamburg.* **120**
 Woman in Mirror. 1912. **121**
 Poster for an Exhibition. **121**
KLEE : Niesen. 1915. **161**
 Landscape with Yellow Birds. 1923. **161**
 Senecio. 1922. *Kunstmuseum, Basel.* **161**
 Head in Blue Tones. 1933. **162**
 Individualised Altimetry. 1930. Klee Stifftung, Bern. **162**
 Town Decked with Flags. 1927. **162**
 Open. **163**
 Dancing Master. 1930. **163**
 Old City and Bridge. 1928. **164**
 Sailor. 1940. **164**
 Death and fire. 1940. **165**
 With the two lost Ones. 1938. **165**
KLEIN : Fire Painting. 1961. **208**
 Anthropometry 82. 1960. *M.N.A.M. Paris* **208**
 Monochrome IKB3. 1960. *M.N.A.M. Paris* **207**
KLIMT : Danae. 1907-08. **68**
 The Kiss. 1907-08. *Osterreilchische Galerie, Vienna* **68**
 Fritza Riedler. 1906. *Osterreichische Galerie, Vienna* **69**
KLINE : White Forms. 1955. **200**
KOKOSCHKA : Portrait of Herwarth Walden. 1910. *Staatsgalerie, Stuttgart* **123**
 Marseille. 1925. *City Art Museum, Saint Louis, U.S.A.* **123**
 Woman in Blue. 1919. **123**
KUPKA : Philosophical Architecture. 1913. **180**
 Blue and Red Vertical Planes. 1913. **180**
KUTTER : Clown. 1930. **130**
LAM : Motherhood. 1965. **195**
LARIONOV : Rayonnism. 1911. **179**
LEGA : The Pergola. *Brera, Milan* **62**
LEGER : Contrast of Forms. 1913. **107**
 Still-life with Beer Mug. 1921. **107**
 Disks and the City. 1919-20. **107**
 The Mechanic. 1920. **108**
 Composition I. 1930. **108**
 Bather. 1931. **108**
 Leisure. Homage to Louis David. 1948-49. *M.N.A.M. Paris.* **109**
 The Great Parade. 1954. **109**
 Butterflies and Flowers. 1937. **109**
 Two Women with Flowers. 1954. *Tate Gallery, London.* **109**
LEWITT : White 5 part Modular Piece. 1965-69. *Musée de Grenoble.* **203**
LICHTENSTEIN : M. Maybe. Comics. *Wallraf-Richartz Museum, Köln.* **213**
LIEBERMANN : Amsterdam. The Zoo. 1902. *Kunsthalle, Breman.* **62**
LOUIS : Column of Fire. 1961. **205**
LONG : Cornish Slate of Circle. 1981. **222**
LÜTHI : « Tell me who stole your smile ». 1974. *Collection Galerie Staedler.* **218**
MACDONALD-WRIGHT : Synchromy. 1916. **181**
MACKE : Sunny Walk. 1913. **125**
 Walkers before the Blue Lake. 1913. *Staatliche Kunsthalle Karlsruhe.* **125**

MAGNELLI : Painting 0530. 1915. 179
MAGRITTE : Human Condition. 1935. 155
 Clear Ideas. 156
 Steps of Summer. 1937. 156
 The Great Family. 1947. 156
 Philosophy in the Boudoir. 1947. 156
 Memory. 1948. *Musées Royaux des Beaux-Arts, Brussels.* 157
MALEVITCH : Suprematist Composition. 1914-16. 181
 Suprematist Composition. 1915-16. 181
 Suprematist Composition. 1915. 181
MANET : Rest. 1869. 9
 Le Déjeuner sur l'herbe. 1863. *Musée d'Orsay.* 10
 The Balcony. 1868-69. *Musée d'Orsay.* 10
 Portrait of Irma Brunner. 1882. *Musée d'Orsay.* 10
 The Fifer. 1886. *Musée d'Orsay.* 11
 Olympia. 1863. *Musée d'Orsay.* 12
 Nana. 1877. *Kunsthalle, Hambourg.* 12
 Mademoiselle Victorine in the Costume of an Espada. 1862. *Metropolitan Museum, New York.* 12
 Two Peony Blooms with Pruning-scissors. 1864. *Musée d'Orsay.* 13
 Le Bar aux Folies-Bergères. 1882. *Courtauld Institute, London.* 13
 Claude Monet painting on his Boat. 1874. *Neue Staatsgallerie, Munich.* 21
MARC : Horse in a Landscape. 1910. *Folkwang Museum, Essen.* 126
 Horses resting. 1912. 126
 The Blue Horse. 1911. 126
MARQUET : Le Quai Conti, Paris. 1947. 88
 Le Quai des Grands-Augustins. 1905. *M.N.A.M.* 88
MASSON : Brought by the Storm. 1938. 160
 Amphora. 1925. 160
 Gradiva. 1939. 160
MATISSE : Portrait of Mme Matisse. 1905. 75
 Open Window. Collioure. 1905. 75
 Michaëla. 1943. 80
 Figure in an Interior in Nice. 1921. 81
 Woman leaning. 1938. 81
 Young English Woman. 1947. 82
 Man from the Rif standing. 1913. 82
 The green Sideboard. 1928. *M.N.A.M. Paris.* 82
 France. 1939. 83
 The Siesta. Collioure. 1905. 83
 Odalisque with Red Trousers. 1922. *M.N.A.M. Paris.* 83
 Nude. 1914. 84
 The Snail. 1953. *Tate Gallery, London.* 84
MATTA : Elle Hegramme to the General Astonishment. 1969. 195
MERZ : Igloo de Giap. 1968. 222
MIRÓ : Nocturnal Bird. 1939. 166
 Hare. 1927. *Solomon R. Guggenheim Museum, New York.* 166
 Composition. 1933. *Museum of Modern Art, New York.* 166
 Snob Party at the Princess. 1944. 167
 Green Background. 1949. 167
 The Beautiful Bird explaining the Unknown to the Loving Couple. 1941. *Museum of Modern Art, New York.* 167
 Sketch for the Wall of the Moon. 1958. *Palais de l'U.N.E.S.C.O., Paris.* 168
 The Mauve of the Moon. 1951. 168
 Woman before an Eclipse. 1967. 168
MODIGLIANI : Portrait of Zborowski. 1917. *Museu de Arte, Sao Paulo.* 134
 Reclinig Nude. 1917. 134
 Young Girl in Blue. 134
 Woman with Blue eyes. 135
 Lunia Czechowska. 136
 Seated Nude. 1917. 136
 Portrait of Soutine. 1917. *Staatsgalerie, Stuttgart.* 136
MONDRIAN. Tree. 1910. 178
 Composition in Grey, Blue and Pink. 1913. *Rijksmuseum Kröller-Müller, Otterlo.* 182
 Ovale Composition. 1914. *Stedelijk Museum, Amsterdam.* 183
 Composition in Grey and Blue. ca 1912. 183
 Composition III with Colour Planes. 1917. *Gemeentemuseum, La Haye.* 183
 Composition in Red, Yellow and Blue. 1926. 184
 Composition. 1921. 184
 Composition Red, Blue and Yellow. 1930. 184
 Composition. 1936. *Kunstmuseum, Basel.* 185
 Composition. 1942. 185
 Victory Boogie-Woogie. 1933-34. 185
 Broadway Boogie-Woogie. 1942-43. *Museum of Modern Art, New York.* 185
 Composition in Red, Yellow and Blue. 1921. *Gemeentemuseum, La Haye.* 186
MONET : Impression. Rising Sun. 1872. *Musée Marmottan, Paris.* 15
 Woman in a Garden. 1867. *Musée d'Orsay.* 17
 La Grenouillère. 1869. *Metropolitan Museum, New York.* 17
 Hôtel des Roches Noires, Trouville. 1870. *Musée d'Orsay.* 22
 The Bridge at Argenteuil. 1874. *Neue Staatsgalerie Munich.* 22
 The Bridge at Argenteuil. 1874. *Musée d'Orsay.* 22
 Rouen Cathedral. The Portal and the Saint-Romain Tower.
 Morning Study. Harmony in Blue and Gold. 1894. *Musée d'Orsay.* 23
 La Gare Saint-Lazare. 1877. *Musée d'Orsay.* 23
 London. The Houses of Parliament. 1904. *Musée Marmottan, Paris.* 24
 Water-lilies at giverny. 1920-26. 24
 Water-lilies at Giverny. 1904. *Musée d'Orsay.* 24
 Water-lilies at Giverny. 1908. 25
MONORY : Irena. 1969. 214
MORANDI : Still-Life. 1918. 144
MOREAU : Delilah. *Musée Gustave Moreau, Paris.* 64
 Woman with a Panther. *Musée Gustave Moreau, Paris.* 64
 The Tattooed Salome. 1876. *Musée Gustave Moreau, Paris.* 64
MORISOT : The Cherry Harvest. 1891. 21
MORLEY : Pacific Telephone. L.A. Yellow Pages. *Louisiana Museum, Humlebaek* 217
MORRIS : Felt Piece. 1974. *Musée d'Art et d'Industrie, Saint-Etienne.* 223
MOSES : Halloween. 1955. *Grandma Moses Property, New York.* 172
MOTHERWELL : Elegy for the Spanish Republic XXXIV. 1954. *Albright-Knox Art Gallery, Buffalo* 201
MUCHA : Sarah Bernhardt. Lorenzaccio. 70
MUNCH : Women on the River Bank. 1898. 70
 The Cry. 1893. 117
 The Day After. *Nasjonalgalleriet, Oslo.* 117
 Four Young Girls on a Bridge. 1905. *Wallraf-Richartz Museum, Köln* 118
 Puberty. 1894. 118
 Karl Johans Gate. 1892. 119
NEWMAN : Dionysius. 1949. 205

NICHOLSON : Painting (Trout). 1924. **181**
NOLDE : Marsh Landscape. 1916. *Kunstmuseum, Basel.* **122**
 Slovenes. 1911. *A. and E. Nolde Foundation, See-Büll.* **122**
 The Tramps. 1910-15. *Wallraf-Richartz Museum, Köln* **122**
NOLLAND : Clearing, 1967. *Musée d'Art et d'Industrie, Saint-Etienne.* **202**
PAGÈS : Untitled. 1980. *Musée des Beaux-Arts, Toulon.* **223**
PENONE : Soffio 6, 1978. *M.N.A.M., Paris.* **222**
PERMECKE : The Betrothed. 1923. *Musées Royaux des Beaux-Arts, Brussels.* **129**
PICABIA : Amorous Parade. 1917. **147**
 Optophone. 1921. **149**
 Udnie or the Danse. 1913. *M.N.A.M., Paris.* **179**
PICASSO : Man's Head. 1912. **89**
 Music Sheet and Guitar. 1912-13. **91**
 Bass. 1914. **91**
 Guitar on a Table. 1918. **91**
 Still-life with basket Chair. 1911-12. *Coll. Pablo Picasso.* **92**
 Still-life with Bust and Palette. 1925. **92**
 The Violin. 1913. **93**
 Nude. 1902. **94**
 Les Demoiselles d'Avignon. 1907. *Museum of Modern Art, New York.* **94**
 The Rescue. 1932 **95**
 Sphinx. 1953. **95**
 Two Women running on the Beach. 1922. *Coll. Pablo Picasso.* **96**
 Women on the Beach. *Museum of Modern Art, New York.* **97**
 Harlequin. 1915. *Museum of Modern Art, New York.* **98**
 The three Musicians. 1921. *Museum of Modern Art, New York.* **98**
 The Painter Salvado dressed as a Harlequin. 1923. *M.N.A.M.* **99**
 Guernica. 1937. *Museum of Modern Art, N.Y. (extended loan).* **100**
 Reclining Woman called « The Sleeping Atlantid ». 1946. *Musée d'Antibes.* **100**
 Woman with Dog. 1953. **100**
 Centaur. 1948. **100**
PICKETT : Manchester Valley. 1914-18. *Museum of Modern Art, New York.* **172**
PISSARO : Le Canal du Loing. 1902. *Musée d'Orsay.* **26**
 Young Girl with a Twig. 1881. *Musée d'Orsay.* **27**
 The Red Roofs. 1877. *Musée d'Orsay.* **28**
 Rouen. Rue de l'Epicerie. 1888. **28**
 Peasant with Spade. **42**
 L'Ile Lacroix. Rouen. 1888. *Museum of Art, Philadelphia.* **43**
POLIAKOFF : Painting. 1951. **186**
POLLOCK : Number 1. 1948. *M.O.M.A. New York.* **200**
 Number 5. 1948. **201**
PUVIS DE CHAVANNES : Young Girls by the seashore. 1879. *Louvre.* **67**
RAINER : Self Portrait N° 13. 1982. *F.R.A.C. Nord.* **225**
RAUSCHENBERG : Pilgrim. 1960. **211**
RAYSSE : Snack. 1964. *Kaiser Wilhem Museum, Krefeld.* **209**
REDON : Pegasus Triumphant. 1905-07 *Rijksmuseum Kröller-Müller, Otterlo* **65**
 Maybe there is an Original Vision in the Flower. 1883. **65**
 The Birth of Venus. 1910. *Musée du Petit Palais, Paris.* **65**
RENOIR : La Grenouillère. 1869. *Nationalmuseum, Stockholm.* **18**
 La Danse à la ville. La Danse à la campagne. 1883. *Musée d'Orsay.* **29**
 Le Moulin de la Galette. 1876. *Musée d'Orsay.* **30**
 Girls at the Piano. 1882. **30**
 Portrait of Madame Henriot. ca 1876. *National Gallery of Art, Washington.* **30**
 Woman Bathing. 1896. **31**
 Gabrielle à la rose. 1911. **32**
 Gabrielle à la rose. ca 1905. *Musée d'Orsay.* **32**
 The Crouched Bather. 1912. **32**
ROSENQUIST : Nomad. 1963. *Albright-Knox Art Gallery, Buffalo.* **213**
ROTELLA : Marylin. 1963. **209**
ROTHKO : Number 10. 1950. *Museum of Modern Art, New York.* **204**
 Sassrom. 1958. **204**
ROUAULT : Pierrot. 1948. **130**
 Before the Mirror. 1926. *M.N.A.M. Paris.* **131**
 The Small Family. 1932. **131**
 The Apprentice. 1925. *M.N.A.M. Paris.* **131**
 Christ and the Fishermen. **132**
 The Blue Bird. **132**
 Christian Nocturne. 1952. *M.N.A.M. Paris.* **132**
 Dreamer. 1933. **133**
ROUSSEAU : Self Portrait. 1889. *Pablo Picasso Collection.* **169**
 Portrait of Pierre Loti. 1891. *Kunsthaus, Zurich.* **169**
 The War. 1894. *M.N.A.M. Paris.* **169**
 The Muse and the Poet : Apollinaire and Marie Laurencin. 1909. *Kunstmuseum, Basel.* **170**
 La Carriole du Père Juniet. 1908. *Walter-Guillaume Collection.*
 The Snake Charmer. 1907. *M.N.A.M. Paris.* **171**
 Exotic Landscape. Negro attacked by a Leopard. 1907-09. *Kunstmuseum, Basel.* **171**
 The Footballers. 1908.
 Sleeping Gipsy. 1897. *Museum of Modern Art, New York.* **171**
SCHMIDT-ROTTLUFF : Rest in Studio. 1910. *Kunsthalle, Hamburg.* **120**
SCHNEIDER : Painting 42 E. 1960 **186**
SCHWITTERS : Construction. Merz 25 A. Constellation. 1920. *Kunstsammlung, Dusseldorf* **148**
SEURAT : Portrait of Paul Signac. 1889. **41**
 Café Concert. 1887. **44**
 Honfleur. Jetty. 1886. *Rijksmuseum Kröller-Müller, Otterlo.* **44**
 Young Woman powdering her Face. 1889-90. *Courtauld Institute, London.* **45**
 Sunday Afternoon at the Grande Jatte. 1884-86. *Art Institute, Chicago.* **45**
 Fishing Fleet at Port-en-Bessin. 1888. *Museum of Modern Art, New York.* **45**
 Une Baignade, Asnières. 1883-84. *Tate Gallery, London.* **46**
 The Parade. 1887-88. **46**
 The Circus. 1890-91. *Musée d'Orsay.* **47**
SEVERINI : Dancer. 1913. **115**
 The Blue Dancer. 1912. **116**
SIGNAC : Saint-Tropez. **42**
 Le Canal Saint-Martin. 1933. **42**
 Woman doing her hair. 1892. **43**
SIGNORINI : Piazza di Settignano. 1880. **62**
SISLEY : Snow at Louveciennes. 1878. *Musée d'Orsay.* **26**
 The Flood at Port-Marly. 1876. *Musée d'Orsay.* **26**
 Regatta at Moseley. 1874. *Musée d'Orsay.* **27**
SMET (DE) : : Large Landscape with Cows. 1928. **129**
SMITHSON : Spiral Jetty. 1970. *Ludwig Collection. Aachen.* **226**

SOTO : Vibrations on Black Ground. 1959. *Museum of Modern Art, Stockholm.* **189**
SOULAGES : Painting. 1977. **191**
SOUTINE : Windy Day in Auxerre. **136**
 Choirboy. 1928. **137**
 Woman in Red. **137**
 Portrait of Maria Lani. 1929. **137**
 The Red Staircase. **138**
 The Little Pastrycook. 1922. *Walter-Guillaume Collection.* **138**
 Maternity. **138**
STAEL : Jazz Musicians, Memories of Sidney Bechet. 1952. **186**
STELLA : Les Indes Galantes. 1967. **206**
STILL : Painting. 1949. **200**
 Painting. 1951. *Museum of Modern Art, New York.* **201**
TANGUY : Hope, Four o'clock in the Summer. 1929. **155**
 Divisibility. 1942. *Albright-Knox Art Gallery, Buffalo.* **155**
TÀPIES : Gouache. 1975. **191**
TINGUELY : Chopin's Waterloo. 1962. **209**
TOULOUSE-LAUTREC : Woman pulling up her Stocking. 1894. *Musée d'Albi.* **57**
 Jane Avril in the Jardin de Paris. 1893. **57**
 A Ride in the Country. 1897. **57**
 Cha-U-Kao the female Clown. 1895. *Musée d'Orsay.* **58**
 La Toilette. 1896. *Musée d'Orsay.* **58**
 Yvette Guilbert. 1893. *Musée d'Albi.* **59**
TURNER : Yacht approaching the Coast. ca 1842. **19**
 La Piazetta. 1839-40. *Tate Gallery, London.* **20**
UTRILLO : Le Moulin de la Galette. **173**
 Snow on Montmartre. 1947. **173**
 The Church of Saint-Gervais in Paris. 1910. **173**
VALLOTON : Portrait of Moréas. **63**
VAN DONGEN : Spanish Dancer. 1913. **77**
 Anita. 1905. **78**
 Woman at the Balcony. 1910. **79**
VAN GOGH : Self-portrait. 1889. *Musée d'Orsay.* **53**
 Field of Flowers in Holland. 1883. *National Gallery of Art, Washington.* **53**
 Portrait of Armand Roulin. 1888. *Folkwangmuseum, Essen.* **54**
 Portrait of lieutenant Millet. 1888. *Rijksmuseum Kröller-Müller, Otterlo.* **54**
 Van Gogh's Bedroom in Arles. 1889. *Musée d'Orsay.* **54**
 Caravans, Gipsy Encampment. 1888. *Musée d'Orsay.* **55**
 Cornfield with Cypress Tree. 1889., *Tate Gallery, London.* **55**
 L'Arlésienne (Madame Ginoux). 1888. *Metropolitan Museum, New York.* **55**
 Docteur Gachet. 1890. *Musée d'Orsay.* **56**
 The Church at Auvers-sur-Oise. 1890. *Musée d'Orsay.* **56**
 Wheat Field with Crows. 1890. *Rijksmuseum Vincent Van Gogh, Amsterdam.* **56**
 The Shoes. 1886. *Rijksmuseum V. Van Gogh, Amsterdam.* **129**
VAN VELDE (BRAM) : Composition. 1955. **190**
VASARELY : Vonal. 1966. **188**
VIEIRA DA SILVA : Golden city. 1956. **193**
VILLON : Seated Woman. **112**
 Race Horse. 1922. **112**
 Joy. 1932. **112**
 Ocean Deeps. 1945. **113**
 Portrait of the Artist. 1949. **113**
 Orly. 1954. **113**
 The Poet. **114**
 Au Val de La Haye. **114**
 Portrait of Marcel Duchamp. **114**
VIVIN : The Louvre. 1930. **172**
VLAMINCK : Woman's Head. 1906. **74**
 Portrait of André Derain. 1905. **74**
 The Banks of the Seine at Carrières-sur-Seine. 1906. **75**
 Red Trees. 1906. **76**
 Sur le zinc. 1900. **78**
WARHOL : Liz. 1963. **212**
 Soup Cans. 1965. **212**
WHISTLER : Portrait of Mrs Leyland. 1872-73. **60**
 On the Beach. ca 1875. **61**
 Battersea Bridge. Night Scene in Blue and Gold. 1865. *Tate Gallery, London.* **61**
WOLS : The Wing of the Butterfly. 1947. *M.N.A.M., Paris.* **191**

$\frac{4}{96}\,^{28}$